Blackshirts
in
Geordieland

Gordon Stridiron

Blackshirts
in
Geordieland

Gordon Stridiron

ISBN-13: 978-1-913176-29-7

Sanctuary Press Ltd
71-75 Shelton Street
Covent Garden
London
WC2H 9JQ

www.sanctuarypress.com
Email: info@sanctuarypress.com

Contents

"There are no machine guns or rifles in here," said Mr. Stephenson with a smile, shepherding me into yet another room, "but there is some chocolate and cigarettes and I daresay we could make you a cup of tea at a pinch."

South Shields Gazette reporter on visiting the BUF office on Westoe Road in April 1935

It was nearly eleven hundred, and in the Records Department, where Winston worked, they were dragging the chairs out of the cubicles and grouping them in the centre of the hall opposite the big telescreen, in preparation for the Two Minutes Hate.

George Orwell, *Nineteen Eighty-Four*.

Foreword

It was necessary to provide some background to this subject and it is contained in the first two chapters of this project that provides information on the arrival of the British Union of Fascists on Tyneside, what they did, what sort of people they were and what happened when war with Germany was declared on September 3rd 1939.

I have mentioned two organisations, The British Fascisti and The New Party, that existed before or during the time the British Union of Fascists was founded in October 1932. They had differences and cannot be considered to be compatible with one another. In fact, Linton-Orman of the British Fascists considered Sir Oswald Mosley to be some sort of Communist, while the BUF thought the Fascisti did not know what Fascism was if it was staring them in the face and rejected them as the far right rump of the Tory Party and referred to them as "three old ladies and a couple of office boys."

Many in The New Party had followed Sir Oswald Mosley from the Labour movement and were concerned, as he was, about unemployment, housing conditions and social progress with the advent of new technology. They were disillusioned with a system that refused to change and provide leadership with the power to implement policies that would improve conditions for the men, women and children of Britain. They were not ready for the new ideas of fascism and they left rather than be associated with it. Mosley disbanded the party and launched the Blackshirt movement.

What concerned all three organisations was how to get the best people of ability to govern the country for the benefit of

all. They wanted people elected who had the authority to get things done, to have a government that was a workshop, not a talk shop. They wanted a government like a football team with its manager and captain that made decisions. They did not want them appointed to form player's football committee's and act on a consensus of mediocre opinion. They wanted people appointed as they were the best people for the job and knew what had to be done and they would get on with it. They knew that people were different and that a system of competition and rewards for hard work would bring out the best qualities in them and result in progress for mankind. And above all they wanted leadership that was motivated by concern for their country and love of its people.

There is another work available on this subject but its accuracy is suspect. For instance, it claims five Gateshead Blackshirts erecting a platform for a public meeting at Windmill Hills was an alleged marching line of chanting Fascists heading towards the Independent Labour Party rostrum with the intention of attacking the 1,000 Socialists and their speakers or where a single Blackshirt wearing his First World War medals giving a talk at Marlborough Crescent Bus Station becomes thirty well dressed Fascists. In spite of its well indexed references, most of it tends to be a work of left-wing political fantasy.

This is far from a compete work on Blackshirts in the area 1932-1940 but I have provided the information that I have collected and hope it will be of interest to the reader of political history.

Acknowledgements

I would like to thank the staff of Newcastle Central Library, Sunderland Central Library, Gateshead Central Library, South Shields Central Library, Middlesbrough Central Library, Durham City Library, Hexham and Morpeth Libraries for their assistance in helping me to compile the information for this book. Also, the Friends of Sir Oswald Mosley for their help and contribution to this work. Kevin Scott, the Director of Civil Liberty, encouraged me throughout and it was in discussion with him that the idea for this work originated. My grateful thanks to Jeff Wallder for his corrections on the manuscript. If there are any other errors they are my own.

The British Fascisti

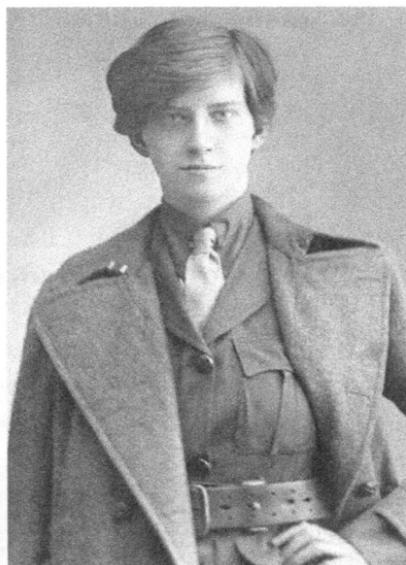

Miss Rotha Linton-Orman was born in 1895 from a long line of family members who served in the armed forces. She joined the Girl Scouts in 1909 and at the outbreak of the Great War joined the Women's Reserve Ambulance and in 1916 sailed for active service in Serbia. She was awarded the *Croix de Charite* twice for gallantry. After the war she joined the British Red Cross and was placed in charge of training all ambulance drivers for the service.

At the beginning of 1923 she was "gravely alarmed at the rise of Socialism and Communism" and decided to insert a series of six advertisements in the Duke of Northumberland's paper *The Patriot*. The advertisements asked for recruits for a "British Fascisti" that was to act as an organised force to combat Red Revolution. The response was good and by May that year Rotha founded the British Fascisti movement and within a few months had enrolled tens of thousands of men and women. To combat the influence of children's Red Sunday Schools - there were three in Newcastle and two in Gateshead - she started the British Fascist Children's Clubs. It represented a strong patriotism to the right of the Conservative party, but those who were more militant said that the British Fascisti leaders did not know what fascism was and left to set up their own fascist groups.

William Joyce (who later became known as Lord Haw Haw) joined The British Fascisti in 1923 when he was only 17 years old. When acting as a fascist steward at a Conservative party meeting at Lambeth Baths in October 1924, communists attempted to rush the platform, intimidate the speakers and seize the Union Jack and, while defending the flag, Joyce was slashed across the face with a razor. He lost that much blood his life was in danger and it left him with a scar stretching from his ear to the corner of his mouth.

Not only right-wing Tory types viewed communists with suspicion. The Secretary of the National Union of Railwaymen, Mr. C.T. Cramp, wrote in *The Railway Review* of 1924; "The public press asserts that communists are responsible for many of the recent difficulties of the NUR. How true this may be I do not know, for in this country communism does not love the light of day and, of this I am certain, that whenever their hand is in a trades dispute, disaster has swiftly overtaken the workers. I speak as a convinced Socialist when I say that not all the efforts of the Capitalist class can weaken the organised Labour movement as would the British Communist Party if they had their way...They have no connection with the Labour movement. No body of employers will continue to recognise a union if it cannot control its membership and no governing body which is elected by the rank and file can afford to be stampeded by any small section of men."

Sir Cecil Hanbury was elected as MP in 1924 and became a supporter of Mussolini. In 1936 he was in the news for donating £100 to the Italian Red Cross as a token of his sympathy with Fascist Italy and its solders in Abyssinia. Some years previously Mussolini had acknowledged his charitable work in the country and had conferred on him the Grand Cordon of the Crown of Italy. His wife, who he married in 1913, was believed to be the first woman to be enrolled as a Fascist in this country.

On March 27th, the Council of the British Fascisti decided to

write to the Secretary of State for Home Affairs to offer the services of the organisation during the General Strike. The Fascisti secretary, A.M. Wroughton, wrote "We wish in the first instance to make it perfectly clear to you that we are not in any way a strike breaking organisation, and men are at present, at all events, restricted from taking part in work of that description. We shall, however, have much pleasure in placing at your disposal a body of men from time to time for the purpose of assisting the authorities in the prevention of violence to individuals, the destruction of property or the intimidation of those who desire to remain at work."

A press release in April 1924 entitled "British Fascisti Movement: What it is and what it is not. Fight against Bolshevism." said "The British Fascisti Movement is making steady growth throughout the country, units have been formed in many parts of London and in several of the provincial centres, including Newcastle. In order to correct misstatements which have been made about the organisation a leaflet has been issued from which it appears that the organisation asks Britons of any age, sex and class to volunteer for practical work, so that an effective force may be raised 'to combat the ever increasing menace of Bolshevism.' The leaflet further states- "It has been organised by a group of people who are in a position to know the danger to this country from the immense amount of communist propaganda and teaching which is allowed to go on unchecked, and who realise the need of a strong patriotic movement to stem the tide of Bolshevism which is making headway in our midst."

"It cannot be too strongly emphasised that the British Fascisti is not a 'swashbuckling' concern, as stated in certain newspapers; nor does it bear resemblance in any way to the Ku Klux Klan or any terrorist organisation. Its object is the preservation of law and order and the prevention of terrorising this country by the forces of revolution which are seeking to overthrow society and plunge Great Britain into the same state of anarchy and chaos that is in Russia at the present time.

"The British Fascisti is not out to provoke force but is prepared to meet force if necessary. It believes that there is a real necessity for a well organised and disciplined body of loyalists throughout the country, ready and willing to assist the police or military in the event of revolutionary disturbances."

The enrolment form for members was printed in the following terms:

> I, the undersigned, hereby promise upon my honour to uphold His Most Gracious Majesty King George V, his heirs and successors, the established constitution of Great Britain and the British Empire. I undertake that, without personal consideration, I will render every service in my power to the British Fascisti in their struggle against all treacherous and revolutionary movements now working for the destruction of the Throne and the Empire.'

The Newcastle *Weekly Chronicle* April 19th 1924 wrote that "The British Fascisti is not a class movement. It embraces all grades of society from peers to the humblest of people. Neither is it connected to Toryism, Liberalism, or any other shade of party politics, its ranks being open to all who have its objectives at heart and who are willing conscientiously to uphold its principles. The British Fascisti is not a strike breaking organisation, but in the event of a general strike designed to paralyse the country, it will most certainly co-operate wholeheartedly with the authorities in the direction of safeguarding the nation's food supply."

This message tended to appeal to patriotic people and right-wing Conservatives and some Fascisti had duel membership with the Tory party. Mr. Blakeney said he had lived for 26 years in Egypt and knew something of the ramifications of the agents of communism there. Although one of the planks of Communism was atheism, there was no aversion on the part of their agents to come to agreement with the Muslims so long as they operated against Christianity and the British. There was a

great effort to train the Moslems worldwide against the British. That the Christian Church was loosing its grip on its faith was emphasised by Dr. Hanslilje, Secretary of the German Student Christian Movement, when he spoke to 2,000 delegates of the Student Christian Conference at Edinburgh in January 1933. He said "Communism is a God given punishment to a lame and degenerate Christianity. The only possibility of Christianity understanding the attack of Communism was to go back to the understanding of its original message. Either Christianity must understand the full extent to which the present crises has come or there is no hope for it."

Members of the Tyneside Italian community gave their support to the new government in Italy when they formed a Newcastle section of the Italian Fascisti. Their first annual dinner was held in the Crown Hotel in Clayton Street on August 8th 1924 when upwards of 100 people were present. Representatives were also present from Edinburgh and Glasgow and at that time there was something like 20,000 Italians living in Britain. At the interval in the proceedings, the new flag of the Newcastle Fascisti section, which had been presented by Miss Toney, daughter of Mr. Mark Toney, was formally blessed by the Rev. Father Canon Newsham of St.Mary's Cathedral who, in a brief address, expressed his pleasure at the fact that Mussolini had now restored not only order but religion in Italy. In an address by Signor Tronchetti of Glasgow he implied that in this country the Fascisti movement was more of a cultural one but that Signor Vegri Francesco had been appointed as the branch political secretary and Signor Valle, the Italian Consul in Newcastle had been invited to speak.

These reunions were still taking place in March 1937 when nearly 200 members of the Italian community, some from Carlisle and Middlesbrough, attended the colony's reunion luncheon at the Newcastle County Hotel. "The room was gaily decorated with bunting and Italian flags and pictures of the King and Queen of Italy. The principle speaker was Signor Gino Gario, the London correspondent of several Italian papers. The Italian Vice-Consul

in Newcastle Cav. Nestore Tognoli proposed the toast to "The King of Italy," "King George VI of England" and "Mussolini." Signor Gario said that the first duty of the Italian was not to interfere with the internal politics of the country in which he was a resident and later gave a lecture on Abyssinia.

A talk was given in September by Mr. R. Wale, formerly a leather worker in Petrograd, under the auspices of the Workers Liberty and Employment League, when he said that it was a pleasure for him to speak at a public meeting, and even to be heckled, for he had recently come from Russia where no such freedom was permitted. He had seen a meeting hall surrounded by Soviet troops, and men shot down and taken prisoner as they left. He had known men dragged off to be shot because they had heckled a Soviet speaker.

Confirmation of communist intentions surfaced in a number of ways. In December 1924, the Newcastle Communist Party industrial organiser, Peter Gibson, was arrested for attempting to blow up Newcastle Town Hall, a local power station, cut off the water supply to the city and rob a bank. The 38 year old came to Newcastle in November 1923 from Buckhaven, near Fife in Scotland, where he had left his wife and came to Tyneside with her younger sister. He had obtained explosives at Seghill Colliery where he was employed as a storeman. He said "I would like to blow that place up" meaning the Town Hall, and that he should like the Lord Mayor and other heads to be in at the time. A considerable quantity of communist literature, a membership card, and a card for the National Minority Movement was found at his home. Some of the literature was from Moscow. He had received money from the treasurer of the Communist Party in Westgate Road and said he would get a lot more money from the CP if he did the job. He was found guilty at Newcastle Assizes on February 27th 1925 of having been found in possession of explosives and sentenced to three years penal servitude. On appeal the judge said he was fortunate not to get 14 years.

Also, in February Sir Philip Dawson MP returned from a country bordering on Russia. One of the leading army Generals there told him that they had found a list giving the names and details of 143,000 people, representing ten per cent of the population of all classes who were to be shot when the communists obtained control of the country. The Labour Party too were concerned about infiltration by the far left. Ramsey McDonald warned the workers to be on their guard against the communists and at the party conference that September in Liverpool, the entire exclusion of communists from the Labour Party was insisted upon by the Executive Committee and the resolution to do so was overwhelmingly passed by the membership. Captain S.R. Streatfield who was standing as a Unionist candidate for Durham Division said he had a list of 150 paid agents who received money from Moscow and that in August Scotland Yard raided premises in the Soho district and seized communist propaganda that was to be distributed among the armed forces. Large quantities of seditious leaflets had already circulated in Aldershot and other garrison towns, and leading communists Albert Inkpin, Harry Pollitt and John Cambell were arrested under breaches of the Mutiny Act.

There was an attempt to kill King Boris of Bulgaria when a communist gang killed two of his aides and wounded his driver. The Archbishop of Saragossa was murdered by the Spanish anarchist Ascaso and, during that time, Moscow supported and financed violent revolutionary groups throughout Europe. In the USA attempts to murder US Senators and blow up government buildings had taken place. Considering what communists were doing across the world, it certainly would have appeared to fascists as though the Reds were preparing for a violent overthrow of the British government.

The writer and historian Nesta Webster was one of the early and most important members of the British Fascisti movement and was well known for her books on freemasonry and international conspiracy theories. She wrote *World Revolution* in 1922 and

two years later *"The Plot against Civilisation: Secret Societies and Subversive Movements"* and penned many other publications, many of them printed by the Duke of Northumberland's publishing firm.

The Newcastle Fascisti held a fund raising dance at the Grand Assembly Rooms in Barras Bridge on March 9th 1925. The committee comprised of Mr. and Mrs. Thirlaway, Mrs. Harrison and Mr. Johnson. The officers who were present were Major Cree, M.C. (County Commissioner), Captain Massey (Area Quarter Master), Mr. C. Sibbald (Propaganda Officer), Mr. Beaumont (Transport Officer), and Mr. J. W. Shand (Area Adjutant) and music was provided by the Peacock Orchestra. Mr. Shand gave a short address to say the Fascisti belonged to no party and was in no way opposed to trade unionism. He said it was democratic and its aims were to oppose extremist activity in the trade union movement and to equally oppose unfair treatment of employees by employers of labour and that in case of a national strike they would be prepared to maintain the necessary social services.

The movement found some notoriety when five well dressed young men, stated to be members of the British Fascisti, were committed for trial for the abduction of leading communist party member Harry Pollitt on March 14th 1925. The names of the accused were James Hayon Browner, aged 35, a tailor, William Cochrane, 30, garage proprietor, George Fraser McGaghen, 30, cotton salesman, James Owen, commercial traveller and a Mr. Rowlandson. Mr. Pollitt was on his way to Liverpool by train when he was taken off by the young men and pushed into a motor car. He was driven around until 2am in the morning and taken to what he thought was a hotel and given some tea and food. No physical harm happened to him and at the court trial of the young men they were acquitted.

The organisation had an office at 148 Barras Bridge in April 1925, it was near the Haymarket in Newcastle, and the site is now occupied by a new University building. The Northern

Eastern Area Propaganda Officer Mr. C. Sibbald said the British Fascist Movement was a non party organisation prepared to uphold, and if necessary, defend the King, his heirs and successors and the established constitution of Great Britain and opposed Communism and all that it implies, revolution, class hatred and atheism. He added: "All members pledge themselves in case of necessity to do everything within their power, without personal consideration, to rid the country of the revolutionary menace and to assist in the march of progress towards peace and prosperity along sane, progressive and democratic lines."

Speaking to Newcastle British Fascists in Burlington Hall on May 18th 1925, the organisation's President, Brig-Gen R.B.D. Blakeney CMG., DSO, described the movement as a voluntary force to combat communism, that in this country they wanted peace and they were constitutional; they stood for King and Country. They stood for free speech, and in this connection he said that in the last election in Newcastle Central free speech was denied Mr. Fisher, the Conservative candidate, until several of their members policed his meetings. He said "Their enemy was Communism and that Fascism was the revolt of reality against rot, of common sense against cant." He said the five points of communism were the abolition of the monarchy, the British Empire and private enterprise, the destruction of family life and religion and these were what the British Fascisti would protect.

On Wednesday July 22nd that year, the Sunderland area fascists had a successful dance in Wetherrall's Assembly Rooms at 13 The Green, which was located near the present Minster Church. About 200 people attended, including the County Commander Major R. Ewart Cree, MC, and the Area Commander Captain T. Sherborn Nesbitt. They were informed that the branch continued to make progress and had recently extended its activities to South Shields, Seaham, Hebburn and Durham City. Brig-Gen Blakeney was again in the area on Oct. 21st 1926 when he spoke to a large meeting held in the Subscription Library Hall in Sunderland. Explaining the aims

of fascism, he said "People on the one hand see luxury and extravagance and on the other the scandalous conditions of the slums. They could not expect people to grow up contented citizens when they were herded together eight to ten to a room." He concluded "We are not a party of hooligans, we are practical idealists. We believe in our country. We believe it is worth dying for and worth living for" and the audience applauded his speech. The British Fascisti had an office at 11 Norfolk Street in the town, not far from where in the 1930's the BUF had its rooms at West Sunniside, and today, due to demolition, the buildings are in sight of each other.

On October 21st, General Blakeney addressed the Newcastle Conservative Club and told them that Fascism was a real force against communism and stood for great ideals and two great principles; "nationality and absolute loyalty." He said that the struggle was "going to be between those who love their country and those who do not."

In a statement to the press on the effects of the 1926 coal dispute on shipping, Sir Walter Runcimen, the well known North country ship owner, said: "We have just emerged from the most devastating strike that has ever been known in this country, disastrous to every phase of commercial life. Some authorities put it at £400 million but to this must be added the colossal loss of markets, which can never be accurately estimated. In Italy, a strike of this character, or any other, would not have been permitted. Under the Mussolini regime local syndicates or federations are established all over the country, composed of doctors, lawyers, business men, working men, engineers and even fishermen. At the head of each is a representative from Rome, neutral in opinion and usually a Member of Parliament. If the local federation cannot come to an agreement, the case is sent to Rome and decided there. Strikes are a thing of the past, so is unemployment and if a man does not want to work he is made to. Justice to employee and employer is fairly balanced and, if need be, enforced. This system is believed in and supported by

all classes, including the proletariat, with the result that Italy which was in 1920 on the verge of ruin, has become a prosperous trading country. Unemployment, for example, dropped from 600,000 in 1921 to 250,000 in 1923, and when I visited the country in April-May of this year it was practically nil."

Gateshead Council was concerned about extremist left-wing activity and in March 1927 decided that no part of the Town Hall would in future be let to persons to be used to advocate communism. Labour's Councillor and Wardley man Tom Smith said: "They should not allow traitors to the State to use the Town Hall to preach their doctrine." Saltwell Park was also refused to communists because they preached "class hatred." In 1928, the Amalgamated Engineering Union were also fed up with the disruptive activities of the Communist Party and passed a resolution stating "We repudiate with all the emphasis at our command the attempts of hostile bodies to create dissention in our ranks, in particular we denounce the attempt from the Communist Party and its subsidiary body, the National Minority Movement, to form rival bodies to the Labour Party and the TUC."

There were a number of splits that developed in the British Fascisti movement, mostly due to its right wing conservative image, or perhaps by others who did not think it conservative enough. Arnold Leese and others left to establish the Imperial Fascist League. Traditionalist Blakeney left during the 1926 General Strike when the fascists would not disband to join the Organisation for the Maintenance of Supplies and social revolutionaries like Neil Francis Hawkins and William Joyce joined the British Union of Fascists in 1932 and took with them about 60% of the membership.

Due to personal problems in her life that eventually took a toll on her health, Rotha died in March 1935 aged 42 years with her organisation all but defunct.

The New Party

Sir Oswald Mosley was born on November 16th 1896 at 47 Hill Street, Mayfair. At 18 years of age he had joined the armed forces and during the 1914-18 war served with the Royal Flying Corps. He was invalided out of active service and decided to go into politics to make Britain "A home fit for heroes" that was promised by the politicians to the returning soldiers. He joined the Conservative & Unionist Party and was elected with a majority of 10,000 in December 1918 as the Coalitionist Conservative MP for Harrow in Middlesex and became the youngest MP in the Commons.

He was a radical and his election manifesto set the tone for much of his political life. What he undertook to fight for were – high wages, nationalisation of transport and of electricity, ex-soldiers to be offered smallholdings, grants for housing and educational scholarships to be provided by the state, fiscal protection for home industries and trade with the colonies, prevention of immigration by undesirable aliens, and the promotion by all possible means of the strength and prestige of the British Empire. He advocated nationalisation of the railways and giving the workers full share in the profits of industry...not typical policies of the Tory party. He became disillusioned with the Tories and stood as an Independent in 1922 and regained the seat. Sir Oswald took part in a Newcastle Peace Conference on October 20th 1923 that was attended by Gateshead Socialist Ruth Dodds, she wrote in her dairy "Mr. Mosley, Lord Curzon's son-in–law, is rather lovely, over six feet tall and like a guardsman."

Looking to Labour as a party of change and action he joined it in 1924. No fewer than seventy constituencies invited Mosley to become their Labour candidate and it was reported in late

April 1924 that he had been nominated by the ILP as candidate for Newcastle West Division. However, in 1926 he was elected as Labour MP for Smethwick. As a dynamic figure, he quickly rose to prominence in the Labour movement and was invited by the miners and trade unionists in 1927 and 1929 to speak at Durham Gala where he shared the platform with other radicals such as Ellen Wilkinson, Jenny Lee and A.J. Cook. He had been a champion of the miners at the time of the General Strike in 1926 and had backed it by organising, and paying for, the publication of a strike bulletin in Birmingham and had given a considerable donation of £500 to the miners when the strike dragged on until the autumn. He was popular among the mining community and as early as 1925 was nominated to speak at Durham Gala by South Shields Westoe Colliery Lodge. Speaking to an ILP National Summer School at Dunmow in August 1925 Sir Oswald spoke on "The State use of Credit" to generate social and industrial progress but added that the bankers would oppose it and said "I doubt whether the possessing and financial classes at the last moment would prefer love of country to their dividends." He became a political and personal friend of the miners' leader Arthur Cook and learned some of his speaking techniques from him. In later years, the Durham BUF office at the Hepworth Building, 21 Market Place, at the top of Silver Street, would have had tens of thousands of miners pass by it on the way to the County Hotel, where miner's leaders and socialist politicians would acknowledge the marchers and their lodge banners during the Gala festivities held every July.

Mosley later said that he took the ideas for rallies from the Durham Miners Gala, not Hitler. He said: "I don't suppose it would be believed for one moment, but I first had the idea of dramatising politics, not from Italy or Germany, but in the town of Durham where I used to go and speak to the Miners Gala. Every year over 100,000 miners used to march into that town with their bunting and bits of colour, marching in formation with as much spectacle as they could possibly manage. I learned that from the miners of Durham not Mussolini."

Speaking at the Gala in 1929, he said that Labour had set a machine in motion to carry out every one of the pledges they made at the General Election but that it would take time and that they could not undo the havoc of centuries in a few weeks. He said "What are we to think of the conduct of Mr. Churchill, who by his policy reduced the country to its present condition and could now find nothing better to do than stand amid the ruins of his own creation, mocking and deriding efforts of his successors to repair the devastation he has wrought. He is like a man who in a spirit of wanton malice sets light to his house and then throws stones at the fire brigade." Sir Oswald said he did not believe England was finished as an industrial nation. It had not begun yet! He also added "I would rather see the Labour Government go down in defeat than shirk the great issues, because from such defeats men arise again with strength redoubled."

The miner's union had trouble from the Communist Party since it was formed in 1920. In 1927 the President of the Durham Miners Association James Robson said: "The Communist Party and the Minority Movement were absolutely alien to the objects of trade unionism, and were doing more to retard the progress of trade unions than any other force in the country...and as so far as the Communist Party was concerned, the fact was plain that members of that party sought election to miners councils or executive committees not to obey the orders of those who elect them, but to obey the orders of Moscow." At the 1928 Gala, uniformed Communist Party members marched onto the race course and two of them had attempted to stop Peter Lee going onto the platform. The Chester le Street Labour party also declared that the only bona-fide members were those prepared to obey the instructions of the people who elected them, and not instructions from a country overseas. During the greater part of a Saturday morning that July, the DMA Council at Miners Hall resolved by an overwhelming majority to lodge a strong protest against the communist or Minority Movement organisation interfering with the working of the Durham Miners association.

Events got worse for the Labour movement in 1930 when Communist Party leader Palme-Dutt proclaimed the Comintern's line that there should be an all out attack on the Labour government and said "There should not be a Labour meeting held anywhere but that the revolutionary workers in that district attend such a meeting and fight against the speakers. They should never be allowed to address the workers." In Glasgow during June 1932 ILP Socialist David Kirkwood said to his communist tormentors "You are a lot of dirty rats," adding "If you Glasgow communists ruled Britain I would join the Tory Party." Later, the communist attitude changed to co-operation with other left wing groups and their hostile attention concentrated entirely on the BUF.

Strong anti-communist feelings had surfaced at the 1924 Durham Gala when police were asked to protect a new silk banner bearing the portraits of Lenin and Marx which was carried in the Durham Gala procession. On the previous day, when the banner was paraded at Chopwell by the Miners Lodge, men and women stoned it and made a push to seize it. On the Saturday, the police were near at hand and the banner was not attacked but it was jeered at by men and women all the way to the racecourse. When they arrived there it had to be folded up and put away. Many people thought it "too German, Russian and foreign" and that there were many local miner's leaders that should have been on the banner. During the 1926 strike, Chopwell communist Steve Lawther, a 30 year old "rent collector" was given 3 months heavy labour for impeding food deliveries. By 1935 he was a newly elected Labour councillor but was expelled from the Labour Party for actions detrimental to the movement.

Sir Oswald Mosley was asked by the Labour Government to come up with plans to help the unemployed and he published the "Mosley Memorandum" on December 8th 1930. He said: "I was determined that the pledges we gave to the workers should be fulfilled and I worked out detailed plans to deal with

unemployment but they refused to carry them out." Mosley believed that "Words should mean roughly what they said." He had become a Socialist because he thought it vital, among other things, that the unemployment problem should be solved: that when Socialists got to power they should try to fulfil their election pledges and give priority to doing this. But then, when they achieved power, largely through holding out hopes by their promises, they seemed to be doing nothing serious about the problem at all. Mosley was outraged by this. He thought if you say you want to solve the unemployment problem then you set up the machinery by which the unemployment problem can be solved, if you do not, then that meant that you did not want to solve the unemployment problem. You should then admit it: any other attitude would be considered as cheating.

Along with miner's leader A.J. Cook, sixteen other Labour MP's signed the manifesto. As the Labour Party would not implement Mosley's proposals he decided "Not to go on drawing his £2,000 a year for doing nothing and that it was time for parliament to stop being a talk shop and become a work shop." Although he was re-elected to the Labour Party National Executive Committee and had prospects as a future Prime Minister, he resigned over Labour's betrayal of the unemployed. There were many Mosley supporters within the Labour movement but when the crunch came and he decided to form The New Party on February 28th 1931, only four MP's followed him. They were John Strachey (Aston), his wife Cynthia Mosley (Stoke), Bill Allen (West Belfast) and Dr. Robert Forgan (West Renfew). The party produced a film called "Crisis" that made much of dozing MP's and irrelevant parliamentary debate as the dole queues lengthened.

The New Party stood 24 candidates in the 1931 General Election. In Gateshead, the candidate was James Stuart Barr, a former socialist lecturer and street orator who had held Labour College classes at Camden Street, North Shields, and who had been nominated as a prospective Labour MP. When John Beckett

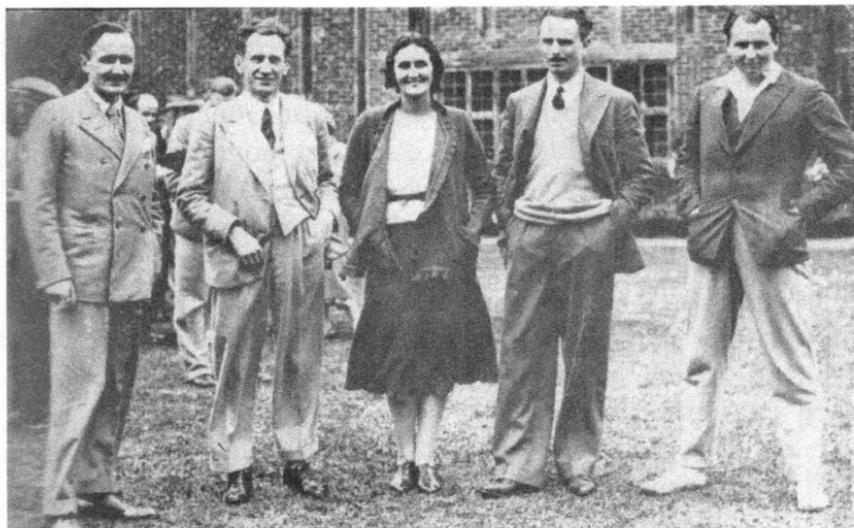

At a New Party conference in 1931 are W.E.D. Allen, Robert Forgan, Cimmie and Oswald Mosley and John Strachey.

was nominated for ILP candidate for Gateshead on January 24th 1924, Gateshead's pleasant and fairly wealthy Socialist Ruth Dodds described Barr as "our quaint little Scots agent." Barr was later to realise that Labour was an establishment sham and joined the New Party. Co-incidentally, John Beckett was also to join Mosley and the BUF in 1934.

During the 1931 election James Barr held a number of meetings in the Town Hall and one in Barns Close School together with about 25 street meetings. He obtained 1,077 votes, this was more than the National Labour candidate but he lost his deposit. Strangely, at the Gateshead ILP branch meeting on 24th January 1924, Barr opposed the nomination of John Beckett who went on to be Gateshead's first Labour MP, yet they both went on to support Sir Oswald Mosley. Beckett had fought Newcastle North in 1923 and was the protégé of Sir Charles Trevelyan, a Socialist landowner from Walling Hall in Northumberland and a Minister in the first Labour Government. Beckett decided not to contest his safe Gateshead Labour seat at the 1929 election after he had an affair with Mrs. Bonschier, an actress. Beckett had spoken at an open air meeting in Gateshead on August 13th

1925 attacking the faults of Capitalism that later took with him into the Blackshirt movement. He saw that unemployment was created in Britain while huge amounts of money were moved around the world by high finance seeking more profit. He said: "Capital did not care where the profits came from - so long as they came. Capital was as international as the sun."

The New Party held many outdoor rallies and street meetings around the country that were often disrupted by left wing political opponents and Mosley employed Peter Howard, the then Captain of the English rugby team, to establish and train a team of security stewards to protect his meetings. Mosley also had the support of former World Welterweight champion Ted "Kid" Lewis who was Jewish and stood as the New Party candidate for Whitechapel in East London. Unfortunately, the election returned such disappointing results that Sir Oswald Mosley decided to visit Italy to see how it had changed and improved since Benito Mussolini had came to power.

Among the factors blamed for the New Party electoral failure was the fact that it was a new unknown party, lacked an organised structure to contest elections, that there was no proper constitution and that during the election campaign Mosley was in poor health and unable to participate in the campaign like he would normally have done. His public meetings had trouble from communists and Labour Party activists who considered that setting up a rival political party was some sort of betrayal, unlike Mosley and his followers who thought that it was the Labour Party that had betrayed the working men and women of Britain. It was in Scotland that a New Party meeting was viciously attacked and changed Mosley's political direction. A giant open air meeting was held on Glasgow Green with a crowd of 40,000 people. The New Party members and the police were attacked by some 500 communists from Glasgow's razor gangs. On returning to London he said to the New Party Executive "We need no longer hesitate to create our trained and disciplined force, from today we are Fascist."

The New Party

The TUC held its 64th conference at Newcastle City Hall in September 1932 and communists had threatened to demonstrate but they did not turn up. Instead, they summoned an open air congress of trade unionists to be held at the Church of England Institute in Hood Street that attacked the TUC as pursuing a policy of peace in industry and that the policy should be changed. One of the TUC speakers said of the communists "There should be no opening of the door which will allow disruptive elements to enter and that any body which is prostituting and taking advantage of the poverty and degradation of our brothers in purely party interests is unworthy of recognition by any comrade. The one avowed intention of the National Unemployed Workers Movement is to discredit trade union leaders and smash the trade unions. There can be no support from the trade unions for such a body."

Walter Hannington, the 35 year old leader of the communist National Unemployed Workers Movement (NUWM) was arrested on October 31st and accused of attempting to cause dissatisfaction among members of the Metropolitan Police and pamphlets and literature were seized from their Great Russell Street premises. In September another member, Mr. Sidney Elias, was in Russia acting under the instruction of the Third International, a group that was in charge of the unemployed movement throughout the world. He was arrested in an attempt to cause discontent, dissatisfaction and ill will between different classes of His Majesties subjects and to create public disturbances against the police.

Communists were also active in the 16 week strike of Ryhope miners in October and accused of interference in the attempts at settling the dispute. One unemployed worker wrote to the Echo, "Let us as workers face the truth and admit the facts in regard to the British worker. The experience of the past is that communist methods and propaganda make bad conditions worse, and the sooner we realise this the better it will be for the worker, the community and industrial progress. This octopus, communism,

is not British, it is a foreign product and these agitations and dislocations of the industries remaining to us are paid for by the foreigner. This devilish organisation has now reached the stage where it has become a menace, a national danger and a destroyer of national progress. There are elements of truth in their propaganda and this serves as a cover for their more sinister objective. Break away now and settle your affairs without this cursed system, communism, which makes bad conditions worse."

Another article said that the Miners Minority Movement had long worked for the overthrow of the Durham Miners Association and that DMA officials had been refused permission to speak to Ryhope miners after communist officials had done so. The DMA said "Communists are working here, as they have done in other districts, and who want to control our disputes and induce Lodges to act against our own Association." Lance Cook of Mafeking Terrace wrote "Men, answer the call of duty, never mind what the 'Moscow comic cuts' say about you. We do not want to be told what we have to do by dictators. We know that the disruptive element in our midst is destroying the principles of the trade union movement. Are we prepared to hand over the reins of office to these people?" Another local miner said "The election of officers will very soon be taking place. We must see that only men of loyalty to trade unionism are elected as chairman, secretary and delegates. If Ryhope is to recover its good name among its fellow lodges, it must do as Chopwell did and throw communists out."

One of the local communists, 38 year old Mr. George Lumley, the Ryhope Miners Lodge delegate, was in poor health and died in the Kremlin Hospital in Moscow in the early days of October. The news was brought from London to his widow by Harry Pollitt, the Communist Party leader. Regardless of how many communists were active in the dispute, the local vicar said "So far from either earning or deserving the description 'Red Ryhope' I write to say that the Armistice Sunday service was never better attended and that it was concluded with the singing

of the National Anthem and sung heartily by all." This event took place during the strike, so not all were singing to the red tune. The left-wing Socialist Governors of Ryhope Secondary School voted to stop the singing of the National Anthem at the school speech day on December 10th, but it was ignored and sung with great gusto by those who attended. The Red political prejudices were certainly not shared by the children or parents that day! At the Jubilee celebrations held in May 1935, the far-left were again trying to disrupt the occasion.

Mrs. M.A. Henderson, a member of Ryhope Parish Council, and who was involved with arranging children's parties and gifts, was forced to resign as Secretary of Ryhope Women's Labour Party Section, as it was decided they would not participate with the Jubilee celebrations or be represented on the committee. Later, the secretary of the Miners Lodge had sent a letter to the council saying there had been a misunderstanding concerning the miner's view and "that they were not objecting to anything that was being done for the children of Ryhope." At the Miners Lodge election in March 1933 there was a complete rout of the Reds at the ballot box with the communist secretary well defeated and the challenge for the post of Treasurer crushed by a massive vote against the communist challenger.

Local communists again offended and upset members of the community when they interrupted the 1932 Armistice Day silence at Sunderland. The two minutes silence was marred by Communist Party officials Brown and Masheder and a number of others who assembled in West Park. They were warned by police that they could not hold a meeting at 11am but they set up a platform bearing Soviet emblems in the Park and when the silence started, one of the communists shouted "Down with the National Government and up with the worker's republic." This Red, and some of his associates, continued to shout throughout the two minutes silence. Elsewhere, a young communist also interrupted the silence at Newcastle Bigg Market and in Edinburgh the two minutes was spoilt by communists singing the *Internationale*.

A number of critics in the Tyneside area claimed Sir Oswald was a political opportunist. One of them, Newcastle Conservative speaker Mrs. Atkinson, who addressed the Bywell and Broomly Women's Unionist Association in April 1934 said "Sir Oswald is a well meaning but dangerous young man who had been practically everything under the sun. They use phases such as 'Britain for the British' and talk about the Union Jack with the result that they make a tremendous appeal to youth."

On closer examination, Mosley's stand was not a case of political opportunism and this distortion of the facts was mentioned by the author Martin Pugh when he wrote: "It is worth noting that his 1918 programme formed his ideas for the rest of his career." Mosley had changed parties to try and get things done but his fundamental policies always remained the same. After he left Harrow Conservative Association he told them "I cannot enter Parliament unless I am free to take any action of opposition or association, irrespective of labels, that is compatible with my principles and is conducive to their success. My first consideration must always be the triumph of the causes for which I stand; and in the present condition of politics, or in any situation that is likely to arise in the near future, such freedom of action is necessary to that end."

1932: The British Union of Fascists

After visiting Rome in 1927, Winston Churchill said "It is quite absurd to suggest that the Italian government does not rest upon a popular basis or that it is not upheld by the active and practical assent of the great masses" and Britain's wartime leader went on to say to Mussolini "If I had been an Italian, I am sure I would have been with you from start to finish in your triumphant struggle against the bestial appetites of Leninism." Why was there this praise from a Tory grandee for the son of a blacksmith and former editor of the socialist newspaper *Popolo d' Italia*?

What was this new radical political movement that was sweeping through Europe and other parts of the world? Who were these people who used the old "fasces" symbol carried on many trade union banners signifying "Unity is Strength", and from which the name Fascist originates, and who were willing to go onto the streets against communist mob violence? Many other leading British figures went to Italy to see this new Fascist form of government. Among them were Sir Oswald Mosley and a number of others from the New Party who travelled in January 1932 to study the Government structure and organisation formed by Benito Mussolini's movement in 1923. On his return to England he found that not all the New Party officials shared his enthusiasm for "the new (fascist) modern movement" and rather than see a damaging split, he simply dissolved the New Party.

Later that year, after negotiations with other fascist and patriotic groups, he formed the British Union of Fascists on October 1st 1932. It coincided with the launch of his book *The Greater Britain* that explained the aims of British Fascism and became standard reading for supporters. The BUF quickly went on to become a nationwide movement with offices in many major cities and

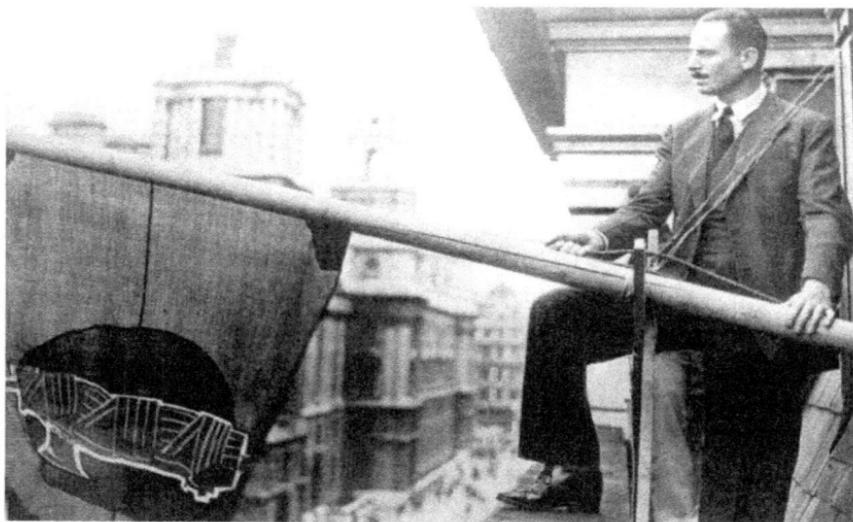

Oswald Mosley unveils the Fascist flag at the BUF Headquarters

towns. The old reactionary parties were alarmed at what they saw was an increasing communist menace and Mr. A.J.K. Todd, the Tory MP for Berwick, said "We have to face the fact that communist agitation is increasing in every country. They are seizing their opportunity when the world is passing through this crisis. They do not care for the suffering caused." Now there was a new kid on the block.

The Newcastle branch of the BUF was one of the earliest to be formed in the country. Member Wilfred "Bill" Risdon, an ex-miner and former Birmingham ILP leader, was supplied with an advance copy of *The Greater Britain* and in September 1932 called together a few friends to read and discuss the book. *The Sunderland Echo* did a review of it on October 1st by journalist Mr. T.U. Kerr entitled *A New Outlook on our Troubles*. He wrote: "One may have some difficulty as to which niche in British politics to put Sir Oswald Mosley for he has ranged from Left to Right and he is still to some extent on the turbulent sea of uncertainty except for a new found belief in British Fascism. This new adopted philosophy he outlines in *The Greater Britain* (British Union of Fascists 2/6p) in which he emphasises that the economic life has outgrown our national institutions, and he is

firmly of the opinion that a Government system designed for the nineteenth century, without complaint of the conduct or capacity of individual Governments, can not be efficiently conducted.

"He sets out in this book to prove by analysis of the present situation and by constructive policy to show the necessity for a fundamental change, and for him that means the introduction of a new movement not only in politics but in the whole of our national life.

"Sir Oswald outlines a corporate organisation which will embody the good in our traditional system, while ridding it of the obsolete and inefficient. In the future he sees the Crown strong and venerated. The House of Lords will be replaced by a National Council of Industry - for the time is long past when the ownership of land was the sole form of industrial responsibility. Learned societies, trade unions, professional associations will be woven into the industrial structure. The distinction will no longer be between producer and non-producer, everything must be done to encourage enterprise - at present everything in financial policy, in social laws and in the system of taxation is calculated to destroy it. On the economic side we must recognise that many of our former markets are gone for good. For ten years we have never had less than a million unemployed. As the Balfour Committee pointed out, our former markets are now making their own goods behind high tariff walls. We cannot, urges Sir Oswald, export against protected local production- or against newly established industry which, protected in their home markets, can afford to export a small surplus at prices which would be unprofitable for the whole of their output.

"The kernel of Sir Oswald's argument lies in his commitment to our export problem. We can produce more food stuffs at home but we shall still have to buy large quantities abroad and to export goods in payment. High wages will not make our goods un-saleable with the use of modern industry.

"An assured and prosperous home market, Sir Oswald contends, will combine high wages with low costs. The United States was organised on these lines in 1929; the system crumbled for lack of a supporting structure as conceived by Fascism.

It is futile, Sir Oswald says, to claim that our position is now "relatively favourable." Industry has failed to respond to the suspension of the gold standard and he claims the Government's credit was not good throughout the conversion period. In Sir Oswald's view Fascist government in Britain will strengthen the ties of Empire, and make the Dominions anxious to participate in our economic organisation. In this way, Britain can regain her former prosperity, and surmount the difficulties which have induced ten years of trade depression.

"Sir Oswald's work is closely reasoned, but it is never obscure and always pleasant to read. He has presented an argument which will be of permanent value as an analysis of our present discontents, and whatever one's political outlook it is worth reading as an attempt to find a solution of our pressing problems."

At this first Newcastle meeting were also Mr and Mrs W. Leaper and Carlyle Elliot. It was a credit to their capabilities and character that these three men, Risdon, Leaper (who had a Jewish background) and Elliot, went on to be prominent staff at London BUF Head Quarters. The result of this meeting was a decision to form a Newcastle branch of the BUF and Bill Risdon was unanimously requested to act as Organiser. Membership increased slowly until February 1933 when the effort of the members started to bear fruit. During that month Bill Risdon was transferred to London to become Director of Propaganda. At the time the branch had about 40 members.

1933: Washington Village has first local BUF Office

Starting to integrate themselves into local politics, one local BUF member wrote to the local press in April 1933 that Newcastle was having a public transport problem around the Haymarket area and that the public were getting disgusted at the state of it. He said "One hour of the Newcastle mess, in even the smallest town in Italy, would result in all the officials concerned having the immediate push back into private life. If Newcastle is any guide, and it is in this writer's opinion that this general muddle exists all over the country, then the Fascist State is long overdue." That same month, another Durham BUF member wrote in the Evening Chronicle about giving fair radio coverage for the BUF. He wrote "The BBC has omitted to allow Sir Oswald Mosley the use of their 'airtime' for 15 minutes. It has been announced earlier that political speakers will be allowed that time to give uncensored talks over the wireless. Why is it that the British Union of Fascists, the only people who are striving for the good of their country, are not asked to participate in this 'boon'? Perhaps it is that the Government - alleged national - is only afraid of Fascists and think that the other parties, no matter what they say, will cut no ice. All British lovers of fair play, however, should see that the Fascists should be given their opportunity in common with the 'old gang' speakers."

Another Durham Fascist wrote concerning the miners; "I would suggest in view of the recent negative benefits for the aged miners that the Socialist leaders would be well advised to invite Sir Oswald Mosley up to the Durham big meeting in order that he may there deliver a few words upon Fascism which is now sweeping over the British Isles." Sir Oswald had been well received on previous occasions. The miners of Northumberland

and Durham were always proud of their independence, uniqueness, dialect and traditions and it must have sounded like a good idea to ask him again. Daniel Defoe (author of Robinson Crusoe) observed this uniqueness of the Northern miners' when he wrote "I must not quit Northumberland without taking notice, that the natives of this country, of the ancient original race or families, are distinguished by a shibboleth upon their tongues, namely, a difficulty in pronouncing the letter r, which they cannot deliver from their tongues without a hollow jarring in the throat, by which they are plainly known, as a foreigner is, in pronouncing the th. This they call the Northumbrian r, and the natives value themselves upon that imperfection because, forsooth, it shows the antiquity of their blood."

Sir Oswald's wife, Lady Cynthia Mosley, died in May 1933 and the *Evening Chronicle* column "A Northern Dairy" commented "To those of us who were in active disagreement with Lady Cynthia Mosley's politics, her death comes as a shock. She was so vital, so lovely, and so courageous that one cannot conceive of death so soon clutching her from her activities. Fascism will suffer a severe set-back by the untimely death. Nine years ago I met Lady Cynthia for the first time. She was trying herself out as a public speaker. Her sincerities threatened to carry her away, and some women in the audience murmured, "She should not worry her pretty head about the condition of the people of the world when she has everything a women could want." But Lady Cynthia Mosley was made of that fine sensitive material that has produced pioneers and disciples of all time. The last time she was in Newcastle she took away some happy memories for, at a crowded meeting which refused to give a young Oliver Baldwin a decent hearing, she was listened to with quite good humour and was cheered to the echo." Journalist Mary G. Ferguson said of her on May 17th 1933 "Nearly two years ago I saw her in Newcastle. This time she was addressing a crowded meeting at the City Hall and her subject was Fascism, as proposed by Sir Oswald. Although the men and women in the hall were suspicious of her politics, they gave her a cheerful hearing because of her charm and beauty,

her humour and her obvious sincerity. She told me in Newcastle that night that she was hoarse from speaking. She said her heart sometimes failed her because the fight for fascism was often more than a woman's strength could stand. Whether her politics were sound or not, she herself was ardent. She was a reformer at heart who passionately wished to make the world a happier place to live in. At 35 she leaves behind her a monument of effort, a record of work well done. She may be one of the few women of the decade whose names will be carried forward to posterity."

A local Fascist wrote to *The Journal* on June 2nd 1933 and said that William McKeag's Liberal MP's had lost all their principles and that Fascism in England was possible. He continued "In this writer's opinion, Fascism in England is certain. In Mr. McKeag's own constituency alone, 40 per cent of the local Fascist strength comes from ex and disgruntled Liberals. The remaining 60 per cent is almost equally divided between Conservatives and Socialists with the odd converted communist."

The first British Union Tyneside office to be opened was on August 8th 1933 in Spout Lane, Washington Village, where it was claimed that it had a large measure of local support. Two national speakers, Captain Arthur Vincent Collier and Mr. J. Dolan opened the new headquarters and addressed meetings in Washington Village and New Washington. The Club was furnished to provide recreation for the members and to give opportunities for reading, writing and debate. The Fascists had for some time been conducting meetings at Washington Station and had gained some support, apart from groups of communists who usually came from Sunderland in an attempt to stop the meetings but they had failed to do so. Mr. T. O'Brien of Derwent Terrace at Washington Station, was the local Administration Officer.

Newcastle had two BUF offices; the first one opened at 10 Shakespeare Street on August 30th 1933, opposite the stage door of the Theatre Royal, and consisted of three floors containing a general meeting room, an information bureau, buffet canteen

and office of the movement. The opening ceremony was again performed by Captain A. Vincent Collier, the National Propaganda Officer, who emphasized that although the aims of the British Union of Fascists were revolutionary, they were loyal to King and Empire. He said "Present day civilisation was in the melting pot." They believed it was necessary to break through the present tendency to allow the economic system to drift, their contention being that the instability of capitalism today was bound to end in disaster and economic chaos. Politics was a racket and they wished to clear it up in order to secure for themselves and their children the benefits of progress made by science and industry. Classes were to be held on political instruction at which members would speak on party policy and national and international policies in general and a defence corps was to be organised to protect speakers from Communists and others who attempted violence at meetings.

An official said "the defence corps was in no way aggressive. Any member who attacks in a physical manner anyone hostile to a meeting before being attacked himself will be immediately expelled. He will only be allowed to defend himself and his speaker when the police are not present. If the police are present the police will be allowed to maintain order. Further, no member is allowed to use anything but his fists. No sticks or cudgels are to be carried." *The North Mail* editorial wrote "It is due to the Fascists to say, however, that they meet with a deal of unfair treatment from irresponsible Reds. If we are to have our Hyde Parks then the rules of the game should be observed. And the first rule is that you should endure in silent patience the argument, or lack of argument, of your competitor. This first may be a trifle difficult at times - but it is at its most difficult when the orator is a rabid Red." The Honorary Organiser, Mr. Francis J. O'Hare, said "We mean to exercise our right of free speech so that people who wish to listen may have the opportunity of judging as to the merits of our policy." The building was attacked a number of times by communists, in September 1933 windows were broken and ammonia bombs thrown at the property.

The Tyneside weekly newspaper *The Sunday Sun* invited Sir Oswald in September to write an article for them but the Editor made it clear that "Though extending this platform to Sir Oswald Mosley, *The Sunday Sun* does not associate itself with the views expressed." Mosley wrote:

What Fascism can mean to the North

The obvious need at the moment is the need for economic planning - the substitution of order for chaos.

There is no lack of ideas and suggestions; on the contrary, there is at present available a wealth of material which might be drawn on for the establishment of new industrial enterprises. Development Societies for Newcastle, Tyneside and the North East Coast, have been able to collect a store of useful suggestions, some of which are already being applied in a piecemeal manner.

There are schemes for the establishment of hydrogenation plants, whereby oil and petrol may be extracted from coal; schemes for the production of new forms of motive power- diesel, electric propulsion for railway traffic, diesel motored lorries and boats; there are ideas for the change over of some of the heavy engineering undertakings to the production of light engineering for domestic appliances; possibilities for the development of higher efficiency mercury tube boilers; data concerning the use of cleaned pulverised coal as fuel - a positive plethora of technical information, much of which is peculiarly applicable to the requirements of the languishing industries of the North, but there is no responsible organisation able to co-ordinate and apply any or all of these schemes.

Fascism will provide the machinery whereby Science, Invention and Research will be linked up with the industries which they should serve.

Fascism will provide the machinery which will control the flow of capital, directing a stream of investments into these channels where it may be most urgently required, relating the activities of British Finance to the needs of British Industry.

Fascism would stimulate the sense of pride in national achievement that has been so sadly lacking in recent years. It would found a Corporate State, based on the wealth of scientific and technical skill which we possess in greater measure than any other nation in the world.

A sense of pride in national achievement would forbid the attempt to flog the 25 years old Mauritania into an effort to recapture the Blue Riband on the Atlantic. It would rather use the resources of the world's most efficient shipbuilders to design and build newer and speedier craft, setting Tyneside to compete with Clydeside for the production of the world's best for Britain.

Pride in national achievement would revolt against the spectacle of slum conditions so prevalent in the industrial centres of the North and would remove such blemishes from our country. It would scrap the old and ugly, the inefficient and wasteful. It would build up the Greater Britain which will lead the world in the future instead of being content to follow lazily in the footsteps of other nations.

Working through the machinery of the Corporate State, and assisted by the sense of national pride, Fascism would deal energetically with these problems which have baffled the "old gang" party politicians.

Class strife will be abolished. Patriotism in its highest and truest form will be developed - not the patriotism of the jingoist, but the patriotism that seeks to improve the lot in life of those who create the nation's wealth.

It is possible to rebuild an era of industrial prosperity in the North, granted the use of the right machinery. That machinery is not the machinery of a parliament 100 years out of date. Only new methods and new machinery can solve modern social problems, and choice is limited in this respect to one or two alternatives.

The virile North will never consent to drift on to chaos under the old system, which has failed you. Socialism you have tried and it has let you down. For forty years it made you promises, and when you gave it a chance the leadership sold you out to the enemy. The new leaders are even bigger nonentities than the old, and the course will be the same.

Conservatism is the creed of lethargy, and lethargy today means death. Communism is the creed of destruction, and today we need not the destroyer but the builder.

Fascism is the new creed of the new century, of youth, of manhood, of high endeavour and National revival.

On March 16th 1933, two Tyneside Fascists held what was alleged to be the first BUF public meeting in Sunderland under the Mosley flag outside the Boilermakers Hall. It proceeded in an orderly manner until it was attacked by communists. Before the arrival of the Reds the meeting had been entertaining. The following week Mr. J. Carlyle Elliott, the Honorary Organiser for the Sunderland area, wrote from his home at 8 Saltwell Place, Gateshead, to *The Sunderland Echo* to say there was no justification for the communists breaking up their meeting and said: "One can only assume that they feared the logic of our argument. Since the meeting several people have expressed the desire to know more of the proposals we are putting forward with the object of restoring economic prosperity for our people. A branch of the movement is in the process of being formed in Sunderland. In the meanwhile, I wish to make it plain that it is a falsehood to declare that we have any connection with any

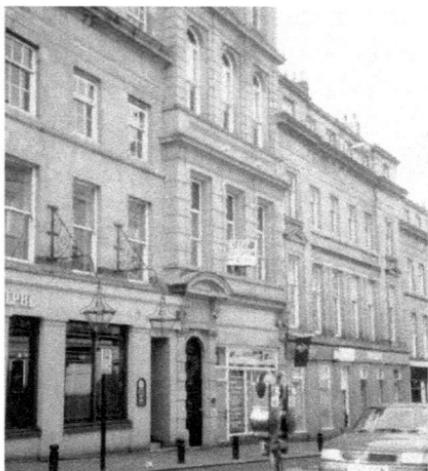

Location of the BUF office in
Shakespeare Street, Newcastle

continental movement, or that we are anti-Jewish. We are essentially a movement concentrating on the abolition of poverty." Another BUF spokesman said that they were not at all dismayed by the organised opposition in the area and that they would in future be holding meetings in Ryhope, Consett, Jarrow and other centres. They had already held meetings in several Durham mining villages and that the Sunderland meeting had been the first rowdy one.

Mr. J.B. Nichols, the principal of Osborne Grammar School, wrote to the Home Secretary in April, to say that he objected to the school receiving three packets of propaganda that was posted from Moscow. A spate of what he considered subversive literature was being sent to many schools in the area. Communist regimes were notorious for their people living and working in miserable conditions with a very poor quality of life while at the same time flooding the world with propaganda extolling how wonderful it was in the "workers paradise." Sir Charles Trevelyan, the Socialist M.P. who lived at Wallington Hall, did the "official" state conducted USSR tour in 1933 and came back to proclaim "The Russians are as democratic as we are, and they are becoming more democratic," "It means the rule of the workers and that a hundred million people are not starving. Stalin cannot do what he likes, if he does he is likely to be brought to book. The actual form of Government is as democratic as our own and even more democratic."

His blinkered vision must have obscured the fact that Stalin was having tens of thousands of Red Army officers and politicians, who he considered a threat to his rule, executed. Nor did they

allow him to see the growing crises in the Ukraine where over six million people starved to death in 1936. The professed Soviet democracy did not exist for tens of millions of non communist party members who were watched over by a vast army of state spies and paid agents. Millions suffered under terrible conditions in Gulag prison camps for alleged "crimes" against the USSR and did not have the opportunity to change the system that oppressed them. Even the head of the secret service and Lenin's 69 year old widow were taken away. She had said that "had her husband been alive, Stalin would have been arrested long ago." Trevelyan should have been in Russia in January that year when a new internal "passport" system was implemented in towns and cities across the USSR. 800,000 people were to be expelled from Moscow alone when a decree was implemented that any person who was refused a residents passport had to leave the city within ten days at their own expense. Many millions of men, women and children throughout the Soviet Union had to move home before April 15th or suffer the rigours of the cruel Soviet system.

A debate continued in the "Letters" page of Middlesbrough's *North Eastern Daily Gazette* about the merits of Socialism. "British Fascist" from Stockton (probably Robert Wood) wrote "Sir, There is no need for "Socialist" to be alarmed at the progress Fascism is making in the North. This progress is certainly due to the fact that the people - not merely the Fascists alone - are actually discovering the fact that Socialism is out of date. Socialism had its origins in the 19th century, but we are living in the 20th century with 20th century problems, therefore we need a 20th century solution found by a 20th century political party - Fascism. Nationalisation will certainly not cure unemployment, because unemployment is the result of rationalisation, the industrialisation of former markets abroad and the growth of new competitors. How can nationalisation alter facts like these, or solve the problems that result from them? We may as well use physic powers to cure a broken leg. As to Fascism saying 'Britain First,' why not? Surely 'Socialist' would rather see his own countrymen in employment and his own country

more prosperous than anyone else? It ought to be unnecessary for me to suggest to 'Socialist' that at the present time a select coterie of our senior statesmen are striving to put other nation's affairs in order before attending to more pressing problems at home. We have had enough of this flabby internationalism, and surely it is time that our statesmen put Britain First." The Stockton "Fascist and ex-Socialist" wrote again on May 16th to say "Your correspondent 'Stockton Socialist' has certainly not studied Fascism, especially British fascism. He says that it seeks to enslave the workers. This is untrue and the existence of the Fascist Union of British Workers proves it."

An organisation was formed at a conference in Gateshead on May 27th 1933 to combat the growing support for fascism and one of its organisers, Will Pearson of South Shields, said he did not treat as bluff Sir Oswald Mosley's organisation. The group of left-wing and communist organisations pledged themselves to anti-Fascist propaganda work, and no doubt to promote the violence and intimidation that comes with such left-wing people.

At Newcastle's Marlborough Bus Station on June 15th a single Fascist, wearing his black shirt and First World War medals, stood on a box and started to address a crowd when within minutes he was surrounded by hostile communists who tried to prevent him from speaking. One of the communists made a lunge at him but this was resented by the crowd, many of them well dressed young men. "Play the game - be British" was shouted and the crowd turned the table and began to surround the Reds. The police then intervened and one of the communists taken away. The Fascist then continued his talk with communists still interrupting but the crowd stood by and prevented them from reaching the box. He continued for another half an hour and then the police recommended that he close the meeting. Some of the crowd helped to escort him from Marlborough Crescent and away from the communist mob that had obviously never heard of fair play or free speech.

A few days later, and obviously anticipating more trouble from Red hooligans, a larger group of five Blackshirts arrived by car on Sunday June 18th at the Race Week gathering on the Town Moor's political corner but were again opposed by hundreds of communists who had also gathered for a meeting. A Morpeth Chronicle reader wrote "Although not a Fascist myself, I cannot help expressing admiration for that brave little band that withstood the Communist attack on the Town Moor at Newcastle, on Race Sunday evening. Special praise is due to the little man who hung on to the platform when an attempt was made by the Communist mob to overturn it. I was standing among the Communists and heard the disgusting remarks they hurled at the Fascist speakers. Sportsmanship and fair play were entirely absent, and I can only conclude that Britain would be a terrible place to live in if we were in the hands of the 'Red' wreckers. It might even become as terrible as Russia itself if these awful men and women took charge. They certainly gave us an idea of what mob law is like. It was only curbed when a few policemen appeared on the scene. For the sake of our wives and families, I trust British common sense may prevail and the Communist pestilence may soon be stamped out."

The communists not only tried to disrupt British Union meetings but the previous August they had plotted to wreck the TUC Congress meeting in Newcastle City Hall on September 5th. Visitors' tickets to the conference had to be cancelled as a result of information received by the local Reception Committee that forged and duplicate tickets were in circulation and that leaders of the communist "National Minority Movement" were on Tyneside in preparation for a plot to disrupt the Congress. A full meeting of the reception committee was held at Burt Hall to consider the situation and a select band of stewards, including a boxing ex-champion, had to be engaged.

On June 25th a debate had been arranged between the Tyneside District Committee of the Communist Party and the Newcastle branch of the British Union of Fascists but Mr. F. Martin,

Secretary of the Newcastle Debating Society, received a letter from a communist official cancelling the meeting.

The BUF in Durham City had an excellent meeting on June 29th when Captain A.V. Collier from London addressed an audience in Shakespeare Hall. Collier said the "Fascist movement was trying to rouse people to a sense of the greatness of their race, and it was to be deplored that the movement was being misrepresented every day and it was thought by some people that Fascists should be shunned and ostracised by everyone. Capt. Collier revealed that communists in the Durham district had been challenged to a debate but a letter had been received from them refusing to take part. He said that they were afraid of the issue."

A debate on Fascism v Socialism was arranged to take place on The Green at Washington Village on Monday August 14th between Councillor E. Moore, the new treasurer of the Durham Miners' Association and Mr. Charles Dolan of the British Union of Fascists who had been a former communist. Fascist activity was increasing in the district and Mr. T. O'Brien, the local Administrative Officer, said: "We have received information that there is to be an organised attempt by communists forces to smash the meeting...We are taking every precaution to ensure the freedom of speech." Precautionary measures were taken and the threatened interruption did not materialise.

Mr. R.W. Coxon, of Washington Urban District Council presided over the large assembly of people who turned up for the debate. Mr. Dolan of the BUF opened the proceedings and spoke for half an hour on Fascist policy. After Mr. Moore had spoken rain temporarily held up the meeting but after the storm cleared away Mr. Dolan mounted the platform and continued to answer questions until darkness set in and the crowd quietly dispersed. The speaker Charles McEwan Dolan was born in Dundee and was sent to a training ship for refusing to attend school, and went to sea in 1908 when 16 years of age. He was a member of the Communist Party from 1921 to 1927 and was said to have been

imprisoned for political activities. He joined the Fascists when in Edinburgh and became a paid party worker. He may have lived in Dobson Court, Gateshead, in 1925 where someone of that name was listed as a ships cook and his politics had got him into trouble at Carlisle.

Towards the end of August, the BUF were on Newcastle Town Moor and "Free Speech" of Gateshead wrote: "I was disgusted by the methods employed by the Communist Party to prevent the British Union of Fascists from putting their case forward at the Newcastle Town Moor meeting. On Monday last there could not have been less than 150 children used in the obstruction methods of Communists on the Moor. Apart from the danger to those youngsters in the event of a "rough house" developing, it discloses the unscrupulous attitude of those who would seek to make this country into a facsimile of the USSR. If there is a weakness in the Fascist policy it would be better to allow the speakers to state their aims and then show the weakness by proper questioning. For some time now I have observed that the Communist speakers in the Bigg Marker are allowed a fair hearing. What would they say if those who did not agree should surround their platform with helpless bairns, and taught to sing and shout in order to obstruct. The police were in attendance at the Town Moor meeting on Sunday, and the question arises whether they would have been within the law in proceeding against those who organised this hooliganism as being likely to cause a breach of the peace. Communists ought to know that such methods as they pursue only arouses the sympathy of any fair-minded Britisher in favour of the victimised. I will fight Fascism as I will fight Communism, but the way to do it is not as the hooligans on the Town Moor think proper."

Fascists in Washington started a new publicity push in the middle of September when a special appeal went out to the 1,500 unemployed in the district to join the movement. Mr. C. Bradford, chief organiser for the Fascist Union of British Workers, had arrived from London and would be addressing meetings

at Washington Station, New Washington, High Usworth, Springwell and Fatfield on the subject of the restoration of wage cuts and the wickedness of the Means Test.

Mr. T. Jordan, the organiser of the Washington Branch of the FUBW, had issued a pamphlet to the "unemployed of the area, of Washington in particular, and the public in general," calling on them to attend a mass meeting of protest against the Urban District Council to be held at the National School in the village. The meeting was held on November 8th and the speaker claimed that councillors were giving their relatives and friends work on council schemes and that they were deliberately ignoring the right of all the unemployed to have a fair share of any work that came along. A resolution was unanimously passed that the council be asked to discuss the situation with a delegation of Fascists and it was unanimously carried. Speaking in support of the resolution BUF member Mr. H. Simpson, a former Conservative, declared that the community of Washington had long been dissatisfied with the Socialist Councils administration of the district labour scheme. "I hope," he said "that there are some councillors among my audience for I am going to challenge them with giving their friends work in preference to unemployed ex-servicemen, many of whom have been without work for years. We contend that the confidence in council practice simply amounts to the wilful abuse of the powers which have been invested in these Socialist councillors by the general public." They also told the council members that they were placed in authority to behave fairly to everybody, and not to grant special favours to any particular section or clique, whether it be in the allocation of houses or in the allocation of work. It was also announced that Sir Oswald Mosley would visit the Washington office during his visit to Durham and Newcastle in December.

At Hebburn police court, also on August 14th, James Cunningham (27) of Ellison Street, Jarrow, was fined 10s for having assaulted Charles Dolan of Kings Road, Chelsea, who was described as a BUF Propaganda Officer. He was also charged as

having created a breach of the peace and bound over for a year. Mr. Dolan said he was holding a meeting on vacant ground near a factory when communists threw stones at him and stopped the meeting. He said: "As I was passing the Station Hotel I felt a punch on the back and, as I fell, Cunningham hit me on the right eye." Three years later, Charles Dolan became a Pastor and worked for the Home Mission section of the Methodist Church. He recalled his conversion to Christ on the way to speak at a Communist meeting where he said he was "ill treated by the crowd." He became the Pastor in charge of Goldthorpe (Yorks) Methodist Church in 1936.

Writing in the Shields News on Sept 7th "Harbour View" applauded the decision of the Trade Union Congress and its General Secretary Walter Citrine when they refused to meet communist organised unemployed marchers. He said: "These Communist agitators are trying by back door methods to break down the Trade Union organisation. We have them in our own borough. They talk about democracy, and yet they themselves oppose anyone else expressing their own views. They condemn Hitlerism and yet they themselves preach dictatorship. In my opinion they will only make conditions worse. However, the Trade Unionists have at last shown them up and treated them the way they deserve and refused to talk to them. They have got what they have given."

Another correspondent wrote concerned about Communists standing in three North Shields wards and said we should not stand any of their nonsense in this country. "We have seen what can happen when these people get into power and we must stand firm and express our determination to resist Communism in 'Wor Canny Town.' Let sanity govern our actions and united effort remove once and for all this menace."

One communist candidate Joseph Johnson was fined for writing slogans and defacing the wall of a house in Appleby Street and of insolence to a policeman. The local branch of the Friends of

the Soviet Union, whose secretary, Mr. S. Bengall, was also that of the North Shields Communist Party, was sponsoring a ship yard riveter Alec Balmer on a visit to the U.S.S.R. but the appeal fund was disappointing. Another Shieldsman who had spent some time in the Soviet Union wrote: "One night I was taken to the cinema (if you could call it that), a ramshackle affair thrown together of rough wooden planks with the bark of the tree still adhering and the same rough planks to sit on and soldiers on guard. And the films shown – ye gods! Absolute filth, shown to inflame the minds of people against God and religion. Scenes of English, American and Continental life were shown in their worst possible phases, so cunningly filmed and worded as to give the impression that Russia was the only country worth living in. The Captain of a three thousand ton barge receives £17.10s a month, but tea was £3.10s per pound and was sold in slabs that had to be broken with a hammer and chisel!"

A BUF public meeting was held on the steps of the Market Cross near Stockton Town Hall on September 10th 1933. About 150 Blackshirts under the leadership of Captain Vincent Collier were attacked on the High Street by about 2,000 imported communists and socialists using potatoes containing razor blades, sticks and missiles. From the outset, it was apparent that the speakers should not be heard. Communists attacked and the fascists defended themselves in Silver Street where most of the hand fighting took place. A Stockton and Herald reporter, who was in the worst of the disturbance, saw a man brandishing a heavy pole, run a distance of 80 yards and strike down a young fascist who was facing in the opposite direction. The fascist struck down was a young Durham journalist, John Frank Rushford (20) of Grey Towers, who needed five stitches in his wound. The fighting started when a fascist had two forefingers stuck in his eyes and his colleague rushed in and struck the aggressor on the jaw. Another BUF member, Edmund Warburton, 21 years old from Bury, was struck by a potato studded with razor blades that blinded him in one eye for the rest of his life. Seven police officers arrived and were able to handle the red thugs and

troublemakers and the meeting was stopped at the request of the police. The BUF members, apart from the two lads taken to the local hospital, marched off singing Land of Hope and Glory.

Local Fascists were indignant that they were not given a hearing and one Blackshirt said: "When the police stopped the communists some weeks ago from using the Market Cross they cried out for the Englishman's right of free speech and one man went to jail for three months for that. Now, when we want free speech, they turn out with sticks as weapons and razor blades embedded in potatoes as missiles to prevent us speaking."

Another Blackshirt said: "We shall always help the police to maintain order at our meetings. Our objects aim at peace as much as anything else. We are out to win power for Fascism and establish in Great Britain the Corporate State, which will ensure that all will serve the state, and that all will work and enrich their country, that opportunity will be open to all of us and privilege to none." At the time, the membership of the Teesside branch of the BUF was about 30 and the administration officer was Mr. R. Wood of Hartington Road, Stockton. He was later to be transferred to duties in London and his place was taken by Mr. H. Jordan of Gateshead.

Another meeting was held near the Boilermakers Hall, High Street, Sunderland, on September 19th, when 13 BUF members headed by Captain Collier held the pitch for over half an hour against several hundred communist troublemakers. The Blackshirts were formed around the platform and, although the crowd came close, the barrier proved impregnable. From the outset the Red crowd were determined to prevent any of the speakers obtaining a hearing. Police Superintendent Cook came forward and appealed for fair play and said "If you don't want to hear the speakers don't cause uproar, but go away" but it was in vain. A group of young men began to sing "Tell me the old, old story" while they were standing in the gutter. The speaker was quick to retort "if you think like that about Fascism" he yelled

"you will always be singing in the gutter." After Capt. Collier denounced communism, the Reds in the crowd turned angry and the police closed the meeting. Without any protest they agreed, and the Blackshirts escorted by two police officers went to the Central Railway Station without any trouble, apart from heckling by communists that followed them. The Blackshirts descended to the station platform without any difficulty, thanks largely to one gigantic member standing guard at the entrance and who the Reds nick named "King Kong."

Captain Collier was interviewed on the platform and remarked "Those disgusting scenes are magnificent propaganda for the need for Fascism in this country. No amount of abuse, misrepresentation, of violence, organised or otherwise, will put a stop to our exertions in this cause." Writing in the North Mail a few days later, BUF supporter "Northumbrian" from North Shields said "I think many of your readers will be disgusted at the conduct of the communists at a Fascist meeting in Sunderland. It seems we have already lost the right of free speech in this country. If things are permitted to continue in this way none but communists will be able to speak in public. The dawn of the Fascist movement in Northern England is indeed a ray of hope to all those people who have the welfare of our country at heart – those whose motto is "England before all!"

The official opening of the Durham branch of the British Union of Fascists took place on Friday September 15th by Capt. A. Vincent Collier. On the following evening thirty people visited the office and joined the movement. Membership had been growing steadily and it had been anticipated that more would join now that the office had opened. The building occupied a prominent location in Claypath opposite the Pallidian Cinema and had been remaining open for over 13 hours a day with members taking charge of the office on a rota basis. The Durham County Advertiser wrote: "The neatness of the interior and the smart front of the premises has created an impression on citizens and many are calling and making enquiries each day. Under

the guidance of Mr. M. McCartan, the Organiser, the branch is making marked progress and the Friday night meetings in Durham Market Place are becoming a feature of City life."

Capt. Collier said "This is a great day in the march of Fascism in Durham - the official opening of the premises in the heart of the ancient city. That ancient building, your beautiful Cathedral, built centuries ago by men of great faith in a great ideal, has witnessed many changes in the fortunes of the nation, but none more revolutionary or progressive than the appearance of Fascism. We are witnessing the death agonies of a great epoch of civilisation and the responsibility rests on our shoulders to see that our world does not tumble around our ears. Fascism is a creed of the twentieth century which inspires us to face the problems of our day by bringing to bear on them the full effects of modern science released by the state. We envisage an ordered state in which all sectional and factional interests are subordinated in the interests of the whole nation.

"The machinery of Government will be rationalised and modernised to cope with the development that has taken place and are still taking place in the industrial field. The ever-growing problem of poverty and unemployment can and must be solved, and the Corporate State of Fascism provides the most viable machinery for such economic planning. The old parties still cling to their outworn labels and are kept so busy worshipping their idols and singing their praises, that events are more and more rapidly bringing down a great and noble race such as ours.

"In Durham, as throughout the length and breadth of these Isles, Fascism waxes in strength daily. Fascism means the re-birth of Britain. The materialism of the nineteenth century culminating in the great European conflict must give place to a higher conception of moral duty. The machinery of Government must be rationalised and modernised to cope with the development that has taken place and is still taking place

in the industrial field." Captain Collier went on to say "A new spirit must be infused into the life of the nation - a spirit of patriotic endeavour. The North has always been the cradle of men and women of courage and vision ready to make sacrifice in a great cause. Believe me there is no greater task than that of national regeneration which must be accomplished to ensure our children their birthright as citizens of a twentieth century state." Other speakers at the opening were Mr. M. Jordan of Washington, who is the North-Eastern Organiser of the Fascist Union of British Workers, and Mr. M. J. McCartan, the Durham organiser. The building was on one of the main thorough fares of the City and a daily increase in the membership was expected to continue.

Another ugly night of communist violence took place on September 24th when the Reds from all over the North East were intent on smashing up a meeting in the Bigg Market addressed by Captain Collier and other BUF speakers. They were organised in groups throughout the crowd and began pushing orderly listeners onto the platform as soon as the speakers started. An "ammonia bomb" was thrown at the speaker that struck a young Fascist in the face but no serious injury was done. The platform was overturned and ten Blackshirts attacked by the Reds but the police held them back. Captain Collier said: "We were able to form up our ranks and march back to our headquarters at 10 Shakespeare Street. A large crowd followed us and stayed in the street until they were moved off by the police." A letter entitled "Free Speech" soon appeared in the local press from a member of the public that said "I would like to express my astonishment at the treatment meted out to the handful of Blackshirts who were endeavouring to hold a meeting in the Bigg Market, Newcastle. The meeting had not long been in progress when it was rudely interrupted by a gang from the ranks of the Communist Party. The police sensing a conflict advised the Blackshirts to disperse which they did in an orderly manner. The question arises, does free speech only apply to the Communist Party or do the Communists stand in fear of the Blackshirts?"

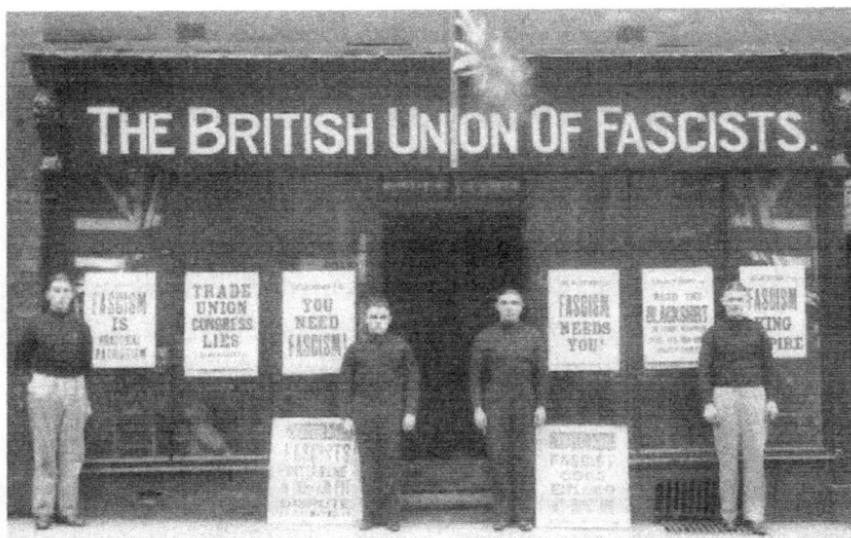

Durham City BUF office at 85 Claypath opened Sept. 15th 1933

In a statement made by Sergeant Drydon at Gateshead County Police Court on November 2nd, he said that every week people had come in from other districts in an attempt to break up meetings held by the Fascists in Felling. Andrew Watson (34) of Clasper Street, Gateshead, was fined for having thrown fireworks while the Fascists were marching away after a meeting held at Felling on October 17th. Felling man Mr. J. Bell wrote that he also received a dose of unfairness from the "Socialists" and said that "In response to the cordial invitation by a poster reading 'All Welcome, Questions Answered,' I attended the Socialist meeting held in the Square, Felling, on a Sunday evening, but after listening to three consecutive speakers I was repeatedly refused permission by the Chairman to put a simple question, and mine was the only question attempted up to that point. Surely, a good sound policy should stand the test of a few simple questions. If not, why not make future poster invitations to read 'Only Socialist Party supporters and their questions welcome.' At least it would be only fair to say so."

With communists disrupting meetings, and even the coal

miner's leaders at Durham Gala subjected to their intimidation, nevertheless, some people wanted to know first hand what life was like in the Soviet Russian "Utopia". One of them was a Newcastle vicar, the Rev. C.N. Middleton-Evans. He was born in Wales and became the first vicar of Holy Trinity Church in Jesmond, Newcastle. In December 1933, he told an Armstrong College audience how he joined a ship as a carpenter and sailed with her to Leningrad to discover the truth about Russia. He said: "I knew that if I went as a tourist I would not see anything, as all tourists and politicians are 'conducted' about the country and they only see what the authorities wish them to see. The point that most impressed me in Leningrad was the extreme poverty and squalor. Everyone looked subdued and cowed and the people seemed half starved. Even the buildings were in a shocking state of decay. The roads were in places almost impassable and everywhere there reigned a sense of gloom and darkness. It is said that Russia is the 'workers paradise' and a progressive country. I say emphatically that it is not so. They claim that they have no unemployment but that is not surprising. If a person does not work he does not qualify for a food ticket and therefore starves. All labour is forced. "I did not intend to stay long but the ship was held up in port and I had the opportunity to study the countryside around Leningrad. Everyone hears propaganda. There are photographs and busts in shops, schools, and even in the churches, of Lenin and his colleagues."

Describing life in Russia today he said it was like a huge army of tramps at work. The story he told to a *Newcastle Weekly Chronicle* journalist was one of poverty, degradation, and misery made bearable to the Russian masses by ceaseless propaganda. He said: "The docks appalled me. Women worked the winches on the ships just the same as the men, in clothes that were little better than rags. I once saw a cook on a ship throw a bone to a half starved dog. But before the animal could get to it, it had been pounced on by a number of men standing by. On another occasion, I saw a man divide a raw cabbage into quarters and sell it to his friends who at once ate their portions. Propaganda assails you

everywhere. Day and night, loud speakers at the principle tram stops echo the same tale. They are clever at it. It seemed to me a country of young people. I saw few aged people. There seemed to be no use for them. It seems inevitable that the Soviet plan must be modified if it is to succeed at all. After what I saw, communism in this country, in my opinion, would be a thing which the ordinary peace-loving Englishman could not even bear thinking about."

Local Fascists intervened in a Ravensworth Colliery dispute in late September by distributing a circular issued by the "North Eastern Area of the Fascist Union of British Workers" to strikers, management and the trade union leaders. The circular declared "That the management immediately give to the men the wages they are entitled to. We do not stand for wage reduction. That the men start work as soon as the dispute is ended. That the management send for the union's representatives immediately and inform them that all money will be paid." It then went on to say "The British Union of Fascists views with alarm the stoppage of your colliery and we feel it is our duty to make to you some statement of our attitude upon this and other disputes. We will decry the practise of withholding men's wages from now onwards with the entire weight of the British Union of Fascists and the Fascist Union of British Workers throughout the Kingdom behind us. On the other hand, we do not agree with irresponsible leaders who are determined at all costs to bully the management into surrender which will mean, if this course is permanently preserved, nothing more or less than anarchy. In the case of your disputes, on one side you have the stubbornness of certain of your leaders, and on the other side you have the crass persistency and adamant attitude of the management. Clearly, such a deadlock state of affairs is sheer folly, and is without doubt one that can but only prove the grave need of a real Fascist organisation where masters and men will be bound by the Corporate State of Fascism to settle their grievances in courts set up for that purpose, and by so doing will save the community from similar situations now occurring at your colliery."

The Evening Chronicle objected to the BUF activity at the colliery and said its involvement in the dispute was "impertinent." Mr. T. Dolan, the NE Organiser of the Fascist Union of British Workers, replied "In the leading article in the 'Evening Chronicle' you dealt at length with the recent action of the British Union of Fascists and its industrial arm, i.e. the Fascist Union of British Workers, 'butting into' as you termed it, the Ravensworth Colliery dispute now in progress. You also suggested it was 'impertinence.' Surely the *Evening Chronicle* should be the last to accuse us of impertinence when you yourselves have times innumerable expressed opinions upon subjects which appear as being of no business of yours. Perhaps you are suggesting that only newspapers such as your own have the right to offer a comment, and offer solutions, for the very many serious problems that confront humanity today? No, we claim that we are as much entitled as the *Evening Chronicle* or, in fact, any other organisation, political or otherwise, to voice our opinion upon all questions that affect the nation, and therefore we make no apology for having issued our statement to the Ravensworth miners and management. The constant repetition of strikes and lockouts, the Editor will agree, would bring about such a grave, chaotic industrial position, resulting in misery and starvation to the workers, that the workers themselves will demand some protection from such calamity. The BUF believes that we can organise the necessary machinery to prevent such disaster."

On another matter, Gateshead Fascist Mr. T. Pickering said: "Following the Whitburn and Boldon stoppages, you correctly state that there is a wage loss to the men and a trade loss to the companies. You also ask whether the men were well advised by their leaders. Let me point out as one who has had experience in these matters that the trade union leaders are never out for the good of their followers in such disputes as these. One or two of them may be sincere but they are over-ruled by trade union parasites. Under Fascist control no owner could lock out his men and no worker would strike. Instead, as soon as a dispute arose experts would be sent to the spot and they would

arbitrate on the question. In the meanwhile the cogs of the industry would still be turning and nothing would be lost to the owners and workers. Can any trade union leaders tell of a strike that has brought any lasting good to the industry which has had to suffer it?"

In the same issue of the *Evening Chronicle* Durham Organiser Michael McCartan made it clear that the "BUF has no connection whatever with the British Fascists Ltd., which is carried on by Miss Linton Orman." He said: "The lack of success of such bodies as the B.F. Ltd., is due to the very good reason that they are not Fascist. They imagine Fascism to be a tame branch of the Conservative Party with Carlton Club politics. In the summer of 1932 three of the four male members of the B.F. executive resigned and joined Sir Oswald Mosley. They were Col. H.W. Johnson, Mr. N. Francis Hawkins and Mr. G.K. Manderville Roe. The persons appointed to fill these vacancies also resigned almost immediately and also became members of the British Union of Fascists. Further comment is unnecessary."

To celebrate the First Anniversary of the founding the BUF in October, a contingent of young Tyneside Blackshirts travelled to Belle Vue in Manchester to attend a large Mosley march and meeting. For many of the young men they were seeing and hearing their Leader for the first time and returned to Newcastle with a deep feeling of being reborn. In his speech Sir Oswald said: "In the lives of great nations comes the moment of decision, comes the moment of destiny, and this great nation again and again in the great hours of its fate has swept aside convention, has swept aside the little men of talk and of delay and have decided to follow men and movements who say we go forward to action, let who dare follow us in this hour. That is the permanence of the mighty mood of Britain, and I say that in the ranks of our Blackshirt Legions march the mighty ghosts of England's past and their strong arms around us and their voices echo down the ages saying…onwards!"

Also, during October a member of the public who attended a BUF meeting wrote "I was present at the Fascist meeting held in Newcastle on Sunday night and one thing that struck me in particular was the number of Roman Catholics who formed the 'bodyguard'" and he wondered if the fascists would make it the chief church in England. The article did not say how the writer knew a Catholic from a Protestant, a Jehovah's Witness, a Mormon or from any other faith. BUF man Cecil Pratt, who lived at 4 Rosebery Street, near the Sunderland Wheatsheaf public house, said he had noticed a letter criticizing Roman Catholics, Fascism and himself, and replied "I am not interested in Roman Catholicism, and do not intend to be drawn into any controversy about it. The suggestion about Roman domination is too absurd to merit further consideration, and the production of such 'red herrings' savours very strongly of professional Socialism. Your correspondent has overlooked the little courtesies usually observed in letters to the press. His undoubted superiority to a humble tramwayman (Mr. Pratt was employed on Sunderland tramways) I shall overlook and remind 'A Regular Reader' that the best people do not shoot at exposed targets from behind a wall, nor do they attach much importance to the ravings of disappointed office seekers."

A large crowd was attracted to a BUF meeting at Newcastle's Cowen Monument on October 8th. There was a group of Reds in the crowd and in the course of a melee Captain Collier, the principle speaker, was seized round the legs and brought to the ground. He immediately mounted the improvised platform again and resumed his speech despite the fact that he had been kicked about the body.

This month the Durham branch took offence at the "fight fascism" resolution put forward at the Labour Party conference at Hastings and sent a telegram to them from the "Ex-Socialists who were members of the British Union of Fascists, Durham City Branch." It stated "Helpfully, we suggest opening your conference with reading chapter six of Jules Verne's 'Voyage from Earth to the Moon.' We are hailing the fast coming Fascist State!"

About 30 Blackshirts took up a stand in Gill Bridge Avenue at Sunderland on Thursday evening October 26th and, at first hand, it seemed as though they might get a fair hearing from the crowd that soon gathered around them, but then communists arrived and there was so much noisy interruption that the police ordered the meeting closed. The Blackshirts obeyed, as they always did, and marched back to the Central Station. The local paper wrote "Although one may think there is absolutely no need for Fascism in this country, there is no denying that these young men are endowed with a good deal of personal courage. It was pitiful to see a mob of street corner loafers yapping at their heels and shrinking back like frightened puppies whenever a Fascist turned round defiantly."

Mr. R.M. Harrison of BUF National Headquarters in London responded on November 1st to an offensive article in the North Mail. He said "In reply to Mr. T.J. Snaith, whatever Fascism offers in this country it is not "a mess of pottage." We appreciate that there are gigantic fortunes at one extreme and anxiety and poverty at the other. The Corporate State of Fascism will retrain the self-interested efforts of the former for the benefit of the latter, and co-ordinate all efforts so that the driving force of personal interest will supply power to the State. Until human nature changes completely, personal ambitions cannot be ignored, but it can be directed along channels for the benefit of the community."

There were a number of derisory comments about Fascism in *The Sunderland Echo* of the 9th and John R. Dalglish replied to one entitled "The Craze for Coloured Shirt Politics" and said: "Many families have turned to Fascism and are thinking for themselves and also of children whom they may one day bring into the world... further he (his critic) says that he cannot see millions of Britishers' dressed in black shirts shouting "Hail" because British people hate ostentation and uniforms... I can hardly express surprise at him for not being able to envisage such an ennobling sight. But I am reminded of the Boy Scout

movement when I read those lines. Where else in the world has the Boy Scout craft gained such a hold as in Britain? And what do the boys love most - the uniform of course. Those boys are proud of their uniform; and so are we Fascists proud of our Black Shirts. It would not have mattered if the colour had been green, red, or salmon pink, we would be just as proud to wear them, because the black shirt is our outward sign to the world that we are determined to think for ourselves and break away from those old traditions carried out by a lot of old fogies. Fascism is a call to youth, and youth is responding magnificently. We stand for our King and Country, and that Britain shall be ruled by its people."

The Sunderland Echo editor had a quip at Dalglish's letter and said that he "thought that Britain was the most democratic Government in the world and that however he might be mistaken as Fascists were such clever people." Dalglish responded "It is not so much cleverness which makes Fascists stand out so favourably from other people. Rather, I think, it is their habit of thinking and studying for themselves. Your other statement that Britain is the most democratically governed country in the world, and therefore ruled, by its own people is not true. A standard definition of democracy according to the latest dictionaries is a 'government by all classes for the benefit of all classes.' … Neither Conservative nor Socialist Governments can represent all classes. Nor can any other party under any other name represent all classes, because class war is the essence of party government. Britain will be ruled by all classes when party warfare is abolished. The solution lies in Fascism. I take this opportunity of renewing the challenge I made verbally to the leaders of the Sunderland Socialist Party. The challenge was to debate Fascism v Socialism in any public hall in Sunderland. Now, Socialists you have had many gibes at Fascism. You have gibed at everything except the creed, because you neither understand it nor do you wish to understand it, because Fascism represents the farewell of Socialism. If the Editor of '*The Sunderland Echo*' can lay down his pen some evening, I shall be pleased to debate Fascism v Conservatism with him wherever he may wish to choose."

Fascist Irons also wrote that they could not apply the 40 hour or even the 36 hour week upon British industry in an Empire developed as an economic unit if sweated goods from foreign countries were not prevented from coming into the country. He said "The rationalisation of British industry continues in ever increasing acceleration; more workers are being replaced by machine, less wages are going into circulation, consumption is reduced still further - thus the vicious circle and it can be countered only by State control on national lines. We must utilize machines to human advantage, and to do this hours should be shorter and wages increased because production is dependent on consumption."

Thomas Burnip, a Durham BUF officer, wrote from the Claypath office to say "None of the present day politicians can solve the difficulties that England has to face... (your correspondent) has seen that neither the National Conservative nor the National Government, nor the Socialists can do anything and he turns to a Coalition Government with Winston Churchill at the head. Perhaps he will take steps to examine the policy of the British Union of Fascists and then he will probably not bother to think of any combination of the present day politicians that may be successful. Within a very short while the British Union of Fascists will be opening a branch in Sunderland." A few days later, he wrote again to say "Fascism is not an effort by men to make English people turn Italian. Fascism, as applied to Britain, is essentially a national movement and has been adapted to the needs of this country. Mr. Robinson (his critic) attempts to eulogize the present system of Government. Perhaps he is one of those who cannot see nearly three million unemployed. Perhaps he does not realize that the present system of Government is for the nineteenth century, not the twentieth century. Lastly, perhaps he does not know anything about the policy of the BUF. It might be mentioned that the new BUF branch to be opened will deal with all questions of policy."

Blackshirts in Geordieland

Sir Oswald Mosley addressed a meeting at Oxford in November and the usual left wing troublemakers were determined to stop the meeting but were ejected from the hall. Ruskin College tutor Mr. J.L. Kity and Professor Harold Laski protested at such "violence" at the meeting and proposed the setting up of an anti-fascist vigilante committee. On the 28th, a Gateshead Fascist signing himself "Hail Mosley" wrote: "I am disgusted that Oxford 'intellectuals' should so far be gulled by those misrepresenting British Fascism that they are forming an Anti-Fascist organisation which is purely negative. English Fascism, I might point out, is nothing like German Fascism, just as Italian Fascism is entirely different from that. Fascism means a national creed which is adopted to the necessities of each nation. I am told that the trouble at Oxford was organised by a certain Northern member of Ruskin College. This gentlemen had gone to the meeting with the intention of causing trouble, and it was he who caused noise during the National Anthem. When he was thrown out for causing the disturbance he was the first to go shouting to the police that he had been hurt."

Another letter from Darlington signed "Hail Britain" said "I am disgusted with the Oxford students and heartily support "Hail Mosley" in all that he says. The trouble at Oxford is that the young men there have not enough to do. In the Northern universities the young men have to work as hard as they can because they realise that their parents are sacrificing to send them there. There are similar people at Oxford but the majority of the students are descendents of the leisured class and need not strain themselves to earn money. That is why many of them in the first flush of youth, turn vaguely anti-something or anti-everything. They think that they might get some fun from it."

The "Fascist Week" No 4 (Dec 1st-7th 1933) said that a University Branch had been set up on Tyneside and that "Amid scenes of enthusiasm, students of Armstrong's College and the College of Medicine, Newcastle, decided to form a fascist organisation. The meeting was attended by about 100 students, representing

all shades of political opinion, and addressed by Mr. Michael Goulding, formerly of London and Mr. W.G. Williams, Senior Propaganda Officer of the movement. Many undergraduates from both colleges were enrolled. The same weekly issue on its letters page had a young correspondent writing from Gateshead. It said "Congratulations! *The Fascist Week* fills a real need. I'm a young man of 21 and feel that I ought to do something to forward the fascist movement in this country but my employers forbid me to take part in any political demonstration. Also, my spare time is very limited in the fact that I am studying for a professional examination. What can I do? Clerical work?" The Editor praised his enthusiasm and told him to get advice from his local organiser.

A party of German Rotarians arrived in Durham on the 26th September as guests of the City of Durham Rotary Club and stayed at the Three Tuns Hotel and were shown the Cathedral and Castle by Coun. W. Gray. One of the party was Herr Karl Schippert who said "When we came to Durham we knew it was a historical place, and it was a great joy to come here. We have had ten days stay in England and we have all remarked upon the fine Rotarian spirit we meet with everywhere." He added that in some English papers they were described as people who intend to make war and disturb the peace of the world and said "I am no politician, indeed Rotary has nothing to do with politics, but may I say quite frankly and freely as a good German and a good Rotarian, that no one in our country wishes to make war or to disturb the peace of the world. Nothing is gained by war. We all know it. We won't have it again. Our wish is to cultivate a good understanding among all the nations, and to try to appreciate the other nation's point of view. We welcome the exchange of children from our country to yours and in that way we will arrive at a time when our nations will become real and sincere friends." The Durham members drank the health of the visitors and sang "For they are jolly good fellows" and the tourists gave the Hitler salute and exclaimed "Heil! Heil! Heil! The Rev. J.C. Bacon intimated that it was possible to have the use of one of

the Durham Colleges for a fortnight for a children's exchange scheme to promote good relations.

While the party of German and Austrian Rotarians remained in the Three Tuns Hotel they met and exchanged greetings with Durham members of the local British Union of Fascists. The party then resumed their journey to Darlington, York and East Coast holiday resorts.

Two successful Northern meetings were held on December 9th and 10th 1933 by Sir Oswald Mosley at Durham and Newcastle. On Saturday at Durham, the Palace Theatre was packed to overflowing, and the speech was relayed to the Town Hall in which there wasn't a vacant seat and also to the indoor and outdoor markets where over one thousand people had assembled. The meeting was stewarded by Fascists from Newcastle Central and other Newcastle branches, and also from Darlington, Sunderland, Washington and Durham. The *Durham County Advertiser and Durham Chronicle* gave fair press coverage of the meeting and its content is reproduced here. The article headline was:

"Policy of Fascism expounded at Durham. Sir Oswald Mosley Speaks in Palace Theatre. No Interruptions."

It went on to say... "Sir Oswald Mosley, the Leader of the British Union of Fascists, paid a visit to the North-East during the week-end and addressed meetings in the Palace Theatre, Durham, on Saturday, and at the City Hall, Newcastle, on Sunday. He was accompanied by his mother, Lady Mosley, and was given a cordial reception. Travelling from London, Sir Oswald reached Durham in the early evening and soon after eight o'clock the curtain in the Palace Theatre was raised to disclose the Leader of the Fascists in his blackshirt, standing in the middle of the stage surrounded by his followers, and facing a large audience. The Union Jack and the Fascist flag were displayed and during the Fascist anthem all saluted according to their custom.

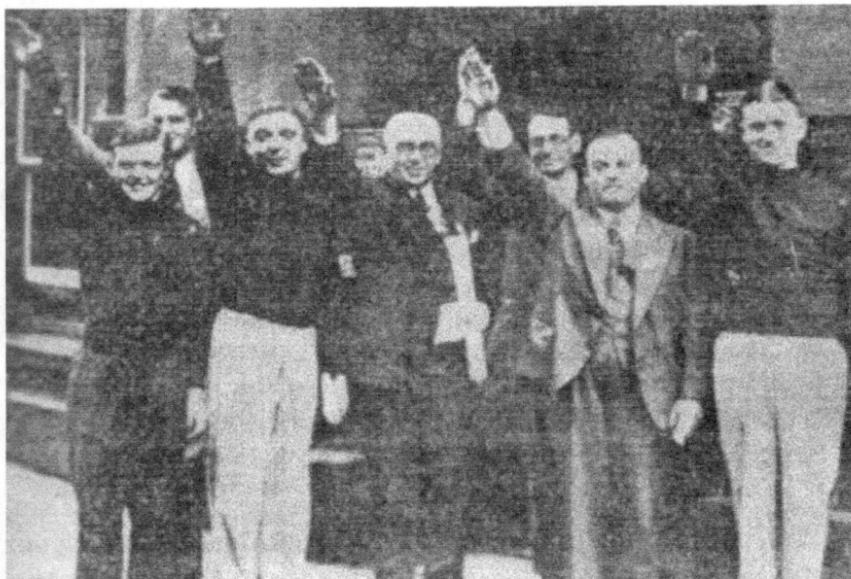

Visiting German Rotarians and Durham Blackshirts meet at the Three Tuns Hotel.

"Sir Oswald at once began his address, and spoke for an hour and a half to a thoughtful audience without the slightest interruption. We have in Fascism a new creed of the 20th century with its own methods and its own forms very different to those of the old parties and old movements" said Sir Oswald, "We attach to our creed and our cause a seriousness, or if you like, a ritual, which you have not seen among the parties of the past. It is about time that someone or some party or movement in this country began to take things seriously. We have had enough playing with policies and playing with the situations that confront us; the young men and women in fascism do take their cause in deadly seriousness and earnestness and attach to it something approaching a religious significance.

"I submit to you that nothing in the modern age is more required than such a spirit in Great Britain today. For that reason we are proud to wear the black shirt that singles out the more active members from their fellow countrymen and countrywomen as people dedicated to the service of their country, determined that

our country shall live again and be great. We wear the black shirt proudly as an emblem of service to the nation and of love of our country."

"Fascism has been described as the superb passion of the best of Europe's youth, the creed of the young men who in days of stress and of danger come together, and band themselves together, that their country might be saved from disaster and collapse. Being Fascists, if we denied our faith, we should be cowards and weaklings and that anything as clear-cut and definite as Fascism cannot be denied if it is to be advanced to the people. We do not seek to advance Fascism without declaring we are Fascists. It is not merely the paper policy of Fascism that is required in the modern world. Far more is required in the spirit of Fascism, the spirit of national revival and a new determination among our manhood."

"I am not here to denounce the person but rather the system under which we live and to point out to them that even if you had a government with the best of intentions in the world, with a real determination to bring changes which are necessary today, those changes would be impossible in the system under which we work."

"No party and no movement, whether of the right or of the left, can possibly do anything in this country today unless they first face up to the necessity of changing the whole machinery of Government."

"Tracing the progress of a Bill through the Houses of Parliament," Sir Oswald said "there was endless talk and a series of mother' meetings, and then a sort of "ping pong" business until the House of Lords received the measure. They make their amendments and then the business begins all over again. Who on earth would run a business like that? Would anybody in the world set out seriously to run any great concern on those lines with 600 people all trying to

talk at the same time and trying to advertise themselves by making speeches for the local paper very much on the lines of a county cricketer making runs. Dictatorship under Fascism was not dictatorship in the old and vicious sense of the word which meant government against the will of the people, but it is dictatorship in a modern sense which meant government armed and equipped by the people with the power to do things that the people want to be done. And that is, after all, what this country had sought in vain for ever since the war. The first act of a fascist majority in Parliament would be to confer on a Fascist Government absolute power to order action. Our principle is that when you have voted for and elected a government you should tell them to get on with their job and give them a chance to get on with it

"I have seen MP's under the present system come up from the industrial districts full of genuine enthusiasm and conviction and slowly they succumb to the atmosphere of Parliament. Parliament, and the old regime take all the life out of them and leaves them just as talking machines and nothing else. We would not keep MP's hanging about in that atmosphere. Humanity cannot stand it. You ruin men that way. We would use our Fascist MP's not to gossip and intrigue in Westminster, but to be down in the localities from whence they came and driving the Fascist Government to action. We would give them a practical job of work to do among the people who sent them to Parliament. It is in that way you will turn Parliament from a talk-shop into a workshop and MP's would once again become men of action. (applause).

"It is suggested that Britons are free just because the whole mockery and make - believe democracy gives them a right to vote for one or two vested interests, but invariably the vote is for their real masters who live in the City of London. Real freedom is a man's certainty in his job and the knowledge that if he does his work well he will keep that job."

"In this system of freedom he would have wages good enough to give him a high standard of life, money enough to feed and clothe himself and his family and to have more for little amenities and pleasures; hours short enough to enjoy his leisure, a decent house, in fact, it is summed up in two words, civilisation itself. That, and that alone, is the freedom of the people of the country." (applause)

"We are going to take away the right of a few old men blithering on forever," said Sir Oswald amid laughter. "We are going to replace it by a greater right for a great nation to live in prosperity and happiness. It is only when you have produced the machinery of government that action becomes possible, and from that machine you will produce men who are capable of action. What is regarded as a dictatorship by certain critics is simply the carrying out the will of the people. There are in it no methods of tyranny but methods of executive efficiency. Existing institutions will be transformed to new purposes that will be much easier and quicker than uprooting as the socialists prefer.

"This country can never be re-organised so long as we have the great power of alien finance unchallenged by any party. The real problem is that scientific and industrial technique in recent years has so increased the power to produce that it has entirely destroyed the power to consume, and the result is that men and women, as well as children, are walking the streets of most countries of the world without the necessities of life while the men who could buy these things are kept in unemployment on a starvation level. That is the basis of the problem today."

Sir Oswald then traced the greater part of the Fascist policy, commenting strongly upon the practice of under-cutting as between nations, and remarking upon the organisation of industry, adjusting consumption and demand to production... "Under a corporate system there would be a uniform and regular raising of standards and wages. Fascism would compel the British banking system to finance British industry instead of

equipping the Argentine or Timbuctoo or aiding Japan to set up factories and mills in which they could place cheap labour in competition with our white labour. Our trade slogan would be 'Britain buys from those who buy from Britain' (applause). We would drive your Durham coal, iron and steel into markets which they cannot enter today because they are excluded from them. Our policy would be 'Right or wrong, Britain First."

"Great Britain," he said, "will not fight in quarrels with which it has no concern. If Britain fights again it will be in defence of its own homes and its own land, and in no other way. (applause) We are not anti-Semitic. We never attack any man on account of his race or religion, but it is a fundamental principle of Fascism that no section or minority within the State shall organise against the State. An immense amount of Jewish money has been used in Britain to work up a war fever with Germany. We say that Fascism will not lose British lives in a Jewish quarrel."

Asked as to the Fascist view regarding co-operative societies, Sir Oswald said: "We would not uproot existing institutions which were functioning well and helping the nation. Anybody who had an interest in co-operative societies would be absolutely safe under Fascism. All these organisations would be woven into the purpose of the nation as a whole. Trade unionism would have a greater scope for its activities; it would be a great pillar of the Fascist State." The meeting closed with the National Anthem and then Sir Oswald paid a brief visit to the Durham headquarters of the British Union of Fascists in Claypath.

The following day at Newcastle City Hall, over 2,000 people had assembled and several thousand people were turned away as there was no room for them. There was not a single interruption during the meeting that was stewarded by Blackshirt men and women. Sir Oswald spoke and answered questions for over two hours and said "The two real rulers of this country are the financers and the press lords" which was received with roars of applause. There was no chairman and he started speaking

immediately on entering the platform. He said "We are bringing the great world creed of Fascism to Great Britain, in a form and by a method which is characteristic of the stability of the British people. We recommend to you Fascism not in a foreign form, but in a British form. In Britain in the first year of its existence, Fascism has made more rapid progress than in any of the countries in which it reigns today. It is the creed of men and women who believe that the civilisation under which we have lived has failed. We are a revolutionary creed. We do not pretend that it is not. But we seek our revolution by peaceful and constitutional means. We do not pursue a creed of violence. We do not contemplate any situation of violence arising in this country, unless and until the country is allowed to drift so far towards collapse that the forces of anarchy are let loose."

After the meeting, there was some trouble with communist opponents when they pushed over a middle aged woman and caused a stampede among pedestrians. The incident was summed up in a letter to the Evening Chronicle by someone who saw it: "Sir, as a peaceful citizen, I attended Oswald Mosley's fascist meeting, and witnessed the ugly scene in Northumberland Street afterwards. The Fascists were marching quietly away when the end of their column was interfered with by their opponents. There would have been no trouble at all from the Fascists had their opponents left them alone. The women who fell in front of the motor-car was knocked down by a non-fascist who made no attempt whatever to help her to her feet. He appeared to be much more intent on causing further trouble." Remarking on the violence Tommy Moran, who was in charge of the parade and Blackshirt defence group that day, said "We do not believe in force…Most certainly no man is expected to allow himself to be attacked without defending himself, he would not be a man if he did not do so." In referring to the violence and provocation imposed on his members he said of them "That the greatest victory is to conquer oneself, we have risen to the occasion as a body and proven to the general public that we ourselves have accepted discipline and good conduct… Never at any time will

our men make attacks upon anyone, but always they will defend themselves when necessary."

At this time it was reported that Sir Oswald would contest the Durham Division at the next general election in opposition to the National Government candidate William McKeag. When told, Mr. McKeag said that on personal grounds he would welcome the advent of Sir Oswald Mosley "as a worthy opponent who would undoubtedly introduce a tonic of vigorous originality into the election campaign." Newcastle BUF official Mr. G. Wood, said Mr. McKeag was a Liberal, or at least one of those National-Liberals who would discover the BUF feeling towards them if he read the pamphlet "Fascism in Britain" available at all Fascist headquarters. He added that Sir Oswald had made no decision as to which division he would contest at the next General Election because it depended on many things but that Durham was being considered among others. However, nothing further was heard about the rumour.

Despite the red violence, membership increased and they soon moved in December 1933 to bigger and better premises at 2 Clayton Street. One of the buildings considered was the old police station in Westgate Road but it was too expensive to rent and outside the city centre. The new building had two large floors. On the top were the BUF administration offices for the area (which included Middlesbrough, Berwick and Carlisle) and the Fascist Union of British Workers that helped and worked with unemployed members. On the lower floor was a big room that served as the club room and also held the office of the Newcastle Central Branch. All the branches of the area (totalling 14) were controlled from the administration office. The club had a canteen and licensed buffet. By November 1934 the office had moved to 16 Lovaine Crescent, the site was near Newcastle Civic Centre. Early in 1939 the Newcastle branch again moved to Croft Street to be nearer the town centre. Part of Croft Street no longer exists but it was located in front of the Laing Art Gallery where the Newcastle Building Society offices

now stands and part of the street still remains near the late 13th century Plumber Tower that was a part of the defences of the old walled city of Newcastle. The other property in Benwell, was first established at 129 Adelaide Terrace and then later moved to a bigger upstairs property across the road at number forty in the same street. In the book "Newcastle upon Tyne: A Modern History" it mentions "Perhaps the most remarkable of all ventures into the Newcastle licensed trade was that by the British Union of Fascists which opened two clubs in 1933, one in the West End of the city having as its stated objective 'the promotion of fascism in Benwell'. The clubs (referring to the liquor licence part of the organisation) closed after only two years but at one stage had a membership of 400."

1934: Fascism has no Connection to Social Favouritism

The Sunderland branch had only been formed a few weeks in January 1934 when it had outgrown its temporary office at 28 West Sunniside and its organiser, John Dalgliesh, was negotiating for new premises. The prospective new central offices they viewed consisted of five rooms and a hall large enough to accommodate 400 people. Although the Sunderland area was an industrial district with a fairly large communist element that was intent on disrupting opponents meetings, he said the "peaceful record of the branch proves that a firm hand tempered with discretion is always the soundest policy. They (BUF) have never gone to look for trouble, but would not avoid the issue if it came along." The branch weekly newspaper *The Sunderland Fascist*, was increasing in sales and the race for the first printed branch newspaper would probably be between Ashford and Sunderland. Unit Leader Robson, was proprietor of the Sunderland Athletic Club and was bringing out a grand team of exponents of the noble art (boxing). Fascist Childs was Northern amateur lightweight champion and Fascist Bainbridge was also a member of the boxing club team that was the best in the North.

William Joyce travelled up from London to be the guest speaker at Hetton-le-Hole Miner's Hall on Tuesday January 9th and spoke to a full house. Joyce joined the BUF early in 1933 at the age of twenty seven and had been a brilliant literature student and had obtained a first class honours degree from Birkbeck College. He told the audience "The Fascist dictatorship is not a tyrannous dictatorship. It is based on the will and judgement of the people. However much you may hate Hitler or Mussolini, those men command the over-whelming

and enthusiastic support of the majority of their countrymen...
We attack democracy because we regard it as the greatest
deception of the greatest numbers. I do not expect that many
of the audience will agree with me and, if you feel inclined,
challenge me, but remember that Sir Stafford Cripps spoke in
favour of dictatorship until he was bullied by the Trade Union
Congress into withdrawing his comments... Under the Fascist
system there will be only one standard of service of merit, and
that is the standard of service to the state, whether a man be
a duke or a road sweeper. Although Hitler is one of the most
powerful figures in Germany he comes from the working class
and there you have the best possible proof that Fascism has no
connection with social favouritism. Mussolini is the son of a
blacksmith...I admit that Sir Oswald Mosley is an aristocrat,
but we have only one. The trouble with Socialism is that it
has 30 or 40 aristocratic leaders, and Sir Stafford Cripps is
one of them." He added "We will build a greater Britain in
which there will be a unity of class, an authority in politics and
a scientific justice in economics. We will build a co-ordinated
Empire in place of the decaying association which is now known
as the Commonwealth of British Nations, and we will work
resolutely for world peace. These are our principles and they
are the principles from which few Englishmen will dissent."
A section of the audience was hostile - but Joyce was quite in
his element in the face of hostility and had the happy knack of
squashing hecklers. The area administration officer Mr. Michael
McCartan regarded the meeting as breaking new ground.

Speaking at a Conservative social gathering at Kirknewton in the
middle of January, Lieutenant-Colonel Todd, MP, for Bewick
Division, said the Minister of Agriculture knew the farmers
needs and was doing all he could and that the government must
continue to be National in every sense of the word. He added "I
hear an effort is being made to start a Fascist branch in Wooler.
That is all to the good. Providing their efforts are directed
towards seeing all that is good in our country brought forward,
I shall welcome them."

Later on January 21st, there was a confrontation when a number of Blackshirts tried to gain admission to a public meeting at South Shields Labour Hall. A former BUF member, Mr. J.H. Fawcett of Washington, who had left the movement after two years, was to give a talk on "Fascism and its Methods Exposed." Nothing unpleasant happened and in the interests of a balanced point of view Mr. Cuthbert Barrass, the chairman, said that one of the Fascists should be allowed into the hall and put forward the views of his organisation. A few days later, the Bolingbroke Literary and Drama Club opened in Shields. It was active among the local unemployed and one of its founder members was a BUF member.

Correspondents in the Shields Gazette said Fascist groups were "led by Capitalists" but were told that they had got Fascism all wrong. A local BUF supporter said: "Fascism controls those people who are capitalist and breaks their monopoly of the wealth of the nation, directs the distribution of money and profits, and welds capital and labour to work for the good of the whole. Fascists are out to purge the defects of the capitalist system, and they work on the principle of doing the greatest good for the greatest number. I will give you an idea of what I mean. In a certain big manufacturing plant near Berlin, a balance sheet for the years work showed a huge profit. Hitler directed that after a 5 per cent profit had been deducted for the shareholders the balance should be used up by enlarging the plant and extra men employed."

The National Propaganda Officer Patrick M. Moir spoke at the Co-operative Hall in Coxhoe, Co Durham, on the 22nd of January. A report printed in the Durham County Advertiser was headed "Fascists at Coxhoe – Control of Mines and Banks" and went on to say "Under the auspices of the British Union of Fascists a public meeting, the first in this district, was held in the Co-operative Hall, Coxhoe, on Monday night and was addressed by Mr. Moir, one of the National Organisers of the movement. There was a good attendance. The speaker, who

said his movement had been boycotted by the Press, in his speech dealt with Fascism, what it meant and the need for the movement. Questions were invited at the close of the meeting. Replying to questions by Councillors R.D. Ayton and W. Pease, who were Labour representatives, and also a Mr. A. Gillett, the speaker stated that they believed in State control of the mines and banks, but did not believe in monopolies as they existed today. They proposed achieving their policy by ordinary constitutional methods, and would do away with the House of Lords, and replace the House of Commons by a House of Industry in which the members would be representatives of the various parts of industry in the country. If necessary, emergency powers would be taken to put laws into operation at once instead of so much time being taken in passing them at the present. The members of the House of Industry would have to work for what they got instead of idling their time as they did at present in the House of Commons until the division bell rang, when they voted like sheep in response to instructions. They would not be interested as to whether people living in this country were Jews or belonged to some other race, but whether they were acting in the interests of this country. The House of Industry would decide the policy of the banks which would have to agree or be taken over without compensation. Further questioned by Mr. Ayton, the speaker repeated that they were hoping to organise so as to obtain power by constitutional methods. They did not intend revolutionary methods as they valued the lives of their members and those of other people."

The Blackshirts held a meeting at Gosforth on January 23rd as part of a campaign throughout the North East. Mr. W.G. Williams (Senior Propaganda Officer from National Headquarters in London) spoke at St. Charles Church Hall to a moderately attended meeting. He said great forces were trying to prevent Fascists from coming to the forefront in this country, but the movement, like those in Germany and Italy, was inevitable. "The old gang politicians are reviling for obvious reasons" declared Mr. Williams. "They have more to fear from

us than from any other political movement and they realise that their day is over." Blackshirt stewards were on duty and it was an orderly meeting. The previous night, Tommy Moran was speaking to a large crowd in Wesley Place, Blaydon. Asked why he had a cordon of Fascists around him, he replied: "Because we thought you might be armed. We ourselves are not an aggressive or militant force." The speaker explained that they have had a rough time at certain places, and some of his colleagues bore the scars of razor blades. "If there is going to be a revolution in this country we will stand behind the flag and the King and prevent the destruction of this country. The Reds will never have a revolution in this country because we will stop it" declared Mr. Moran to a crowd of about 400 people.

A Sunderland BUF members' whist drive was held at Wetherall's Assembly Rooms at 13 The Green, on January 29th and all were cordially invited and tickets were available from Mr. Dalgliesh. The recent visit of Sir Oswald to Durham City resulted in an increase in local membership and the office at 85 Claypath was growing too small and it was hoped new premises would be obtained soon that would have the usual fascist facilities for athletic training, speaker's lessons and recreational rooms. It was said that the former organiser, and recently promoted, Mr. McCartan "had done a good job of work during his tenure of office and his successor would find taking over a pleasure."

At the end of January there were some local appointments made. In Darlington Mr. Walker-Wilson, Mr. H. Hill, and Mr. W.G.H. Allen became Unit Leaders and Fascist J. Hall was made Assistant Propaganda Officer.

South Shields Fascist Union of British Workers organiser and former communist Mr. W. Harrison replied to an "Anti-Fascist" correspondent from his home at 28 H.S, Edward Street that "Any keen observer of politics within the last decade has surely seen how Parliament has ceased to function in the interests of the nation as a whole. Fascism is first as much against vested interests

as Socialism is and under Fascism and the corporate state the banks would be the servants of the state and not as they are today controlling the state. I would like to ask your correspondent if they can quote any instance when a great upheaval, political or otherwise, has taken place throughout the history of the world where some innocent people have not suffered. When a crisis arises, Fascism intends to deal with it immediately and not waste time appointing a committee to enquire into it, then appoint another committee to go into the findings of the first and then pigeon hole it, as we have seen done by previous governments. Fascism will also deal with the trade union bureaucracy. We can well do without trade unionism which benefits only the trade union leaders. Fascism is not out to break up trade unions but to re-organise them and rid them of the present leadership which is exploiting the unions for their own benefit."

In another article he replied to a critic "What he has failed to observe about the old political parties is that they are representatives of international bankers and high finance who are not concerned with the welfare of the people of Britain, but of financing other countries to develop their industries to compete with British manufacturers, raising the price of commodities and reducing the purchasing power of the workers. Fascism will prevent financiers from investing their money to the detriment of this country and its industries. It will preserve the markets of the British Empire for British manufacturers. Any other commodities required will be obtained from those countries that purchase goods from Britain or the Dominions. It will make the British Empire self supporting and it will raise the standard of living throughout the whole field of industry. Let us first put our own house in order and not sacrifice the British worker on the altar of international finance." He also refuted a critic's statement that Fascism is based on militarism and said "Because it is a disciplined organisation it does not make it military. Discipline is essential for the control of a large body of people. For example, our civil police force is a disciplined body of men, but I don't think he would say they are militarised."

BUF members hoisted the Union Jack in Wesley Place, Blaydon, on Monday 29th January in a response to the destruction of a Union Jack in Blaydon Council yard and the banning of the flag by socialist members of the council. BUF member Tommy Moran addressed a large crowd in Wesley Place and challenged the person who had burnt the flag in the council yard to come forward and try to take the Union Jack out of his hand but there was no response from among the crowd. Someone asked "When is Mosley coming to present medals to the two warriors who put the flag on the water cart?" Tommy replied that "the flag would fly higher than it had ever done on the Blaydon Council premises."

Blaydon Council was again criticised when the Socialist council would have nothing to do with the Jubilee celebrations for King George V held on Monday May 6th when thousands of people joined in the festivities organised by the local Empire Day and Jubilee Committee. The flying of the Union Jack on the Labour council buildings was again taboo but overnight some patriotic person put a flag on the door of the council offices and others were placed on the gas lamps at the entrance. The council were so against flying the Union Jack that it even went on to accept Labour Councillor's Bell suggestion that the flag pole be taken down so as to prevent the Union flag being raised during the night! In an act of defiance, workmen on the Hallgath housing scheme hoisted a Union Jack on one of the houses but Councillor Steve Lawther and others removed trophies used in schools for sports and dancing on Empire Day. One woman complained that one night they went around the streets of Blaydon shouting "We will keep the red flag flying" but she wished "the whole pack would get off to Russia. The good old Union Jack has been good enough for us for centuries. We shall be at the celebrations and bring our children." The left-wing council received another counterblast on Empire Day May 24th when 2,500 school children took part in a huge Empire Day procession. The proceedings commenced with the crowning of Miss Esther Tench, a 14 year old girl guide, as the May Queen, then the

large procession left the marshalling ground in Shibdon Road and proceeded through the main streets to a field near Axwell Park where Dr. Howard Morrison, Chairman of the celebrations committee, unfurled the Union Jack. A programme of children's' sports events were carried out and a May Pole dance competition held while a wonderful band of women provided the children with refreshments.

At the weekly meeting of the North Shields Literary and Debating Society in the Stephenson Street Congregational Church Hall on Jan 30th a large audience attended when BUF member Mr. Patrick Moir delivered an address on "Fascism."

"The Fascist movement," he said, "believed in raising the cultural and physical level of the people. The fascist aim was to make lock-outs and strikes illegal and modernise trade unions into a more central organisation, and that cutting waste would make a large sum of money available for the development of sport and culture." He contended that the standard of living among the masses was becoming lower and lower and physical deterioration was rapidly developing.

Mr. Moir claimed that the mechanisation of industry in Japan and other Eastern countries, mass production methods and standardisation was driving Britain out of the markets of the world. The lower standard of wages existing in those countries also gave them a great advantage. "Fascism faced the fact that it was impossible for Britain to hold her foreign markets.

Under Fascism British industry would be called upon to fulfil the needs of her own people. British markets would be reserved for British goods, foreign goods would be excluded. The elimination of foreign imports from our markets would give employment to a large number of men in industry. It was also the aim of his party to considerably develop agriculture.

"Fascism aimed at raising a greater national spirit. It had no

desire to foster a spirit of aggression because under Fascism the struggle for world markets, that is one of the principle causes of war, would be eliminated. Its uniform, the black shirt, was intended to get rid of the class spirit and showed that the wearer was dedicated to the movement. In Fascism," he claimed, "lay Britain's real and only hope for the future." The talk was followed by a lively discussion and Mr. Dixon Scott accorded the speaker a vote of thanks.

Similar to the Blaydon flag incident, a Sunderland Fascist placed a flag on the roof of the local Socialist headquarters in Murton Street in the early hours of February 2nd bearing the words "God Save the King." The District Branch Officer, John R.M. Dalgliesh, at the BUF premises at 28 West Sunniside, had received a written statement from the Fascist responsible which explained his actions. He wrote that his reasons were:

1) The Socialists are privately and insidiously working against the King and the Royal family.

2) Socialists who attended the Fascist meeting the previous week remained seated during the singing of the National Anthem, and some actually sang the "Internationale" in opposition.

3) Members of the Socialist Dance Committee at the recent "Victory" dance held in the Rink following the November elections gave instructions to the orchestra leader that he had not to play the National Anthem at the conclusion of the dance. The orchestra flatly refused to obey this instruction.

In his statement the Fascist said "I felt that some action was necessary to show the almost universal contempt of the people of Sunderland for such underhanded propaganda as practised by the Socialists". Mr. Dalgliesh added "As Chief Officer of the BUF in Sunderland I wish to say that I fully endorse the sentiment,

if not the action, of this Fascist. It is time someone showed the supporters of Socialism the sort of men who are leading them." Councillor Ford, Secretary of the local Labour Party, said he was not worried about the incident and claimed that there were more people in his offices who fought for the flag than in the BUF. Dalgleish replied "Councillor Ford said that the Labour Party headquarters houses more ex-Servicemen than the Fascist headquarters. I will definitely dispute this statement and I claim from a full knowledge of both movements that the British Union of Fascists both in Sunderland and throughout the country has a higher percentage of ex-Servicemen than any other political movement. The Labour Party may house many ex-Servicemen but surely it is not so long ago that the Socialist leaders insulted the whole town and the men who died in Flanders by refusing to attend the Armistice ceremony. Only one or two Socialist councillors attended the parade. These sort of actions hardly concur with the high sounding idealism of Socialism but undoubtedly suit the narrow-minded, un-Socialistic outlook of the baffled and disgruntled leaders whose outlook is no further than they can actually see."

A number of South Shields critics were answered during February. BUF supporter Walter Lilley said "Fascism means unity and strength... The Communist Party want revolution and the Labour Party are paid to bolster up a government and collaborate to put the workers on the Means Test. Fascists want a constitutional change. For 200 years the profit makers have never been placed on this basis. There has never been utilisation of profits to benefit workers. The corporate state will remedy this." Another supporter said "Permit me a few lines in your paper to express my appreciation of the efforts of our local Fascists. When we look around and witness the present day results of our Parliamentary system, is it to be wondered that our youth are getting impatient. Fascism has an urgent job of work to do. It has brains, youth and driving power behind it. It is apparent that it is the only movement that will raise this nation of ours to the proud position it once held."

He went on to say "I have tried honestly to sift the arguments of "Anti-fascist" and Mr. A. Lowther and I find there is a repetition of stock arguments against Fascism which have proved to be false time and again. For instance one says "The bankers, industrialists, etc, reign supreme in Germany." Let us have the truth. The German nation has been united under Hitler as never before. The nation is not run by Capitalists. It is gradually beating unemployment. It has suppressed those who have been eating at the heart of the nation, the money lending, rent collecting type of parasites who batten on the poor. The German nation under Fascism acts quickly. Democracy in the last few years has undoubtedly been a failure under both Socialist and Conservative parties. The latest failure of democracy is France where corruption and graft are rampant culminating in the Stavisky scandal (an embezzler and confidence trickster with links to government ministers) and the riots in Paris. Look at the physical condition of our people in Northumberland and Durham under our so-called democracy. Under democracy "Nero fiddles while Rome burns."

One of the BUF critics and frequent newspaper correspondent Mr. Anthony Lowther, who was chairman of South Shields Communist Party, wanted to know what is Fascism and Mr. Harrison pointed out that a public challenge to debate Fascism had been issued a few days previously at a BUF meeting in South Shields Market Square but no one had taken him up on it but that it still held good. He said Mr. Lowther had "made an erroneous statement when he surmises that the conditions of the workers are worsened because the production and distribution are still in the hands of the capitalist class.

Under Fascism the corporate state would control both production and distribution, and reserve the home market for British manufacturers who would then be able to pay better wages to their employees with a feeling of security knowing that their products would not be undercut by cheap foreign goods produced under sweated conditions." He added that Mr. Lowther had

given the standard communist point of view and that he himself had "left the communist party on account of the low standard of mentality and to prevent himself from becoming one of the unemployable. If he wants to know what Fascism is, it may be as well to quote a few points. 1) Fascism is the Corporate State, 2) All shall serve the state and none the faction. 3) All shall work and thus enrich the country and themselves 4) Opportunity shall be open to all but privilege to none 5) Poverty shall be abolished by the power of modern science released within the organised state 6) The barriers of class shall be destroyed and the energies of every citizen devoted to the service of the British nation which by the efforts and sacrifice of our fathers has existed gloriously for centuries before this transient generation, which by our own exertions shall be raised to its highest destiny - the Greater Britain of Fascism."

Harrison was again writing on Feb 22nd saying that "The idea that 'free trade' will solve our unemployment problem is totally erroneous. If the foreigner is to be allowed to dump his cheap goods unrestricted into this country, it only needs common sense to understand that British manufacturers would be compelled to reduce wages and resort to longer hours of labour to compete with the foreigner, and this means the lowering of the standard of living of the people of this country. Why should a British manufacturer be pushed out of his own market to suit the foreigner when other countries will not allow British goods to enter their markets without paying a high tariff? Free trade is a thing of the past. It may have been all right when Britain had the world markets at her command and other countries were not producing sufficient for their own needs and competing in the world's markets for an outlet for their surplus goods. The need today is for Britain to develop the Empire market for British manufacturers and keep the foreigner out. This is the policy of Fascism." He added that those who lamented the taxation of foreign goods that they considered essential to our national welfare had "failed to observe…that these same goods were made by British manufacturers before the poor foreigner thought about making them, and that it is better that

we should have British goods that are so essential to our national welfare in preference to foreign goods."

BUF supporter "Northumbrian" wrote on February 19th in the Shields News: "Your correspondent wants to know why Communists are always regarded as 'hooligans.' One reason I should say is the fact that at every opportunity they hold the flag of our country up to ridicule and contempt. Indeed, I understand up Blaydon way one was recently burnt in public by Communists. The public burning of the Union Jack naturally is not looked upon with favour by decent men and women. The Fascists at least are animated with a magnificent loyalty to the flag the Communists so much disparage. Very shortly after the above event took place Fascists visited Blaydon and challenged the hero who burnt his country's flag to come forward and burn another but he wasn't having any."

The Sunderland Echo allowed Sir Oswald Mosley to put forward his ideas in an article published on March 7th entitled "The Case for Fascism: A Creed of Action" and he went on to explain how the old parties have been tried and failed. He said the country had given an overwhelming majority to a combination of the old gangs (the National Government) in the happy belief that, if they united every elderly failure in politics, salvation would quickly follow. "Those hopes have proved illusionary and industry continued to languish and the stock exchange continued to boom in a trade recovery that never reached the unemployed. Such were the incidents which led to the birth of Fascism. We picked ourselves up and reorganised, for it is the capacity to come back from a crises which makes a movement." He continued that "They had united patriotic elements of both the left and the right who stood for action in a new organisation built from nothing but their bare hands, building on the solid rock of sacrifice. Thousands of young Englishmen and women grew new hope in Fascism and had come to swell the ranks of the Blackshirts. They suffered a storm of abuse and misrepresentation but advanced a great cause that rested on facts and figures that would be won by

reason and argument." Sir Oswald asked the public to study his claim with British fairness and then judge for themselves.

Two Fascists distributed leaflets at Jarrow on March 9th announcing that they were to speak at an open-air meeting near Jarrow railway station. When the two Fascists arrived Communists had organised a meeting on the same spot and were speaking to about 20 people. Undaunted, the Blackshirts set up a box platform and started to attract attention. The Communists rushed over to them in an attempt to howl them down and were deterred from doing worse by a police presence. The speaker refused to submit to intimidation and continued until the meeting closed and they were escorted to the bus station on Grange Road West and safely boarded a bus.

A large Empire Day display and exhibition was also held in Sunderland that May which included country dancing, eightsome reel's, Morris and sword dancing. Mayor Ditchburn said: "The display you have witnessed was not organised for the purpose of impressing upon the minds of the younger generation the glory of war or the desire of conquest, but that they should honour the flag, remember with pride the glorious achievements of the past and appreciate the benefits which we all derive today as a result." About 2,000 young people took part in the parade. Such well attended events showed just how out of touch left-wing politicians were with the patriotic feelings of local people in the area.

At Sunderland, five communists were chased out of the working class area of the East End and Hendon district by irate residents enraged by their attempt to use the Jubilee celebrations as a subject for communist propaganda. The leader of the communists had intended to tour the area with a megaphone shouting communist propaganda but was barred by crowds of people waving Union Jacks and shouting "Get back to Russia or we will lynch you." One of the disgruntled comrades tried to tear down a Union Jack from the wall of a house at the corner of East Street and Railway Street. The crowd rushed at him but he was saved by

a man who draped the Union Jack around him. The Red was punished by being escorted out of the district by a jeering crowd singing a mighty chorus of patriotic songs. His four supporters who had tried to sell copies of the Daily Worker newspaper were similarly hustled and their communist papers taken from them and torn to shreds by the crowd. One witness said "He came to the wrong quarter if he thought he would find an audience to listen to his rot. He forgot this is England, not Russia!"

During February and March a disgruntled former Sunderland BUF member, Walter C. Bothell, who had been expelled from the movement, started to say that Fascism was not a success in Italy and that the unemployed were worse off and did not want their thinking done for them by Sir Oswald Mosley. Roker Fascist P.J. Fannen replied "Since when has Mr. Walter Bethell become acquainted with the general views of many thousands of unemployed in Sunderland? Also, why disparage Italian methods of alleviating the distress caused by unemployment without State aid. Surely a country hitherto without starving masses has something to its credit that its inhabitants have never been over-burdened with taxes, etc, as they are here. Mr. Walter Bethell is evidently more concerned with unemployment relief than a country striving for prosperity under the creed of Fascism that is based upon a 'solid rock of sacrifice' and the sacrifice referred to by Sir Oswald Mosley is the sacrifice of a few for the benefit of the majority."

By this time there were a number of BUF supporters in Middlesbrough and in a "Letters" page of February 5th in the North-Eastern Daily Gazette one wrote: "We Fascists, while upholding the right of liberty, deplore and seek to control the unregulated licence which is destroying the moral fibre of the nation. Surely, however, a system of government which is allowing licence to predominate and to control the nation's affairs is wrong, and to clear the misuse of licence, the system of government must also be changed if the root of the trouble is to be got at. Fascism is a modern creed of a modern age."

Sir Oswald held a rally in Middlesbrough Town Hall on Sunday February 10th. It attracted a communist counter demonstration but the Town Hall meeting itself was orderly and members of the public had ready access to the Hall that was stewarded by about 250 Blackshirts from various parts of the district. An attack on the present system of international trade, controlled by high finance behind a figurative "smoke screen" was made by Sir Oswald that lasted for over an hour.

Behind the international system, declared Sir Oswald, were the financiers, who, with their capital, were establishing industry in the East which threatened ruin to the white man. British export markets throughout the world were being gradually closed and Japanese and Indians were been driven from villages and hamlets into the cities to work ten hours a day under sweated conditions in the factories which sent out their cheap products to the rest of the world.

"Who has summoned up this nightmare of the East which is threatening practically every staple industry in the country?" asked Mosley. "The same force that dominates every party in the State and that insists on internationalism in trade. That is the force that is elected by no one, and is responsible to no one, which has gripped Britain since the war - the international financier. The financier sat in his office in the City of London with the credit of every country in his grip. Every party said 'You can only live by trade with the world'- and there was the figure of the financier in the background. No one saw much difference when one party came into power and another went out. Behind the smoke screen of the Parliamentary system the real game was played by a force which made and broke Governments and parties.

"The tamest of all was the Labour Party, which was in the grip of the financiers. 'Enough of internationalism and enough of financiers' was the Fascist cry." Sir Oswald criticised the present Parliamentary system. When a Fascist Government came into power things would be done in a different way. Since the war

the people had demanded and voted for a change, but they have not received it. The Fascist movement seeks power by legal and constitutional means. "We believe the experience of the last 17 years has proved that the old parties and systems, no matter what their programme and promises, by reason of their very nature are incapable of the action which the country today requires" said Sir Oswald.

"When they talk about the freedom of the people under democracy what humbug it becomes! If the freedom of the vote is to mean anything, the first thing to do is to give the government power to do what the people vote for. It is the denial of that first principle of action that was responsible for the present condition of the country. All that freedom of democracy meant today was the freedom to work for low wages, with two million unemployed ready to take one's job; freedom to live in rotten houses; to work rotten hours and in rotten economic conditions. The people had one freedom alone - the freedom to starve in the midst of plenty.

"Every party in the country today was pledged to perpetuate the present Parliamentary system, behind which the real dictators opposed the will of the people. The only way to alter the state of affairs was to give the Government the power to act by order. Eventually, a Fascist Government would come to power, elected not by a geographical system, but by a system of occupational representation. Steelworkers would elect a steelworker, doctors a doctor, and so on. This would result in a technical Parliament, the members of which would be in close contact with the people they represented.

"If the Labour Party, for instance, during their two years of office had a cure for unemployment they should have presented it to Parliament. They had not got one and they had not the courage to fight. They remained in the office until the bankers knocked them on the head, like tame rabbits in a pen. On the North-East coast the people have been told that they are in a middle of a boom. But where was it?" he asked. "There had

been a boom in the luxury trade and on the Stock Exchange but not in the steel industry. The way to make the boom permanent was to raise the purchasing power of the nation by higher wages."

In the aftermath of Mosley's Middlesbrough meeting one of the local branch members was dismissed from his work as an employee in a local store. The store employed two BUF members but one attended the meeting at the Town Hall in uniform and was told to leave because he had done so. A North Shields supporter commented in the local paper "I always understood that in England everyone had a right to their own views on political matters. Strangely enough in your correspondence section appeared a letter from a number of people seeking financial aid for German Jews - victims of political oppression. Would their efforts not be better employed in helping their own people? Apparently victimisation for political views is not exclusive to Germany."

Soon afterwards, in response to comments by Mr. Arthur Greenwood MP concerning fascism and democracy, BUF officer, Patrick Moir, wrote to the Durham Advertiser on the 16th February and said that "The present day politician follows his own inclination and, at times, he consults the people, but never does he rise above the principle that the possession of office is infinitely more important than its use. He must pretend on occasion to respect the popular mandate. He must make the promises that will win him the most votes. Our sham Democratic offspring of plausible bribery...secures that neither the people nor the politicians shall govern...the rate of the relative influence varies as to the proximity to and from a General Election. This is how the Democracy of Messrs Arthur Greenwood MP, Peter Lee, Mr. McKeag MP and Col. Headlam MP works... Thus too will Durham County find itself with the type of County Council it deserves until, after the awakening, fast rising Fascism will provide the Government it both needs and requires."

Many of the Newcastle communist hooligan element clashed with a group of Fascists on February 20th who were speaking in the Bigg Market. There was a struggle for possession of a Union Jack flag belonging to the Fascists which the Reds had taken and attempted to destroy. The flag was retaken and the Blackshirts then marched back in orderly formation to their Clayton Street offices. They were followed by a cheering and booing crowd of about 150 that was dispersed by four police officers who were waiting at the junction of Clayton Street and Blackett Street. None of the Fascists were injured, though one of the speaker's Defence Corps got rapped over the head by a Communist who used the flag stick as a truncheon. It was noticeable that as soon as the Blackshirts attempted to regain their Union Jack several of the "opposition" took to their heels.

Some of the members in the Newcastle Central branch in March 1934 were: District Branch Officer Campbell, Deputy Branch Officer Atkinson, Branch Section Leaders G.R. Pallister, Mr. L. Lynn, Mr. R. Sheville and Assistant Propaganda and Research Officer Mr. George Cameron Simpson. One of the members of the Fascist Union of British Workers was E.J.S. Pickering who worked with the unemployed members of the party. Fascists G.R. Pallister, L. Lynn and Mr. Sheville were to be Branch Officers. At this time, District Area Officer Michael J. McCartan requested to revert back to the rank of Fascist and the area then came under control of the Northern Command.

Acting Area Officer Mr. G. Vincent was to be the Officer in Charge of the Northern Counties of Northumberland, Durham, Cumberland and Westmorland and with his second in command, Mr. Vincent Keens, they had spent several weeks on Tyneside working on the re-organisation of local branches that was necessary due to increased membership. Major Ormstone DSO was appointed Officer in Charge of Newcastle and Mr. Waterman as Propaganda Officer; he had held a number of meetings in the district and trained a number of speakers that he now thought were ready for the field. The Women's Durham

section was organised by Miss Marshall of 165 Durham Road, Spennymoor and in February Section Officer Mr. Bell was appointed as Officer in Charge of the Newcastle youth group. At Durham, promotion was given to Fascist T.Byrne, E. Austin, J. Smith and R. Anderson. Fascist R. Stubbs was made section leader.

Another stormy meeting took place at the Cowen Monument on March 4th when the Red rowdies were waiting to break up the meeting. Boos and groans greeted the appearance of the Blackshirts carrying a Union Jack at the front as they marched to the monument. The speeches were interrupted but the meeting continued. The returning march was attended with a good deal of disorder and attempts were made to tear away the flag, but the score or so of Fascists stubbornly fought back their assailants who numbered hundreds and they managed to get back to their Headquarters with the flag intact.

On March 18th, Mr. Charles Joseph Bradford, an officer from the London BUF National Headquarters addressed the crowd at Cowen's Monument and when the communists caused problems the police requested the speakers to close the meeting. When marching back to Clayton Street the opposition overtook them and tried to assault several of the Blackshirts. Tommy Moran, the officer-in-charge, said to a Journal reporter "The rowdies began kicking our fellows in the legs. We were well able, however, to defend ourselves and did so, afterwards proceeding to the headquarters with our flag intact."

A former Armstrong College student, Mr. Andrew Michael Brown of Croydon Road, Newcastle, went to Germany in September 1933 to spend two years researching Bavarian history at Munich. While at college he was an outstanding 22 year old scholar as well as an athlete. In a recent letter home to a local parish magazine he gave an interesting impression of the city and said Munich was a city of great buildings and fine streets and that "The laws against throwing away paper in the streets

and the virtual absence of smoke, combined with German thoroughness, produce a city whose cleanliness would be a revelation to English magistrates." His brother said he "recently had been on a 600 mile tour of Southern Germany. He was presently lecturing once a week at the Anglo-German Club and had made many new friends in Germany."

At this time the Sunday Sun reported on March 31st that 500 members of the BUF had offered their services to fight in the Gran Chaco war between Bolivia and Paraguay. It was an absolutely crazy suggestion to make and John MacNab said that no such offer had ever been made.

Concerned about social problems and unemployment, the Rev. A.G. Moore of St Barnabas Church in Sunderland said on April 21st that in his own parish boys left school without much chance of apprenticeship or opportunity of learning skilled craftsmanship. He said he felt there were opportunities for new industries in and around Sunderland and that within a small radius nearly 250,000 people required the necessities of life - clothing, boots, furniture etc, and also to that could be added the comforts of life that can be purchased such as bicycles, wireless, cigarettes, motors, and so on. He estimated that about 80 per cent of these things were made in other places and wondered if Sunderland people were patriotic enough to give preference to locally made goods.

Rev. Moore had talked with a local shoe repairer who told him he had only received two orders to make a pair of boots during the last year. He suggested that if everyone was determined to wear shoes made in Sunderland that a boot factory would soon be an accomplished fact. He pointed out that money is subscribed to a fund to provide boots for poorer people and that it should be spent buying locally made goods and go to local tradesmen. He said this should apply to many things but even the placards advertising goods for sale were manufactured elsewhere. He suggested that people who desire to promote employment should

use only Sunderland made goods and to get others to do so. Rev. Moor further suggested that a display of goods manufactured locally to show what can be done and that a new local chamber of manufacturers could be formed to foster new and enlarge existing industries, and to advertise them to the world.

He went on to say "There is a patriotism here, but it wants rekindling by some great awakening - stirred up by some noble cause. I feel that when it is fully realized that every pound we spend may help to give men work and that the millions annually spent on necessities could be so used as to absorb all, or nearly all, the unemployment in Sunderland, we shall have a cause which will arouse people's best and most intense patriotism. If we create a demand, new industry must follow." It was not known if the clergyman had read BUF literature but it certainly sounds as though he had!

Newcastle communists attacked a BUF meeting held in the Bigg Market in February and a Union Jack standard, carried by a young Fascist, was broken in the melee. On April 29th, the Reds again attacked a meeting held at the Cowen Monument. The BUF members were greatly outnumbered and two were injured, one was treated at Newcastle Infirmary for a severe head cut. The opposition threw stones and walking sticks and umbrellas were used as weapons. When the Blackshirts defended themselves there was a wild scene for several minutes until the police succeeded in dispersing the attackers. The Blackshirts then marched back to their headquarters in formation and got medical help for their comrades.

Similarly, at Sunderland "Eye-Witness" wrote to the Echo (May 15th 1934) and said: "Last week I was listening to a Fascist meeting outside the Central Police Station. This meeting was held by two young men dressed in black shirts. The young men did not seem to be more than twenty years of age, and were having a good time except for a number of Communists who seemed to be there for the sole object of making trouble.

At the close of the meeting a Communist rushed through the crowd and butted the young speaker and this caused a small disturbance. The Communist who caused the trouble, however, carried out the policy of the Communists by running away. If this is the action that Communists intend to take towards peaceful speakers I think it is time the police kept an eye on them. I have read a great deal about the rough Fascists, but I advise anyone to visit a Fascist meeting and see for themselves who causes the trouble." Another witness to the incident wrote: "When we carefully examine the speaker in question we find he was two stone lighter than his attacker and was suffering from injuries from previous meetings and is permanently lame in one leg. What a victory against Fascism? The speaker now suffers from wounds caused by a broken bottle in Newcastle and has seven stitches in his wounds.

The Communist policy published in their German paper "Rote Fahne" on Nov. 29th 1929, under the title 'Fascism's General Call' states "Beat up the Fascists wherever you meet them! This is our slogan which strikes terror into the hearts of the Fascists. Beat up the Fascists! That is the fighting slogan of the revolutionary proletariat. Only by open political mass struggle, only in the Bolshevist way can we smash Fascism." Such statements by Marxists clearly showed they were the real thugs and perpetrators of violence.

Another Sunderland supporter said that in Sept. 1928, "Pravda," a Moscow published newspaper, had wrote "The world nature of our programme is not mere talk but an all embracing and blood soaked reality. Our ultimate aim is world-wide Communism, our fighting preparations are for world revolution, for the conquest of power on a world wide scale and the establishment of a world proletariat dictatorship." While the communists and their fellow travellers in the West campaigned under a façade of "world peace and disarmament" patriotic fascists were in the front line of defence against left-wing thugs and violence.

Communists again attacked a BUF meeting at the Cowen Monument on April 29th and two fascists were injured. When Tommy Moran mounted the platform the communists rushed the plinth and a fierce battle ensued but in a few moments the slender bodyguard of Blackshirts were hemmed in and all available weapons used against them. After several minutes the police succeeded in dispersing the attackers and the Fascists were able to form up and march back to their Headquarters. One Fascist named Moody was kicked in the leg and collapsed when entering the building and another was rushed to Newcastle Infirmary where he received six stitches to an injured lip.

The Newcastle Propaganda Officer, Mr. L.G. Waterman, corresponded from the BUF Clayton Street address to the Hexham Courant on May 5th and wrote: "Sir, With regard to the projected Socialist Agricultural Campaign, I would be obliged if you will allow one the courtesy of your columns to comment on the same. In 'The Clarion' of March 31st 1934, Ellen Wilkinson informs us that Socialism is seriously considering the advisability of intensive propaganda among the rural electorate. The farmer and the farm worker is faced with a hard choice if they have to decide between the two internationalists of Marx and Mammon. Fascism, with its policy of a Nationalism based not on class or sect but, in the fullest sense of the much abused word, claims to offer the only real solution to the problems of agriculture.

"Conservatism cannot offend its task masters, the international financiers, by pursuing the obvious policy of absolute prohibition until home produce has been consumed. However, to deal with the socialist Ellen Wilkinson, in the course of the article referred to she admits that to use her own words, this almost too industrialised movement must be made to realise that here is a sphere too long neglected. She also, rather naively, admits that the driving force is not so much concerned with agriculture as political expediency, for she says 'still we must not let the Fascists get at them first.' With its avowed international sentiments and contacts, Socialism cannot attempt to put into practise the

essential policy of self sufficiency that alone will save British agriculture. They (the socialists) dare not offend their Lords and Masters, spiritual and temporal, resident in the Kremlin, by prohibiting the entry of Russian products for this would result in the withdrawal of the 'moral' support of the USSR and the consequent collapse of the puppet figures of British Marxism.

"I ask the farming community from your locality, to be wary of the sudden solicitous Socialists. In the near future the BUF will be extending their already successful agricultural campaign in the North East area and all classes of agricultural interest will then have the opportunity of hearing our policy and deciding for themselves where their real salvation lies."

There was another attack by Communists, some of them imported from Glasgow and Carlisle, on a Newcastle Fascist meeting in the middle of April. Trouble culminated in a fight in Clayton Street after 9 o'clock in which an 18 year old Blackshirt was felled and was carried by his comrades to their Headquarters amid a booing and shouting crowd of well over 1,000. The Fascist who received head and bodily injuries was Cyril Nicholson of Queensway, Fenham. Several other Blackshirts received severe cuts on the arms and legs. The Reds also had one or two casualties, one of them being knocked out. Others, many much older than the Blackshirts, ran away when there was any retaliation.

Despite the violent behaviour and attacks by communists, or sometimes because of it, people still joined the BUF. "A New Blackshirt and Proud of it" attended a meeting on April 29th and wrote: "Having witnessed the affair at the Cowen's Monument last night, I wonder how long it will take the comrades to realize that their obstructive methods are going to cause a lot of people to go home and begin to wonder just why Socialists and Communists are so frightened to let other folk talk? It was evident that by far the greater portion of the assembled crowd really wished to hear what the Fascist speakers had to say, and I am wondering if that is the exact reason why the assembled hooligans behaved the way they

did. At any rate, I, and a good few others came to the conclusion that there must be something radically wrong with the policy of any Party whose sole sense of safety lies in howling down, and attempting to knock down, all exponents of other views on life. As for their courage...enough said!"

The Reds were again inciting violence during May Day meetings at Windmill Hills outside the Labour Exchange. About a thousand Socialists and Communists were having meetings when five Blackshirts arrived but before they could set up their platform they were attacked by hundreds of opponents urged on by communists. One of the Blackshirts was knocked out and was carried away for medical attention. Another received treatment for head and bodily wounds. A member of the group declared that "The ambush was organised by the Reds who kicked the unconscious Blackshirt as he was being carried away." The Newcastle organiser, Tommy Moran, said: "Our membership has increased by 18 people since last Sunday and people are disgusted at the way in which we are being attacked by Reds." He also added that "the ex-Labour MP for Gateshead, John Beckett, was due in Newcastle today to conduct a series of meetings."

The Evening Chronicle editorial on May 7th derided the speech given by Sir Oswald at Liverpool when he put forward plans to save British shipping and jobs. London Staff Officer Mr. George Erroll De Burgh Wilmot replied: "Your leader column of Monday night poses some frivolous questions on Fascist policy. I will endeavour to enlighten you to our mutual satisfaction. You criticise Sir Oswald Mosley for having 'something original for each locality he visits.' This criticism is not valid, simply because Sir Oswald, in outlining the Fascist plan throughout the country, naturally to some extent lays stress on those points in our policy which effect the audience to whom he is speaking. He would be misguided if he did not. But the main theme of his speeches is always the same outline of Fascist policy. You also criticise the declared "isolationist" policy of the Fascist movement, and have

some flippant suggestions on the sale and purchase of motor cars. The unvarnished truth is that we aim at national economic self-sufficiency. Which means simply that we believe that the British Empire can and should feed itself. Nothing could be less open to misunderstanding."

A review of Fascist activities was given in the Journal on May 9th. and said that "Since April 1st of this year there have been no less than 14 street fights in Newcastle and Gateshead with Communist and Socialist extremists, and casualties - involving bodily injuries to Blackshirts - have totalled 36." All the incidents took place at Fascist meetings as it was the Communists and Socialists who came looking for trouble. The article went on to say "If British Fascist recruiting is affecting the membership of any political Party it is that of the Socialist's. A large proportion of the Newcastle and District Blackshirts are unemployed... who have leapt behind this political drive knowing well that they have little to lose in a re-shuffle of the present economic and social system. Whatever progress is made is mainly among the disillusioned Socialist rank and file." It added: "The opposition methods adopted by their Communist opponents are disgraceful and intolerable" and that Blackshirts "have been felled by Reds who use poles, clubs and knuckle-dusters," and that uniforms may be 'provocative' but the fact remains that much of the violent fighting in Newcastle thoroughfares is due entirely to prearranged Communist attacks."

In conclusion the article ended: "Peaceful outdoor meetings are out of the question as long as Red hooligans and other boys are permitted to continue this outrageous behaviour. Which way, therefore, can any police action lie? Are they to suppress speakers who with all their faults are little more than a collection of young men who wish to expound their theories in peace. Or are they to check the methods of unruly, un-British 'audiences' who strike first and then bolt for protection squealing: "That man was a public incitement."

A reply to the article by ex-Labour MP for Gateshead, John Beckett, said he wanted to "point out that with regard to peaceful meetings, we have held over 50 meetings in the area since April 1st and only 14 of them have been disturbed. Usually the good people of this area are quite prepared to listen to any case in which they are interested and the disturbances have been due to the damaging and devastating analysis of Marxian theory and practice which have proved so harmful to Socialist membership." The news article contained some criticism of the new and young BUF speakers and he wrote "Gibes about young speakers are surely unworthy of your columns. The Conservative and Labour Parties would both be very glad to have the type of young speaker we are developing and surely the author of the article cannot have attended open air meetings held by these parties or else he has forgotten the very poor type of speech made outside their national and professional ranks."

Mr. Beckett addressed a BUF meeting held at the Hotspur Assembly Hall on the evening of May 16th. Fascists in black shirts acted as stewards and there were also many girls in uniform. It was first proposed to hold an open air meeting on the Links but the Council had refused permission.

"Communists and Socialists," said Mr. Beckett, "stated that Fascism was the last resort of the Capitalist movement, but that was not so. Fascism was the modern movement for the modern man and woman and would restore England's prosperity by modern methods.

"It was not necessary," he continued, "to wear the Blackshirt in order to be a member. The Blackshirts were active members but they were only about 20 per cent of the total membership. Their members consisted chiefly of two types, those of the speaker's own age who had served in the war and, secondly, those who were too young to take part in the war but suffered through it by having to face an apparently hopeless future. Fascism would give them their rights!"

A young woman speaker in uniform appealed for new members with the hope of beginning a branch of the Fascist movement in Whitley Bay. She denied that the movement was financed by Lord Rothermere, Sir Oswald Mosley or big capitalists. "All members," she said "paid subscriptions and provided their own uniform."

Mr. Burgh Wilmot was again defending the BUF in *The Sunderland Echo* in July when he wrote "Your correspondent signing himself 'Youth' maintains that Fascism intends simply to strengthen the present economic system and preserve its injustices. Far from this being so, Fascism offers a way out of capitalist chaos to an ordered economic system, preserving only that which is acceptable to the community as a whole and replacing that which is distasteful to them. There is moreover opportunity in Fascism for initiative, and the development of individual ideas, which is not to be had in Socialism, based as it is in the first place on resentment. Your correspondent apparently finds the truth 'amazing' judging by the reference to Bernard Shaw. If he suggests that Shaw's 'Intelligent Woman's Guide' is either Socialist or true, I cannot agree with him. It is long since I read it, but I still remember that everything that could possibly have been amazing, or shockingly true, was so diluted as to be quite innocuous. When your correspondent learns to face reality (or truth) for what it is, and not for what he would like it to be, he may withhold such travesties of the truth as the allegation that Italian Fascists ever persecuted the Jews." Many years later, BUF member George Burgh Wilmot was to pass away at Torbay in 1992 after many years service to his cause.

Sunderland BUF member John E. Theodorson set up a box and had started addressing a meeting in an open space near the Police Station on May 9th when he was knocked off his stand and head butted by Communist Thomas Jobling. In an attempt to stop Theodorson speaking, a section of the crowd had rushed toward him and Jobling said he had been 'pushed' against the complainant. Later that month the magistrates accepted his

version of what took place and said there was no deliberate assault and dismissed the case.

Gateshead's first Labour MP John Beckett made a return visit to speak for the BUF at the Town Hall on Monday the May 14th 1934, he had joined the Blackshirt movement that March and was appointed National Liaison Officer. The previous night, Beckett had spoken at Cowen's Monument in Newcastle when the usual left-wing extremists tried to stop the meeting. It was an innovative meeting as the Home Secretary had previously said that the wearing of the Blackshirt uniform was provocative and, bearing this in mind, it was decided by the BUF to hold the meeting in Newcastle without wearing any uniform and withdraw their stewards who were also accused of inciting the violence of opponents. Two BUF officials had been sent from London to see whether Newcastle Fascist conduct and speeches were responsible for recent fighting.

The result was chaos and very nearly murder. Stones and other weapons were hurled and the police had only sent along a few officers to keep order. Two communists were arrested and a knuckle-duster was shown in court. Violent scenes had ensued all the way up Clayton Street to the BUF Headquarters. A Fascist youth and a young woman friend had set out to walk home along Blackett Street when beside Grey's Monument they were surrounded by a hostile crown of hundreds. The young man became involved in a fight and a score of Blackshirts dashed from their office to his aid and turned on their enemies and laid into them. Mounted police officers were called to break up the fighting. Another fight broke out in Westgate Road when a crowd of Red roughs made an attack on six Fascists, one was a young woman. One of the Fascists, Stanley Bell of nearby Swinbourne Place, was pulled down and kicked repeatedly on the head and was taken heavily bleeding and in a state of collapse to the *Newcastle Journal* office by a reporter and was followed by an intimidating crowd. Tommy Moran, the Fascist Organiser, said that the police had promised to ensure free speech at the

Cowen Monument provided there was no Defence Corp, but they had not provided the means to do so.

A number of bystanders, not connected to the movement were also injured. A young Gateshead girl who happened to be wearing a black coat was struck on the jaw by communists when near the Cowen Monument. She immediately went to the BUF office and joined the branch and 71 year old Thomas Grey was knocked down by the raging Red crowd and taken to the Royal Victoria Infirmary.

The Fascists were not deterred and the next day, a party of 50-60 Blackshirts were given permission to march from their office in Clayton Street to Gateshead Town Hall but the Reds again caused trouble. Constable Hardwick said that at 7.20pm on Monday night he was on duty in Swinburn Street when the Fascist march passed the entrance to the Police Station on the way to the Town Hall. Two men, John Clarkson of Leonard's Court and William Young of Saltwell Road were shouting remarks and throwing stones. Blackshirt John Collins, who had gave his address as the BUF office in Clayton Street, was in the rear of the marchers and said some people began to kick and strike him from behind, he turned round and "squared up" to the crowd when Clarkson and Young began to punch him and he said: "Naturally, I had to slam out in self-defence" and several blows were exchanged. Clarkson and Young were arrested and Collins re-joined the column going to the Town Hall. The fascists were attacked with stones and sticks and one small child received head injuries and other members of the public sheltered in the police station while the Red mob passed.

Mr. Beckett commenced his speech by saying: "It is a matter of great regret to our movement, and the public as a whole, that so many people who have bought and paid for tickets to come to this meeting have either - if they are responsible and law abiding citizens - been quite justifiably nervous of coming to the meeting after all the threats that have been made and troubles that have

John Beckett

arisen in Newcastle in the past month, or have been unable to gain admittance to the building. To the extent of minimizing the attendance here tonight, the Red Terror in Newcastle and Gateshead have been successful, but to the extent of stopping propaganda on Tyneside and the North-East coast, I can assure you that these methods will not be successful. More and more Blackshirt meetings will be held, and the opposition overcome as in every other industrial area."

Mr. Beckett went on to recall how "he had been returned for Gateshead as 'a young and innocent man,' who thought he would be able to fight the case of the depressed workers. Apart from a large number of individual unemployment and pension claims, which any M.P. worth his salt would deal with, I do not think I can claim that during the four and half years that I was able to carry through, or even support of the carrying through to a successful conclusion, one single Act of Parliament or one single piece of legislation or action of any kind likely to be of the slightest benefit to either the people of this country or the people of my constituency."

Explaining some of the reasons for his conversion to fascism, Mr. Beckett had said: "In the Parliamentary Labour Party I discovered a new low level. Some would have been decent had it not suited their comfort and economic position. Those who mattered would have nauseated a cosmopolitan crook. Some sold themselves openly for a job; the majority succumbed to a double whisky and a condescending nod. Their self-satisfaction and sluggishness was colossal. They cared for nothing for the

cause or promises they made from the platform. The Labour Party could steer them to disaster; they were too lazy to think; too coward to kick. I saw my friend Wheatley martyred, Mosley derided and Maxton driven out like a pariah. These things sickened me. I cared for England and its people. Fifteen years in the working class movement taught me that the workmen want security. They do not want to govern. I put on my black shirt and submit to that discipline which alone can bring salvation, and prepared to take up my small part in building a land where the myths of committee government, and freedom to slack and starve, are replaced by the stern and practical realities of fascism and manliness. Courage, thought, and discipline are weapons with which security, peace and comfort can be obtained."

The meeting closed with the singing of the National Anthem that was interspersed with boos and an attempt to sing what sounded like "The Red Flag." A crowd of many thousands waited outside the Town Hall, among them were hundreds of Communists and roughs. The 32 Blackshirts got into marching formation outside the Town Hall and, singing patriotic songs, marched down West Street, High Street and across the Tyne Bridge to the Newcastle Headquarters in Clayton Street. The police were thanked for their assistance. It was later reported that Labour's Councillor White had tried to be critical of allowing the Town Hall meeting and asked what the cost of policing the event had been. Chairman of the Watch Committee, Alderman Ritson, replied that only two policemen came from Newcastle and that the cost was nil owing to a mutual agreement. He said "Councillor White's squib was a damp one, being fired against a movement with which he disagrees, to wit the Fascists. The cost to Gateshead was nothing additional as no extra pay was due to the police."

Middlesbrough's BUF membership was growing and one Linthorpe Blackshirt wrote to the North Eastern Daily Gazette in February to say "We Fascists, while upholding the right of liberty, deplore and seek to control the unregulated licence which is

destroying the moral fibre of the nation. Surely, a system of government which is allowing licence to predominate and to control the nation's affairs is wrong, and to clear the misuse of licence the system of government must also be changed if the root of the problem is to be got at. Fascism is a modern creed for a modern age." In May, he answered why Reds fight at British Union meetings. He wrote "Conservative meetings are rarely, if ever, held in area's where the speakers are likely to encounter physical violence and their indoor meetings are almost entirely supported by members of their own organisations. Consequently, the Red opposition and interruptions do not reach anything approaching the degree to that which the Fascists are accustomed to expect. The Blackshirts operate in an entirely different manner and under different conditions. They hold their meetings in every area where their organisation exists and the Communists, realising that in Fascism lies the only existing menace to their movement, organise violent physical opposition to wreck Fascist meetings and to prevent their policy being explained. The Reds go to these meetings armed and ready for violence and, without physical provocation, do not hesitate to start a fight."

Another article in the Daily Gazette suggested that Blackshirts were "enemies of law and order." He wrote back and said "Their function is to preserve order at open air meetings which they hold, and their defence units are disciplined to carry out this work. They are a defensive and not an aggressive organisation. There has never been any attempt on the part of the Blackshirts to disrupt any political meeting held by any other political party - their only concern is to preserve order in the face of violent and organised Red opposition at their own meetings. Writing as an ex-Conservative with considerable experience of open-air meetings in this area, I can definitely state that to hold a Conservative or Liberal meeting in some quarters of this town is virtually impossible. Communists and Socialists can always get a hearing, but the patriots and loyal parties have their meetings wrecked with monotonous regularity. Instead of giving way to the Red element, the Fascists meet it and uphold the principle

of free speech, which has undeniably perished in many parts of the country."

Sunderland BUF member Cecil Pratt had resigned his membership of the Liberal Party in October 1933. He had been both chairman and secretary of the Liberal Party in Sunderland. Before returning to his native Sunderland 14 years previously, Mr. Pratt had held a full time post as an organiser of the Lloyd George Liberal Association in Manchester. He had fallen out of sympathy with the party political system and was turning more to Fascism as a policy for youth and action. He was a member of the union for tramway men so he may have worked on the local trams. He had said: "The party game is wrong. It is dishonest because the parties are simply out for votes, instead of making the country's interests their chief aim." On May 16th 1934 he was to write that Fascists wanted a fair deal and said concerning an article in the Echo: "I read with interest your lead article on hooliganism at meetings. As one who has had considerable experience of this sort of thing long before the British Union of Fascists existed, I would like to make some observations on the subject.

"Conservative and Liberals are still permitted to hold meetings of sorts in the open air, but only if they refrain from mentioning Socialism except in terms of idolatry. They must utter no word which is liable to hurt the delicate feelings of the creatures of the Socialist and Communist parties who attend meetings with the sole intention of creating disorder. Most decent minded politicians capitulate to this rabble.

"Liberal and Conservative party organisers are compelled to limit outdoor propaganda considerably because of a disgusting anomaly which should have been stamped out years ago, and now, when a body of men are not prepared to forgo the hard won privilege of free speech taking up the cry of the Socialist Press to ban Blackshirt meetings instead of noting the fact that only the Socialists have meetings free from disorder. I do not, of course, refer to their private meetings and conferences.

"Only the Socialists can post bills at election times without having them defaced or torn down. The Socialists alone are responsible for inflaming their mob spirit with the half truths with which we are familiar. I could cite scores of instances of hooliganism at Anti-Socialist meetings. My Mother was once dragged from a rally and kicked, because she dared to criticize the present Prime Minister at a parliamentary by-election. At that time Mr. McDonald was the darling of the Socialists, my mother was 59 years of age.

"The Blackshirts are well able to take care of themselves and are fully alive to the fact that the police are in a difficult position for they know as we do that the hooligans welcome arrest as it signifies martyrdom for the cause of Socialism, and stamps them as heroes in the eyes of the poor things that they mix with. Some of the shrewdest politicians in the country, men of all parties, have spoken of the tremendous growth of Fascism. That being so, we claim a fair deal, all we ask is the right to defend ourselves, being British to the core."

Soon afterwards a number of Wearside writers declared that Fascism was not British and it resulted in a number of BUF responses. John Theodorson, responding from their office at 28 Sunniside said: "First of all Mr. Pratt's statement was that Fascists are 'British to the core.' Neither of your correspondents attempted to deny this. It would be futile for them to do so, the patriotism and loyalty of the members of the British Union of Fascists is well born out by the large number of ex-servicemen who number among the members of this organisation. Again one of the conditions of membership of this organisation is that the person applying for membership must be a 'British citizen, loyal to King and Empire' – Fascists are British to the core! 'Fascism is not British' is the cry of your correspondents. The fact that Italy was the first to adopt Fascism does not label fascism Italian. If for this reason alone we must reject Fascism then we must also reject Liberalism, Socialism, and among other things, even Christianity."

Cecil Pratt then took up his pen to say "What Germany and Italy have to do with the totally different policy of the British Fascists only your correspondents know. They are like all our critics, absolutely ignorant of our policy, or they would not write such childish piffle. Both of these nearly politicians would deny us the right to propagate our policy, but we find encouragement on reading the sixth letter from a Socialist organisation. The Workers Educational Association claims that 'the maintenance of freedom of thought and speech is a vital national interest,' and further that their work is 'based upon the principle of unprejudiced examination and free discussion.' Mr Robinson of course, will not associate himself with the latter arguments, as Socialism originated in Germany. However, the point made in the first place was that if a stand was not made against the organised breaking up of meetings the Socialists would soon have a clear field to continue their campaign of class hatred, bribery, intimidation and a 'love of other countries (but their own).' We are making the last stand against them. It is not the black shirt that causes the disturbance. We have had meetings broken up when we have appeared in ordinary attire. Even Mr. Samuel Storey MP has been treated shamefully by his Socialist opponents, and that is the whole point of my original argument."

The following day branch officer John R.M. Dalgliesh said that there were many complaints about the ungracious and disgusting manner in which Sunderland Council refused to present the freedom of the borough to WWI Admiral of the Fleet Earl Beatty after granting him the honour in 1919. He said everyone knew the decision was simply the feelings of a few "internationalists" who think about England in their dreams as an "internationale of Hottentots." The British Union of Fascists in Sunderland set about organising a petition of 50,000 names to present to the council and demand the council honour its obligation and forms were made available from their office at 28 Sunniside.

On May 31st BUF members attended a meeting to hear an address by Area Officer George Vincent who had been confirmed as in charge of activities in the North of England. He announced that an intensive door to door canvassing campaign was to start and a series of indoor meetings had been planned for the coming months. Major E. W. Ormston, DSO, formerly of the Durham Light Infantry, had been placed in charge of Fascism in Newcastle and on Tyneside. Captain Vincent Keens was appointed his second-in-command.

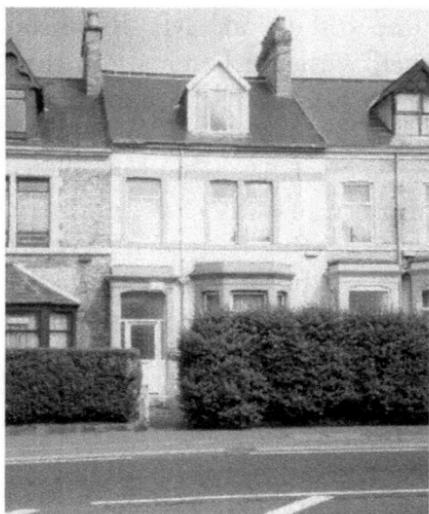

Former BUF office at 8 Abbey Terrace, Durham Road, Gateshead.

On June 1st 1934, Sir Oswald Mosley spoke on a Friday night at Usher Hall in Edinburgh that was attended by groups of Newcastle and Gateshead Blackshirts who acted as stewards during the meeting. In the early hours of the following morning the Gateshead BUF office at 8 Abbey Terrace in Gateshead (now part of Durham Road) was found to have been damaged by communist criminals calling themselves "Greyshirts" intent on murder.

The property had been provided by two teachers who were local supporters and was in use before December 1933 when the branch propagandist Michael Goulding lived on the premises. The damage and break-in took place when 14 members had travelled to Edinburgh to support a Mosley rally. Member Arthur Henry Baggs, who lived at 20 Summerset Street at the Sunderland Road end, had locked up the property in the evening and when he returned at 2am in the morning to prepare a meal for the returning Blackshirts he found the place in disorder and all the gas fittings had been left on in an attempt to cause as much harm and damage, if not murder, as possible and regardless

of homes of neighbours on either side of the property in the terraced street. The office of the District Leader Mr. T. Clabbey had been ransacked and a Union Jack stuffed up the chimney in an attempt to keep the gas concentrated in the room. Many years later, when war was declared, Arthur Baggs left his job working on the trams in Gateshead, where his father was employed as an inspector, and joined the army. He later became a Quarter Master in the Territorial Army. His son's wife said that "Not only was he a good father-in-law but also a good friend." She recollected that he never drank alcohol, loved cowboy books and was a good family man. He had also organised dances in Wrekenton, something that he had enjoyed doing. Arthur also helped a number of widows with pension appeals and was successful in getting them increased. It was said by the family that his grandfather came from Weymouth and that he had been deported for helping form a union. It's possible his grandfather was one of the Tolpuddle Martyrs. Arthur Baggs died in 1949.

Fascists were continually accused of promoting violence at their own meetings in the press. It did not make sense to do so at a public meeting when you are trying to convert the audience to your point of view but it did not stop *The Sunderland Echo* from saying so on June 11th. A local fascist wrote and said:

"I was greatly interested in your "Curb the Fascists" article that appeared in last Monday's *Echo*. You say that intense indignation has been roused by the alleged brutality of the fascists, and you say that these methods are foreign to British politics. You also state that the Government should put a stop to the wearing of black shirts, and that we have an adequate body of police in this country capable of maintaining law and order.

"If any party takes and pays rent for a building to hold a meeting that party expects the right of being heard more so than if a meeting was held in a public street. Then I ask you: Is any sensible party going to spend sums of money and to allow other parties to create disturbances in the building that they have paid for?

"The Fascists have held at least two meetings in church halls in Sunderland, yet we have found that there are a certain class of people in other parties who even attempt to turn the church into a stadium. This is why the Blackshirts are proud of their defence force. I ask you, Mr. Editor, who creates the disturbances at these meetings? Surely it cannot be the Fascists because it has been proved that these disturbances have been started before their arrival and on their departure.

You say that these methods are foreign to British politics. Then why don't you attack the foreign parties. You must know that there is no British Union of Communists, yet the British Union of Fascists has to put up with all the insults of their fellow Britishers while the foreign (Communist) party is allowed to do all the damage they can, and will do, as long as the Fascists are receiving the blame for what they are doing.

"You state that we have an adequate body of police to maintain law and order. Do you not know that the police are attached to their own towns and that under the present circumstances seeing that communists are imported in from all districts when a Fascist meeting is advertised there is not an adequate body of police at hand to maintain law and order? This is why the BUF Defence Force was formed, but it is never used except when communists call for it to be used.

"I challenge any person to attend a Fascist meeting and show me where a Fascist has interfered with anyone, even if he is threatened, as we are when at meetings. We don't cry for mercy in a fight, we cry for justice and a fair deal."

The BUF held a great rally at Olympia on June 7th that was exceptional for its organised communist violence, but the press once again took the side of the perpetrators of it. Newcastle Fascist H. Bradley said "I was at Olympia and saw as much as anyone. I witnessed the horrible spectacle of some of my greatest pals slashed in the face and disfigured by razors and I witnessed

heavy bludgeons used on defenceless men. If I was a brilliant writer, I could make some fine sob-stuff out of that, but I am not trying to do so. It is pure hard fact, and it is the absolute truth. Fascists are not allowed and do not want to carry any kind of weapons. It is only their self-defence that allowed the leader to put across his brilliant address. Again, I wish you had been there and had seen for yourself. Lord Lloyd sat at the front part of the hall near the speaker, and could not see the events which led up to anyone being ejected, and I am afraid that the Press representatives were similarly placed. Therefore, I cannot allege that either are misrepresenting what they thought they saw, but I might add that it seems suspiciously like it."

The left-wing violence used against the Fascists actually gained them support. One "Soldier's Widow" wrote: "I am afraid public sympathy is being forced round in favour of the Fascists. I am not a Fascist, or likely to be one, but if I were judging Fascism by what I have read in the 'Echo' my vote would go to the men in black shirts."

Two uniformed members held a meeting at Harbour View on Wednesday June 13th and eventually had a fair number of people around them. It included some Communists but apart from some verbal exchanges the meeting went off without incident.

Derisory comments on BUF policy claimed that a self contained Empire, that could fulfil all our needs, was not possible and was answered by Mr. De Burgh Wilmot of the press department on June 21st. He said it was possible to make the Empire self contained and that a move in the direction of agricultural development in Britain was essential to the continued health and life of the nation. But, he added, it was only possible if proper government, with authority and organisation, was first installed in Westminster. He also refuted the allegation that it was their intention to "pull everything up by the roots" but said what is good will remain and be utilized. What was bad would be uprooted and replaced. Team work, he said, must be part of our

daily life if we are to pull through. We cannot afford to forget about it until a time of crisis.

With a Town Moor meeting pending with Sir Oswald as the speaker, member Maurice Taylor wrote to the Journal to ask why the paper had thrown its influence on the side of the Communists. He asked how could they condone razor-slashing like that which took place against Blackshirt stewards at the Olympia meeting. He added "The conclusion that you are for the Communists has been reached only with the greatest of unbelief, but we Fascists, lovers of King and Empire, freedom and a Greater Britain, cannot come to any other conclusion when you allege that there was Fascist brutality at Olympia... I write in consequence of our meeting on Sunday on the Town Moor. There you will be able to see who commences the trouble at our meetings, who attacks our stewards with bludgeons and razors and who causes all the disorder. Socialists are as much to blame as their 'redder' friends because they condone such filthy attacks upon our members."

The BUF meeting was arranged for the Town Moor on June 24th 1934 but Mosley decided to cancel the event. He reached this decision out of consideration of the tens of thousands of women and children who would be at the Town Moor for Race Sunday, an annual Tyneside family festival. There would also be communist and co-operative movement speakers. The Socialist and Co-operative principle speaker was to be Mr. Fred Longdon MP., a close friend and colleague of Sir Oswald's during the days when they were both Socialist candidates in Birmingham.

The anti-fascist communist "Greyshirts" were also expected to cancel their meeting on the Moor but refused to do so. Concern about the meetings had been shown by the local authorities and Mosley wrote to the Home Secretary saying that "In view of your statement that Saturday June 24th on Newcastle Town Moor was essentially a festival for women and children and it would be difficult to maintain order... I have given instructions

for the cancellation of the meeting. It will be held on a later occasion in circumstances in which no danger to the safety of women and children can arise."

The rival creeds of Fascism and Communism were simultaneously expounded at Harbour View, North Shields, on July 4th and a sensation was caused when on the Fascist bench dressed in his Blackshirt a man appeared who for years had been a prominent North Shields communist. The communists began to hawk around an "Anti-Fascist Special" and there was a laugh when one of the communists wearing a red shirt attempted to sell the paper to the three Blackshirts. The meeting was reasonably good humoured and there was no occasion for interference by the police who appeared to find it as entertaining as most people did.

It embarrassed the local Communist Party and Secretary Mr. A.S. Bengall claimed that the Blackshirt had never at any time been a CP member. The former Communist was James Nichol who lived at 14 Elmwood Road on the Ridges Estate, one of the poorer areas of North Shields that was due for demolition. He replied: "I would definitely point out that for a considerable number of years my activities have been given in the interests of the National Unemployed Workers Movement and Communist Party who are affiliated. The positions I held were: NUWM-Secretary, chairman, treasurer and organiser. Communist Party-Secretary for Claims Committee. I have seen the fallacy of these movements and as they are definitely working against the interest of my country I have decided to don the 'Blackshirt' and have become and active member of the British Union of Fascists who without doubt will soon obtain their desire of a greater Britain for which they have so gallantly striven. The Union Jack is my flag and by it I stand. Hail Mosley and a greater Britain!"

Mr. Nichol later wrote: "The Communist and N.U.W.M. clique seem to have a very short memory. I have fought tooth and nail to secure the food and rent to keep their homes going, and because I am now putting my country first I was set upon last Friday

night upon my way home. It is because I have experienced the Communist procedure that I have donned the Blackshirt and will in spite of any threat continue to do so."

During this debate, "Northumbrian" commented on "Anti-Fascist" criticism of Mussolini and Italy. He said: "Anti-Fascist" shows a lamentable ignorance of the affairs in both Italy and Russia. The comparison made with regard to the employment in these countries is quite absurd. Italy has no slave labour; in Russia it exists to an enormous extent. Everyone has heard of the frightful timber camps in Northern Russia where priests and others with Christian views slave and suffer under the most frightful conditions.

"From a personal knowledge of Italy I know the benefit Fascism has brought to Italy. Conditions have improved tremendously since 1923. When the Fascists took over government Italy was in a state of anarchy, Italy today is in every way one of the greatest nations of the world. In conclusion 'Anti-Fascist' asks 'What have the Fascists done to make a greater England?' The fascists at least have placed love of country first, which is certainly more than the Communists have done!"

The meeting was re-arranged for July 29th when tens of thousands gathered on a brilliant Sunday afternoon to hear Mosley at the Town Moor. Despite the heat, the crowd listened with attention. There were some hecklers, but their shouts were hardly heard owing to the amplified speaking system. Viewing the great and orderly crowd it was difficult to realise that it was held in the face of threats and violence from communists. For many weeks the Newcastle Red extremists had attempted to stir up working class opinion against the Blackshirts and said that the meeting would not take place. The threats of violence had failed in the face of the disciplined Blackshirt organisation... and a tribute to the common sense and decency of Newcastle people. From the moment when the first Blackshirts marched onto the Moor people began to group themselves around the

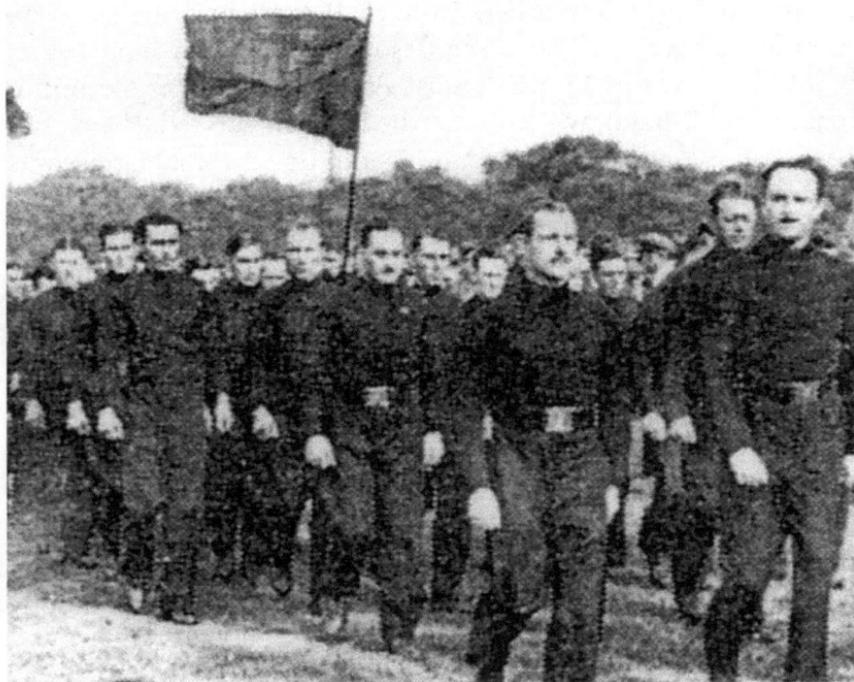

Sir Oswald Mosley and the Blackshirts - Newcastle Town Moor in 1934

platform. When Mosley arrived punctually at 3.30pm crowds pressed forward and cheered him on the way to the platform, it was a great reception. Some two or three hundred Reds also took up position near the platform but their insults and gibes at the Blackshirts were taken in good humour, it was obvious that the overwhelming majority of the vast audience had come to hear Mosley. His decision not to hold the meeting during Race Week because of Red threats of violence and its dangers to women and children holiday makers must have impressed Newcastle people with his desire to prevent disorder and violence. Throughout the meeting, despite the heat, the crowd grew in number and enjoyed what Mosley had to say. Only a small section of the crowd was inconvenienced by the ridiculous jeering of communists.

The Reds were furious at their inability to incite the crowd to violence or to disturb the Blackshirt stewards which had a subduing effect on them. There were about 450 Blackshirts

in uniform and many others in normal dress but there was no disorder. There were no casualties, except that a young fascist had to be attended by the Fascist Ambulance Corps for minor injuries to his hand, while one of the hecklers fainted. Police and Fascist ambulance men went to his aid, but the anti-fascist was well enough to spurn the drink which the Blackshirt had offered him and accept a drink from the police. A North Mail journalist spoke to Mosley while he was waiting for the Blackshirts to form into marching order at the close of the meeting. "All our meetings have been quiet like this recently," he said: "You will always get a small body of hecklers. The majority of the public, however, will listen to our policy even if they do not agree with it. It is significant that this meeting has gone off so quietly, especially when it was the meeting which was expected to bring trouble," he added. A Blackshirt official said they had banned their women from the meeting, but there were a number of other women in the crowd, including a row in front of the small body of hecklers.

The trend of the meeting was lightly humorous rather than charged with any tense political atmosphere. Hecklers were heard to describe Mosley as "Public Enemy No. 1" and copies of a communist paper were held up. Mosley spoke quickly and clearly for about an hour and only stopped once for interruptions. In his speech he declared "That they stood for a movement which challenged every one of the old parties, every one of which they believe had failed them. He was speaking for the most part to those who belonged, as he had himself, to the Labour Party, and to some who might be thinking of voting Labour.

"Now I am going to put it to you," declared Mosley, "that if you do vote for a Labour man exactly the same thing will happen that happened on the last occasion. You will be let down. Therefore, I have come to ask you to support a new movement. This new movement is the only hope of raising the standard of living in this country and would be able to find an outlet for the goods the country produced." He said that the Socialist Party were

pursuing an internationalist policy instead of the national one that was necessary for Britain. It was then that some of the crowd pressed forward but the Blackshirts linked arms and forced the struggling crowd back. "Just a moment my friends" called out Mosley, "We are having a little of that 'Red hooliganism' which continually tries to deny us the right to speak." He went on to say there was no other movement except that of Fascism that could hold a meeting on Newcastle Town Moor in opposition to the Socialist and Communist elements. "You are having an illustration of how necessary it is to have a Blackshirt movement to meet Red Terror," he declared.

He added: "The Labour leaders who are appealing to you are exactly the same men who held office in 1929-30 and kept office by promising to deal with unemployment. They said that the last time that they did not get a majority in the House of Commons. But why did they not produce their unemployment policy in the House of Commons and go to the country for a new mandate? The truth was they had neither the policy or the will to fight, and exactly the same men are leading the Labour Party to-day. I wonder how long people are going to return to power these dodgers who will promise anything in opposition and never do anything for you in office." He continued "We do not take our orders from Berlin. We don't need to go abroad to learn, because we have a British policy for a British future. We do not require any foreign model."

Question time proved the success of the meeting. From all parts of the crowd came questions on BUF policy that Mosley had referred to during his speech. Mosley answered questions for more than half an hour. One referred to "blood on the continent" brought a challenge from Mosley. He declared that two million had been executed in Soviet Russia while a few people only had lost their lives in Germany. Trade Unionism would be encouraged under fascism, he told one questioner, but "we would remove a few political adventurers who seek to advance their own interests at the workers' expense."

He continued: "It is often said that Fascism leads to war, but that is one of the silly lies told about Fascism. Lately, there was a possibility of war similar to that in 1914. But war was averted, the reason being that the two countries principally concerned, Italy and Germany, were linked under a system of government which prevented war. But suppose these two countries had been living under democracy. Public opinion would have been inflamed and war would have ensued. Fascism leads to peace and not war," declared Mosley. Soon after this part of his speech men, probably Communists, spread the rumour among the crowd that a special bulletin broadcast from London had announced Austria and Italy had just declared war on Germany. It had upset a number of people until they learned that the rumour had no foundation.

Other points in his speech were: British crews and white crews for British ships. "We want oil and petrol for British needs from British coal." A member of the Durham Miners Association cried out "Fascism is the last hope of Capitalism," Mosley replied: "I tell you Fascism is the last hope of the working class." Britain, he said, must buy from those who buy from Britain. The singing of the National Anthem was impressive and stirring and it was a splendid close to a great meeting. Promptly at five o'clock Mosley marched at the head of his Blackshirts along Barras Bridge, thousands of people pressed forward to see him. Mosley and many of the Blackshirts stopped for tea at a Haymarket café. The stewards never once had to deal with ruffians such as they had met some months previously. It was a historic gathering worthy of the many great meetings held on the Town Moor. The *Newcastle Journal* wrote "Sir Oswald Mosley's visit was a welcome change. It was the biggest fascist rally that had been seen in the North since the movement was founded in October 1932 and it must be said that, on the whole, the Fascists were a presentable and smart a type as ever donned a coloured shirt."

The Evening Chronicle lead article wrote after the meeting that there had been a parting of the ways between the press baron Lord Rothermere and the BUF since he had discovered that Fascism

was anti-conservative! In true Conservative fashion, Rothermere then quickly took up a different and opposing point of view in the rush to save the profits of his business empire. Another of the same political mould was the industrialist Lord Armstrong who at a Newcastle Tory garden fete held at Blagdon Park on July 7th 1934 gave a "warning against Fascist danger" and said that people should not follow the "foolish guidance of Sir Oswald Mosley."

Not all Town Moor meetings were so peaceful. Archie Wilson was a member of the prewar British Union London Drum Corps that went to Newcastle in support of a Mosley meeting on the Town Moor. There had been a large contingent of communists present. At the end of the meeting the Blackshirts formed up behind Mosley and the band to march back to the local office. As they marched along the main street, the Reds took up position down the side streets and, as the Blackshirts passed the top of each one, a shower of bricks, bottles and rocks were thrown at them by the Reds. One half brick hit a woman Blackshirt on the head drawing blood. Mosley saw this and, what's more, saw the Red who threw it. So he immediately left the march and dashed over to the guilty party and proceeded to give him a thrashing. His Red comrades were so shocked by this they did nothing for half a minute and then started to set about him. The boys in the band saw what was happening and Archie Wilson, who was a bugler, and some of the others dashed over and began to extricate Mosley from the melee. As they were heavily outnumbered, Archie felt no compunction about using his bugle as a sort of knuckle-duster, punching left and right with it. After several minutes they managed to get him back to the comparative protection of the marching column and make it back to the DHQ. As they marched back Archie looked at his right fist and noticed that with the impact of the bugle on the heads of the reds, it had been flattened and shaped itself perfectly round the contours of his knuckles.

At the time of the Town Moor meeting, Newcastle member Ken Dick was one of three Blackshirts who had been chosen to tour

the agricultural area of North Anglia and districts in the South West of England and spread BUF policy among the farming community. Although disappointed not to be there he went with local members to other great rallies such as two of the five held at the Albert Hall, Olympia, Hyde Park and Edinburgh.

On the Second Anniversary of the founding of the BUF Tommy Moran was transferred to the staff of the London National Headquarters and Jack Lynne was appointed District Officer. During those first few days of October the regular meeting took place at the Bigg Market opened by Fascist Bell and Mr. S.C. Crossley spoke for about 40 minutes and was clapped at the end of the meeting. The usual Newcastle Central office Tuesday policy class also had a large attendance.

Three Blackshirts were at Harbour View, North Shields, on July 4th, to hold a meeting. One was James Nichol, who had for many years been a prominent North Shields Communist, wore a Blackshirt and spoke from the platform. He was greeted with a howl from the communist element in the crowd but went on to describe his conversion and announce that he would continue his devotion to the working classes. There was some heckling but the meeting ended without any interference by the police. On the following Wednesday, July 11th, the three BUF men arrived and started addressing a large crowd of unemployed men when a meeting was started by communists alongside them. Their efforts were directed towards shouting down the Blackshirts during a dinner hour meeting and trying to incite the crowd against them and, after burning a copy of the fascist newspaper, approached the BUF speaker and tried to shove him off the seat he was standing on. A melee ensued and three Reds were arrested by the police.

A Newcastle reader of the Shields News wrote he had followed the James Nichol controversy and he "can definitely state that James Nichol had worked for the Communist Party. Nichol had the courage to come out into the open and all sensible people

will appreciate the fight he must have before him. I as one of your readers wish him the best of luck and would implore upon him to stick to his guns, i.e. The Union Jack and Britain first.

He added: "Now regarding the scene at Harbour View yesterday, I saw everything that happened. First of all three Blackshirts were quietly distributing literature, and no one can say they misbehaved themselves. Secondly, their speaker took his stand and was greeted with boos and hisses from a small section of the crowd. I was delighted to see and hear that a large section of the crowd went there to see what the Blackshirt business was all about. They heard and read both sides of the Olympia affair and I am sure we all see what Communism would mean if it came to England after what happened there. Let us have free speech, especially from the men who put Britain first."

Later that month, a communist anti-fascist speaker lost his entire audience to a Blackshirt meeting at the same spot in Harbour View, North Shields. This time the Blackshirts were 24 strong and Major Ormstone and Mr. John E. Theodorson held their meeting not far from the communists. As the first speaker, John Theodorson, warmed to his subject the audience that was surrounding the opposition platform began to drift over to the Blackshirts and after 20 minutes there was no one listening to the anti-fascist. Mr. Ormeston had only been on the platform five minutes when the anti-fascist gave up and climbed down from his stand. The mixed crowd of about 400 continued to listen attentively throughout the meeting and a crowd of children enjoyed joining the Blackshirts as they formed up and left the area. There had been no disturbance from the large crowd. For a short while, the BUF had rented an office in the town for enrolment purposes but by March 1935 the organising was done from elsewhere.

Miss Grace Hunter, the daughter of Mr. J.P. Hunter, District Branch Officer of Chester-le-Street, passed away on Wednesday August 8th 1934 following an attack of diphtheria. Her funeral

took place on a Saturday and the Tyneside area of the BUF had turned out a very smart unit of picked men of the Newcastle Central Branch Defence Force in her honour. At the cemetery, the officer in charge of the unit, stepped up to the grave and laid a beautiful wreath of white lilies on behalf of the party and the unit gave the Roman salute. Sadly, the grave (H812) near the war memorial does not have a headstone but is two plots away from Regimental Sergeant Major E.F. Beveridge.

The Sunderland Echo and Shipping Gazette carried an apology to the BUF on August 24th. 1934. It concerned an article in the paper on July 28th by a Mr. Hugh Longdon who had written in the paper that "Blackshirts not wearing uniforms were allowed to carry knives and those who did might only carry knuckle-dusters." He apologised and said the information on which he had based his remarks "were without foundation."

At the end of the month it was reported that good work was still being carried on throughout Tyneside. Paper sales for *The Blackshirt* No 69 were good and the Central Branch was sold out, and it was wondered if any other part of the country could beat them. Mr. Thomas O'Brien, one of the first Blackshirt members in the Tyneside area, had become a very able speaker and had addressed a large crowd at a meeting in Sacriston

In early August 1934, a small group of members went to Jarrow. District Branch Officer J.O. Tong of Sheffield, Assistant Propaganda Officer J.E. Theodoson and SPO G. Cameron-Simpson took a supply of 1,200 leaflets advertising a meeting for the next day, 500 policy leaflets and 500 copies of The Blackshirt. Despite all of them receiving some abuse from the Reds, they succeeded in distributing the literature and had talks with many men in the town where 83% of them are out of work. The meeting took place the next day and went well. Mr. Theodorson spoke and answered many questions. DBO Tong had opened the meeting for the speaker and was impressed by the order of the crowd. The "United Front" communists put up a

miserable show and had a bad time singing the "Red Flag." The crowd of over 1,000 were anxious to hear what the Blackshirts had to say and some described them as "a fine body of men."

At the end of the month, a speaker's class was held at South Shields by Assistant Propaganda Officer John Engelbert Theodorson. It was the first class to be held at Shields and the efforts of the members were good. One was 14 years old and a member of South Shields Secondary School debating society and it was hoped soon to have a debating team for the Junior members of the branch. Mr. Theodorson had started the branch and had sown the seeds of future growth. They had just recently moved into bigger premises in Westoe Road. At a meeting held in the Market Place, a crowd of 200-300 people listened to Mr. Theodorson explain the policies of fascism and he attacked the present system where South Shields seamen were unemployed and walking the streets while British ships were manned by foreign seaman. He later spoke at Wallsend for about an hour to a friendly crowd.

A Gateshead correspondent called "Briton" wrote to the Journal concerning the employment of foreign seaman. He wrote: "Sir, I saw a placard saying "Bulgaria Goes Fascist" and reading your paper I also saw that British interests are pleased at the change of Government. I then wonder why so many political parties get hysterical about Fascism in this country. Tyneside seems to have a kink in its sporting spirit. A boxer, sculler or football team visits us; and they get encouragement to do their best and applause when they put up a game show. No one can deny the fascists aren't game. Their programme is to help Britons, yet Tynesiders allow a lot of hooligans to set about them. For seaman especially their programme is splendid. I wonder what stevedores or miners would do if their employers paid them off and put Chinese or Lascars to do their work for a quarter the wages they receive. Yet, that is what a lot of ship owners do, and we cannot fight against it whether our Government is National Conservative, Liberal or Labour. Fascists intend to forbid cheap

Asiatic labour on ships in the home trade. Ship owners contend they need this cheap labour on tropical runs, which is nonsense. The Orient Line doesn't use it and where is there a hotter trade than the New Guinea, Soloman Island run from Sydney, yet Burns Philp (an Australian shipping firm) use white labour?"

He was again writing on September 23rd and said "Mr. A. Vincent Collier's letter should give encouragement not only to seamen but to all who have the welfare of their fellow countrymen at heart. I also liked 'Watch Dogs' letter replying to 'British Trade Unionist.' The latter might be a union official, but I don't think he is a seaman or he would know that the man they respect and trust is the captain who is firm, a strong disciplinarian, gives a square deal to all and knows what is best for his vessel and crew in times of danger. They will do their best for such a man. We want a man like that at the helm of the 'ship' of State, instead of a bunch of haggling politicians, all fighting for command, slinging mud not only at other parties, but at members of their own, who work in harmony only when giving millions of our money to foreigners who won't pay their debts, but ask for more time to assist them in taking our trade. The Fascists have a policy that appeals to me, 'Britain for the British.' Good luck to them. It will be a hard fight because of whom they will have against them. First, a lot of employers - because cheap and sweated labour will be stopped. Second, the Communists - because Fascists are going to build and not destroy. Third, Labour leaders - who by mixing up with politics have lost the faith of the workers, and will fight hard to save their soft jobs, fat pay envelopes and happy outings to favourite holiday resorts."

Captain Edward Tupper, National Organiser for the National Union of Seaman, spoke in GMW Hall in Sunderland on November 7th and said that all they wanted was fair play for the seamen and that they had no fight with the just employer but were out to make the unjust ship owners play the game. He said "We are conducting everything in a constitutional manner. We are not (Communist) extremists. We have driven them from our

ranks. We are believers in the ballot box and are asking for the restoration of the wage cuts made in 1932."

Newcastle Fascist Francis J. O'Hare joined in the correspondence and pointed out that in Germany and Italy their governments had the majority of their people supporting them and that "A little while ago, a German boat was in the Tyne and its Captain had declared that all his men supported Adolf Hitler and that at the last Italian election in 1927 the Fascist government polled 96 percent of the votes. He went on to say "We Fascists quite agree that trade unions among seaman and others have done much for the working class, but not with the present leadership. Contrast the sacrifices of the men who made trade unions possible with the leaders of today who seek their own security first and the advancement of their political careers. Remember 1926 when their 'personal possessions' were endangered. Seaman do not want dictatorship. Neither do Fascists. Let workers speak for themselves, as they will under Fascism and you will find that what the worker wants is the right to earn a decent living and security, and that is what Fascism stands for."

The year before, a similar correspondence took place in *The Sunderland Echo* when a number of people complained about employment in the Merchant Fleet. One wrote "Heartfelt is perfectly right in what he says about Arabs and other Oriental races being employed while thousands of white British seamen draw dole and P.A.C. relief. The union accepts these men as members. It is a deplorable condition of affairs altogether... helping to a great extent to crowd out the white man." Another from the Ford Estate wrote "As an out of work seaman, I hope some day to get a ship, but I got a shock this morning. I have never seen so many coloured seamen signing on the 'dole' book as I did this morning. I wonder who left the door open for these people to come in. Are there not plenty of white seamen out of work in this town without these so called Aden seaman." BUF officer Vincent Collier wrote to a local paper "What are the plans...regarding the mercantile marine and British seaman

should we get strong enough to fight those great autocrats, the Labour leaders...Fascism in Britain certainly means 'Britain for the British' and a square deal for all sections of the community. Unfortunately, thousands of British seaman have been displaced by Lasars, Chinese and other foreigners on ships flying the Red Ensign. The unions are powerless to protect the interests of their members, and owners in some cases are unable in the present chaotic condition of the shipping industry to employ our own seaman. Under Fascism it would be impossible for shipping magnates to sacrifice the interests of our seaman and to amass fortunes of the magnitude left by the late Sir John Ellerman. Our policy is 'British goods in British ships' manned by British seaman enjoying a fair and just rate of pay and working conditions compatible with the organisation of a twentieth century State."

Further concern was shown at Sunderland when Mr. J.J. Rogers of the East Ward wrote in *The Sunderland Echo* on Oct 17th "I, on behalf of many East End people, have been asked if the authorities are going to allow Arabs to colonize at the East End of town, as it appears that many more have homes and others are enquiring of the same. I protested over three years ago about this same subject and, for a time, it ceased, but I know they are attempting to purchase a building with a view to making a boarding house near the docks. Feelings are very bitter against the landlords who are letting these houses to coloured men and many women and young girls living near their quarters are alarmed when meeting them at night. After, what happened at South Shields not long ago, we down East are determined that no more will be housed down here. Landlords, please take note."

A report in September 1934 said that members had been active in bringing fascism to many towns and villages. At Blyth Public Library fascist literature was discovered between the pages of magazines and periodicals. After displaying for some time "Blackshirt" in the news room of Middlesbrough Public Library they received a number of complaints which the librarian brought to the attention of the Libraries and Museum

Committee. He said "For some time we have received a copy of Blackshirt free and it has been in the building for quite a long time." Councillor G. Carter asked if the objections were from other political groups, the librarian Mr. Lillie replied "At first they were from the Labour Party, and later an objection came from the Jews." Councillor A. Edwards remarked that to boycott the paper would be silly now that the BBC were allowing free political speech on the wireless. It was agreed that no action be taken on the matter.

This month, it was pointed out by a letter writer calling himself "Anti-Humbug" that "Mrs Sidney Webb, daughter of Richard Potter of the Grand Trunk Railways of Canada, Director of the Hudson Bay Company and Director of the Great Western Railway had, with her husband, posed as Socialists in the Seaham Division and out of their wealth gave nothing to anybody or anything and left the miners to pay their election expenses. I make no comment!"

During this time, more than 20 BUF meetings were being held regularly each week. In one week, meetings were held in Houghton-le-Spring, Birtley, Trimdon, Wallsend, Durham, Walker, Esh Winning, Hexham, Blaydon, Shiney Row, Newcastle and other places. The main speakers were Mr. Theodorson, Mr. T. O'Brien and Mr. Barnes, although the latter was a septuagenarian, he still possessed a youthful outlook on life and was a brilliant speaker. At Wrekenton, he delivered a critical attack on the government and then described how miners would benefit from Fascism. He was congratulated by many of the people in the crowd who heard his speech. At the Hexham, meeting held on September 25th, the local newspapers story was headed "Fascist Policy: Blackshirts and the British Farmer" and said: "Members of the British Union of Fascists revisited Hexham on Tuesday and held an open air meeting in the market place during the afternoon and evening. In opening the meeting Mr. Theodorson of the Newcastle Head Office pointed out that among the many lies told of the Fascist movement was one that

they paraded in armoured cars. This was entirely false. The windows of the cars were merely protected by wire meshing as a safeguard against the broken bottles and razor blades of communists. Captain Vincent Collier, Senior Propaganda Officer, then proceeded to outline the policy of the Blackshirts." He said: "Fascism comes not to make strife but to end political party strife and to sink the quarrels of factions in national unity. The welfare of the nation is above all party politics. In a Fascist state private enterprise is encouraged within the limits set by the state. Enemies of the Blackshirt movement say that Fascism is repugnant to Britain and that its arrival here means an end to your liberties and the imposition of all kinds of restrictions on the Press. What it really means is the granting of real liberty - the liberty to earn ones living and play ones part in the life of the nation. Fascism believes in a revival of agriculture. This is one of the most vital of British industries, that of providing food for our people. The British farmer should no longer be sacrificed in the interests of investments abroad, the returns for which can only come in the shape of cheap foreign food which is flooding our markets and ruining our farmers. The definite exclusion of all produce which British agriculture can provide would enable our production to be doubled in three years. That would be the policy of a Blackshirt Britain. The British farmer first, the Dominion farmer second and the foreigner last of all. There would be no mistakes or doubts about that statement of policy. Our policy is Britain First!" The meeting closed with a question time during which Captain Collier answered questions put to him.

A few days later, Captain Collier was in Alnwick and attracted a very large crowd. He and a colleague had undertaken a five month tour of the agricultural districts of England in a Blackshirt van and were finishing at Berwick on the 29th. He said that in a very short while they would remember the BUF visit to Alnwick because the people would realise that the movement was sweeping the country and that the BUF would have support among farmers. Repeating BUF policy at the annual meeting of the Durham branch of the National Farmers Union held in

Durham on Dec 28th 1935, the Chairman, Mr. Stanley Hall of High Simonside Farm, South Shields, said that the government's agricultural policy should "put the British farmer first, the Dominions second and the foreigner last."

September 26th 1934 saw a party of 36 German and Austrian Rotarians visiting Durham as guests of Durham City Rotarian members. They were greeted on arrival by three members of the BUF and later lunched at the Three Tuns Hotel and visited the Cathedral and Castle.

In the first few days of September 1934 Gateshead BUF held a whist drive and social evening. A non-fascist band gave their services free and, after meeting members and talking about BUF policies, they all enrolled! Soon afterwards, Newcastle Branch sent a letter to Thornley Miners Welfare Debating Society offering to send speakers to give a talk on BUF policy. The Society said that if they took it up it would have to take the form of a debate with Thornley members. They would have been one of many groups asked if they wished to hear the BUF programme. On the 14th a Newcastle supporter wrote to the Chronicle saying "that only one voice was raised at the Weymouth Trade Union Congress to say that while Fascism was criticised it would be blatant hypocrisy not to include Communism. He wrote "Fascism was founded in 1919 when communists seized an Italian motor factory and thrust the "bourgeois" metallurgists into their own furnaces. As far as I can see it is the only remedy for political savages inspired by Russia." A private session at the Congress held by the International Federation of Trade Unions did condemn Communist overtures for a "United Front against Fascism" and declared that the suggestion of the "Red" International of Labour Unions at Moscow was "a manoeuvre devoid of any sincere intention."

Every October, former miners gather for the Thomas Hepburn Commemorative Service held at a packed St. Mary's Church, Heworth, in Gateshead. Hepburn was the founder of the first

great miners union in 1825. He was blacklisted for his trade union work but eventually found employment at Felling Colliery where he was set on as a deputy and provided with a home in Office Row on the provision he did no union activities. He later became the lamp inspector until age and ill health compelled him to give up his work. He continued to reside at Office Row until three months before his death, during the later years of his life he had several strokes which to some extent affected his memory and reason. This necessitated his removal from Felling to Newcastle where his son-in-law, Mr. J. Laws, kept a public house in The Side known as the "Old Brandy Butt." There he died on Friday Dec 9th 1864 and was buried in Heworth Church cemetery.

Every year, many colourful miners' banners surround Hepburn's grave where part of the service is performed and the miner's hymn Gresford is played. The hymn was composed by a local man Robert Saint whose home in Victoria Road East, Hebburn, is marked by a blue historical plaque. Gresford was the scene of a terrible explosion on September 22nd 1934 when 266 miners lost their lives, including BUF members Stephen Penny and William H. Higgins. Unit Leader Stephen Penny had recently been present at the BUF rally in Hyde Park that was attended by over 100,000 people and was employed at Gresford Colliery, near Wrexham, about five miles from his home at 10 Stansty View, New Rhosrobin. On the 21st September, Penny had already completed his shift and spent some spare time selling copies of "Blackshirt" at the entrance to the pit. Keen to ensure he had sufficient funds for the Oswald Mosley meeting at Belle Vue, Manchester, he volunteered to do a second gruelling shift. At 2.08 on the morning of the 22nd a violent explosion ripped through the Dennis section of the mine taking the lives of 266 miners, among them Stephen Penny, aged 24, and fellow Blackshirt William Higgins, aged 26. It was recorded that Penny had managed to rescue a young miner from the initial explosion but in his second attempt to reach colleagues he was overcome by fumes. Local BUF member Captain Rhys Soar described him as a "man of noble character and untiring energy."

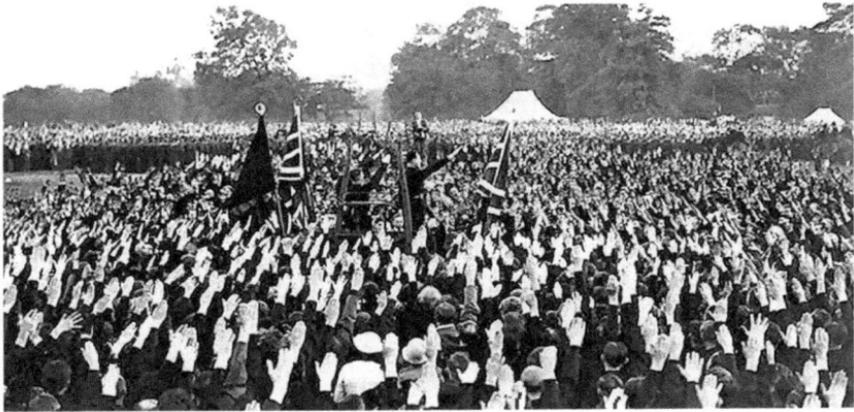

Stephen left behind a widow and two young children. Only twelve bodies were recovered, the remainder, including those of Penny and Higgins, were left in the Dennis Section that was never reopened again. A "British Union Gresford Disaster Appeal" was set up and contributed to the £566,546 raised for the widows and children of the miners killed in this great tragedy. The Chief Constable of Newcastle and the officers and men of the force and the Fire Brigade also forwarded a cheque for £50 to the relief fund and £18 was sent by Jarrow Town Council.

The reports that other countries had better regulations for coal mines was the complaint of Sir Evan Williams, President of the Mining Association, when he gave evidence on behalf of the Association on Safety in Mines at Caxton Hall, London. "They were told that haulage in Germany was far more advanced from the point of view of economy and safety than it was in this country," and said this should be the subject of an investigation by mining engineers and the manufacturers.

Mrs. Swire visited the Gateshead women's section on Tuesday, 9th October 1934 with Miss Jean Cossar, an ex-conservative organiser and speaker who had recently joined the BUF. Miss Cossar explained that she first learned about the movement when walking past the National Headquarters in London and

saw posters proclaiming "Britain buys from those who buy from Britain." It left a lasting impression on her and she later decided to work for the Blackshirts. The Gateshead women also started a weekly study group and speaker Miss Cossar appealed to them to do their utmost for the cause. Within a week of joining the BUF, Miss Cossar addressed Alnwick members and was the first woman fascist to address a meeting on Tyneside. She had left Newcastle in 1923 to become Women's Organiser for the Conservative Association in the Wansbeck Division and was later transferred to the South Hackney Conservative and Unionist Association.

Blackshirts of Newcastle branch were represented in the Lord Mayor of Newcastle's Armistice Day Parade to the war memorial by Major Arthur Heads MC, Sub Branch Officer Ferry and APO Englebert Theodorson of the Northumberland and Durham area. After the two minute silence, wreaths were laid at the foot of the war memorial and Major Heads stepped forward and laid his wreath and gave the fascist salute. The wreath was inscribed "BUF" in red poppies with the inscription "We shall not forget." Theodorson was born in Sunderland and kept faith with his patriotic principles until he passed away in Northampton in 1986.

Newcastle BUF branch had to suspend Captain Bruce Norton, Area Staff Officer, in September. He had joined the fascist movement in Newcastle in April and had served as an officer in the Royal Flying Corps and also in the Royal Irish Constabulary. He had been living in Africa for a number of years but had become interested in fascism and came to England with his wife to study it. It may have been a case of going too far too fast, but it lead to problems and in November, Major E.W. Ormstone, Officer in Charge of the Northern Counties for the BUF said that when the branch moved from Clayton Street to Lovaine Crescent it was decided to give the people on Tyneside Fascism as it was in the rest of the country and it was time for a change of command.

Not only Blackshirt meetings were disrupted by left-wing hooligans. Socialists and Communists attempted to wreck a mass meeting of the Progressive Reform candidates held in Victoria Hall, Sunderland, on October 29th. The hooligan tactics were condemned by all, except by the Socialists. From the start of the meeting groups of socialists in various parts of the hall set out to shout down the speakers.

The Blackshirt report on November 23rd announced that there was intense activity in the area as branches were moving to bigger premises. Newcastle had moved and new members were still enrolling and the previous week's supply of newspapers was sold out. Gateshead branch had transferred to more suitable premises at 14 Catherine Terrace, located opposite Bewick Road and Denmark Street on High West Street, and at its launch "an opening meeting and social evening had been held on Wednesday last. Many old and new members had attended an enjoyable evening. The officer in charge that night was Fascist Arthur Bond-Roose who had already gained a lot of experience in the movement." He was to pass away in Torbay in 1977.

The Durham BUF soon moved its branch to better premises at Hepworth's Chambers, 21 Market Place and better things were expected from the growing branch. The District Officer in 1936 was Mr. J. Ellison, Propaganda Officer Captain Vincent Collier, Staff Officer Captain T.W. Armstrong and Women's Organiser Miss M.F. Rawes. The following year a number of staff changes had taken place and Michael J. McCartan, B.Sc., was the Officer in Charge, Propaganda was Mr. C. Clark and Staff Officer Captain P. Whitam and Political Officers Mr. W. Risdon and Capt. E. Atherly. In 1938, the year book and business directory states that the BUF objective was "To establish in Great Britain the Corporate State," and the staff were Mr. R.W. Elana, Mr. M.J. McCartan, Mr. R.A. Plathen, Mr. W. Napier and Miss M.F. Rawes. The daily office hours (except Sunday) were 10-1; 2.30-5.00 and 6-10 in the evening. By 1939, the Durham City year book does not give a local office address but the contact

is given as Mr. K.R.R. Dick of 29 Cragside, High Heaton, Newcastle upon Tyne, which was the home of his mother-in-law where he was temporarily residing.

South Shields BUF Headquarters opened in July and was said to have a very efficient Branch Officer and speaker in SBO Stephenson and the women section continued to hold weekly meetings and some members brought their friends along. There were speaker's classes, physical culture and Ju-Jitsu lessons held every week that were well attended and preparations were being made for a grand bazaar on Saturday, December the 8th 1934, at their premises at 208 Westoe Road. Christmas toys of every type would be on sale, ladies and gentleman's clothing etc. The members had been working for months making things for the bazaar. An autographed copy of "The Greater Britain" had been presented to the branch to be auctioned and proceeds given to branch funds. The weather had turned bad and outdoor meetings had to be curtailed but indoor activities continued to bring in good results.

"Our movement is essentially British. The problems we have to solve are the problems of Britain and the Empire and, above all, the problems of the working people of Britain and the unemployed." These were the words of William Joyce at a British Union meeting held at Durham Town Hall on Tuesday December 11th. "Some people regard Fascists as violent people who employ force. We have no desire whatever to use force, but if deliberate attempts were made to break up our meetings we would not tolerate such treatment. Wherever Communists attempt to use methods of terrorism against us we will retaliate as best we can. Should there ever come a time when the people of this country were invited to choose between the Union Jack and the red flag, if force should be necessary, the Fascists would use it on the side of the Union Jack against the Reds.

"Money must be made the servant of industry and not the master. British capital and British credit should be at the

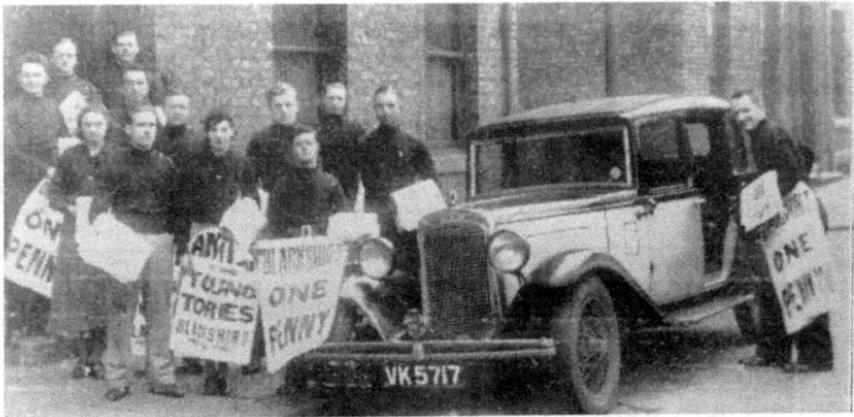

Blackshirts heading out for a newspaper sale

disposal of British and imperial industry. A few months ago trade unions were collecting money for Austrian Socialists, and the British Government was borrowing money for the Austrian Government. How much better and wiser it would have been if the trade unions and Government had kept the money at home and used it for the purpose of our industry and the British working man. We would raise the wages and salaries of the workers and thus increase the purchasing power that is so essential for trade."

1935: Preventing the Public Hearing the Fascist Case

The New Year Message from the new and youngest Newcastle District Officer Jack Lynne was that after four years of the National Government and "In the face of press misrepresentation we must continue and widen our Blackshirt efforts in 1935 in getting the Mosley Message to our people." The number of newspaper sales pitches in the City was increased but it was decided that year the BUF would not contest the 1935 General Election but concentrate on building up the Movement's infrastructure and used the slogan "Fascism Next Time." When the election did arrive, although not standing candidates, the local Blackshirts campaigned in a much wider area to promote British Union policies. Theatre and cinema queues, railway and bus stations at peak periods and selected street corners saw newspaper sales teams as well as the visible presence of Blackshirts with placards serving the purpose of keeping the BUF in the public eye and combating the press silence.

An advertisement appeared in the Shields Gazette for a public meeting to be held at the BUF office in Westoe Road. A BUF local opponent said that he went to a meeting held there two weeks previously and contended that if Fascism was sweeping Britain, like it had been suggested, they should be holding meetings in public halls. Angus MacNab replied "That the fascist movement was the only political body today capable of filling such great halls as the Albert Hall, Olympia and Manchester Free Trade Hall at great national rallies. Nevertheless, we have not got vast funds to throw about and each of our branches must maintain itself. We are not ashamed of poverty, and reckon it good policy to make a small beginning which shall later on grow to a great and prosperous branch." He went on to say that perhaps the

critical opponent would find it possible to sign his name to his correspondence and that "The truth is, and always has been, that our movement is supported entirely by the subscriptions and donations of our members but not all of them are able to declare themselves openly for Fascism through fear of economic blackmail by their employers or business associates." When they had filled such huge halls, on each occasion, a crowd of Red ruffians tried to prevent the "British public from hearing the Fascist case and was indeed responsible for many recruits among those who noted the kind of persons who constituted the opposition to a great patriotic movement."

On a tour of the area in February 1935, Captain Vincent Collier addressed a number of successful meetings in the North East. After a well attended meeting at Washington he visited the Miner's Welfare Club. He also addressed a large meeting at South Shields and two good meetings in Durham City. Blackshirt meetings were also held at Darlington, Benwell and Felling. On Wednesday, February 20th, Collier addressed a meeting at the Temperance Hall, Trimdon Station. This was the first indoor meeting held at Trimdon which is a large scattered village in the heart of the Durham coalfield, and the meeting and support pleased the local organiser Mr. J.R. Crosby. About two to three hundred people were present, and listened without one interruption to Mr. Collier who spoke for over an hour. He also had an interesting meeting that was held at Easington Colliery in the centre of Ramsey McDonald's constituency where a large crowd had gathered to hear the speakers. About 50 members and friends were at the Durham District Headquarters on St. Patrick's Day March 17th to enjoy music from Fascists Armstrong, Lyle and Murphy. The concert was arranged by Miss Rawes and Mr. E.F. Austin. Vincent Collier spoke again at the Bigg Market on March 22nd and, in spite of two rival meetings already under way when he arrived, a large crowd still attended to hear BUF policy. On the 28th he spoke at Darlington's North Road Schools on the betrayal of British interests by the old gang of politicians and financiers.

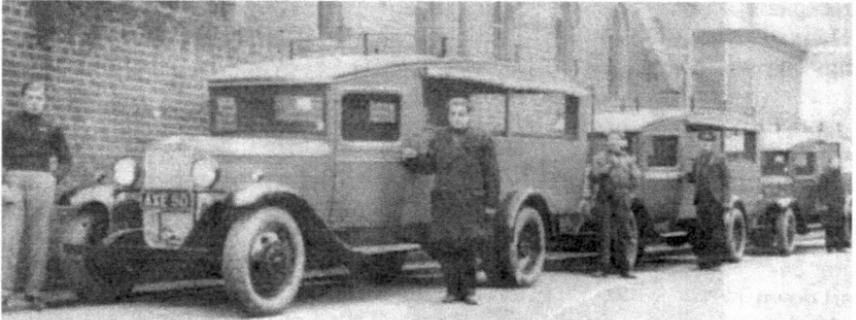

The Blackshirts received three transport vans at their Chelsea Headquarters in January 1934. Windows had grills on them for protection against missiles. The press misleadingly referred to them as "armoured vans."

At the end of the month he held good indoor meetings at South Shields and Berwick, and many open air meetings were held by able speakers McLaughlan, Simpson and a new speaker, Mr. H. Bell and a number of others. In early April, Collier was the main speaker for the Berwick branch when a meeting was held in the Corn Exchange. Reds tried to create a disturbance but the meeting went well and ended orderly. Questions were answered and a good amount of literature was sold.

With St.Patricks Day approaching Mr. R.J. Grett, the Hon. Secretary of the Tyneside Irish Old Comrades Association, said that the Tyneside Irish Brigade had lost 2,073 officers, NCO's and men during the Great War who were killed in action or died of other causes, apart from the thousands who were wounded physically and emotionally. There were thousands of other Irishmen who joined other regiments, in particular the 27th Inniskillings. He also said "The object of his committee is not to boost warfare but to keep green the memories of the gallant lads who stood by this country in her hour of need." This tragic toll expressed the great fondness many Irish and their descendents held for Britain. Many of the Irish had called Oswald Mosley "Ireland's greatest friend" when he opposed the Black and Tans and other injustices in Ireland.

BUF official Mr. Arthur Keith Chesterton (cousin of G.K.

Chesterton) took to the correspondence pages of the North Mail in March when writer "Billy Fairplay" had written that rank and file members of the Labour Party and trade unions would become "victims" of Fascism when it came to power in Great Britain. Chesterton replied "It is one of our first principles that there must be 100 per cent trade unionism and that the trade unions shall enjoy an equal partnership with employers associations in the self government of their own industry - a privilege they do not enjoy today, and one that will be of incalculable benefit to them, since it means that they will have a direct voice in all legislation affecting their own wages and working hours. Moreover, in the Corporate State of Fascism, the high-wage system will be introduced in order to bring purchasing power into line with the nation's power to produce. If there are to be any victims they will not be found among the rank and file of the Labour Party, but among some of the leaders." In a later correspondence he adds "I am sure Billy is a charming individual, but that does not prevent him from being the most reckless reasoner I have ever encountered. He asks us, for example, to remove the discredited trade union leaders even before we come to power. Fascism can do much, but with the best will in the world we can't do that. At any rate, we are glad when we do secure a majority we shall have the support of your correspondent. He pledges himself 'to stand by any Government that is elected by the free vote of the people,' and Fascism has no intention of assuming responsibility by any other means." Chesterton had served with distinction during the First World War in the Durham Light Infantry, gaining the Military Cross at the age of twenty. In the Second World War he served with the British forces in the Middle East. After the war he founded the League of Empire Loyalists and then became the first chairman of the National Front.

There were letters in February and March in the *Echo* between Mr. C. Claxton Turner and BUF member Angus MacNab when he said: "Readers should study both sides of the argument and think it out for themselves. We desire nothing better than the public should consider our (Fascist) case on its merits. We do

not appear to have heard from Mr. Claxton Turner any criticism of our proposals for solving the distribution of wealth by the elimination of cheap competition at home and abroad through the exclusion of cheap foreign goods and the unification of industry in great corporations wherein employer and employed share the control; nor of our proposals for liquidating the present system of party strife and substituting that by an expert assembly elected upon the occupational franchise in order that every citizen may express an informed opinion upon subjects of which he himself is a master... he only has vague and sweeping statements about "dire involuntary self-destruction," "dragooning," and "armament races." It is significant to note, however, that while he seems unable to produce any arguments against the economic case of the British Union of Fascists, he admits that Mussolini and Hitler - whose policies represent the brand of Fascism suitable for their respective countries - have each been "an outstanding success."

Mr. Claxton Turner also accused Sir Oswald of wanting Britain armed second to none. MacNab replied that he was incorrect in his statement and that Mosley had never proposed to enter into any arms race. "What he had said is that Britain must have an Air Force equal to the strongest in Europe, that our navy must be adequate to safeguard our trade routes all over the world and that our army should be modern enough and scientific enough to defend our territory. It is weak nations possessing vast wealth which invite attack. Mr. Turner is equally erroneous in his statements about foreign countries. The extent of the proposed new German forces has been made public in every paper recently but Germany has not announced any desire to possess greater armaments than other nations. On the contrary, she has shown that she will be content with an army 50 per cent smaller than the USSR."

Claxton Turner also attacked the Italian war in Abyssinia and Macnab pointed out "that between 1928 and 1935 Abyssinia was guilty of 25 assaults on Italian diplomatic representatives

and consuls in armed attacks on the life and property of Italians in Abyssinia, and no less than 51 raids of armed bands into Eritrea and Italian Somaliland. If this is not unprovoked aggression, what is? The only reply we have heard is that the Negas (Emperor Haile Selassie) is incapable of controlling his own slave raiding chiefs. If this is so, then law and order do not exist at all in the Empire conquered by the Abyssinian monarch and it is the duty of the nearest colonial power to remove such a menace to the colonists and native people. Such a task should have been the duty of the League of Nations before military operations began. The attitude of the British Union of Fascists is not one of participation but a demand that our country shall not be involved in another European war on behalf of either Abyssinia or the discredited rump of the League."

He added: "The League of Nations ought to have acted to remedy the abuse, to abolish slavery and to carry out its own purpose of extending civilisation. The League has done none of these things and the Italian nation, goaded beyond endurance, has undertaken the task and now the Claxton Turners, the Socialists who would not fight in 1914, the Communists who wish to destroy Britain and every other yelping little internationalist in the country are trying to force British people into a war to restore the status quo and make North-East Africa a slave traders paradise." MacNab went on to say that sanctions against Italy cost the jobs of 36,000 miners and that Italy had been transformed from a friend of a thousand years standing into a bitter opponent nor had it checked the Italian campaign in Ethiopia that had set free a million slaves.

Correspondent Mr. J.P. Robinson said Mr. MacNab should stop wasting his time addressing pompous "bunk" to the English and take his "Scotch-German-Italian political haggis" to his own people. He replied "Mr. Robinson has an acid wit, and, Scottish as I am, I enjoyed his jokes at my expense. Surely, however, your correspondent will agree with me that in times of lethargy and decay the inspiration of leadership is necessary

to rouse the people to national effort before chaos and disaster is actually imminent. Mr. Robinson is at liberty to disapprove of Fascism to his heart's content; but surely in his own country abundant evidence lies before him that something far more radical than the tinkering expedients of the present Government are necessary. As a realist, he should be prepared to produce an alternative policy capable of safeguarding our standards of life against the competition of oriental coolies, and thus rendering possible the proper distribution of the wealth whose production science has rendered so easy to-day."

An allegation was made that at a regular BUF open air meeting at the Wouldhave Monument on Ocean Road, South Shields, on March 27th 1935, that one of the Blackshirts was in possession of an iron bar. The statement was greeted with amusement by BUF Branch Officer Robert Stephenson who described it as "Just another piece of Communist bunk." A resolution of protest about it was passed by the South Shields Communist Party Secretary Mr. Anthony Lowther and referred to "Fascist gangs in possession of armoured cars" and a copy was sent to the Mayor Coun. J.W. Watson, every Labour town councillor and trade unions in the borough demanding the closure of the "Fascist barracks in Westoe Road." The curiosity of a Shields Gazette reporter lead him to make an impromptu visit to the local BUF headquarters requesting Robert Stephenson to allow him to make a complete inspection of the "barracks" which was happily granted.

The reporter wrote: "In one spartanly furnished room there was nothing but a dozen chairs and a photograph of Sir Oswald Mosley. The secretarial office next door contained only one wooden table and a small portable desk. 'There are no machine guns or rifles here' said Mr. Stephenson, with a smile, shepherding me into yet another room, 'but there is some chocolate and cigarettes and I dare say we could make you a cup of tea at a pinch.' Ranged along the mantelpiece was the branch reference library. Nothing here to bring a flush to the most suspicious

cheek. 'Pears Encyclopaedia' and a 'Handbook on Latvia' seemed to be the most readable volumes. 'No copy I suppose of 'Infantry Training 1914?' I enquired. 'No, just a rather old fashioned book on boxing,' said Mr. Stephenson handing it to me. Judging from the diagrams, anyone who staked his life in this year of grace on the instructions inside would be dead within five minutes of entering the ring. 'If you look through this window you will see there are no armoured cars or tanks in the back yard,' said Mr. Stephenson with pleasant irony. 'Actually,' said Branch Officer Mr. Stephenson 'this is just another piece of communist bunk. Any member of this Fascist branch found carrying anything which could possibly be used as a weapon would be instantly expelled. Members are searched before they leave for a meeting. Even pen knives are banned. As for this iron bar allegation it really is too absurd. On the day this incident is alleged to have taken place, Ocean Road was being widened. There was a good deal of building materials, including iron fishplates lying around the steps of the Wouldhave Memorial and I gave instructions for some of it to be pushed to one side. One of my men was probably throwing one into the gutter which was seen by a young boy who the communists afterwards got hold of and twisted the story.'"

Mr. Lowther was also a supporter of Republican (Red) Spain that closed churches and killed priests. South Shields man John Grimes wrote "Like all Communistic drivel, the letter from A. Lowther is as clear as mud. Following the Red formula, it sets out to attack but very soon becomes a painful repetition of 'Communism has done this, Communism has done that.' We do not need to be reminded of what Communism, the scourge of all the nations, can do. We do not need unimportant creatures like A. Lowther to recite the achievements of Satan's protégé, Catholic Spain is doing that. Let him understand (if understand anything but Communism he can) that in the considered judgement of Christianity and rational Trade Unionism, Communism is the curse of civilisation, a political rat and as such its extermination should be encouraged."

It was reported on May 3rd that Sunderland had held three successful meetings during the past week. Assistant Propaganda Officer J. Engelbert Theodorson, one of the original members of the branch, was out of town on other activities but DAO Anton of National H.Q. and Fascist N. Phelp addressed the meetings at Gill Bridge and the Wheat Sheaf. The British Union held a meeting at Newcastle City Hall on May 5th 1935 when Communists disrupted the proceedings. One of the rules stipulated by the City Hall authorities for the hire of the hall was that the police, and not the Blackshirts, would be in charge as it was said the police would be better at keeping order. They found out that they were not.

One spectator from Kenton wrote to *The Chronicle* that "The gross unfairness of the proceedings which prevented Sir Oswald Mosley from speaking – he was interrupted and shouted down without his having made any contentious statements - roused me, and others, to such an extent that we have since procured all the Blackshirt literature with a view to reading up on a subject of which we are not allowed to hear." Another wrote: "I was profoundly disappointed at the attitude of the police towards the gang that tried to stop the meeting. With this feeling the majority of the audience were in agreement judging by the applause which greeted Sir Oswald's admonition to the hecklers. There was nothing provocative in his opening remarks and it was evident that the interruptions had been carefully planned…I regret that Newcastle's sense of fair play has suffered such an eclipse. Why should an ignorant mob be allowed to disturb an important meeting of citizens." After half an hour, as the police would not deal with the situation or allow the Blackshirts to eject the red troublemakers, Mosley announced to the audience that he had to close the meeting. He said "Ladies and Gentlemen, I offer you my deepest apologies that you have been prevented by the police from hearing the speech and I have no other option but to close the meeting." He said it would have been a farce to continue the meeting with red roughs standing up and shouting with the police protecting them from ejection.

A letter later appeared in *The Blackshirt* by Newcastle supporter Mr. E.L. Merton, he wrote "The attitude of the police at Sir Oswald Mosley's meeting at Newcastle has disgusted all fair thinking people on Tyneside" and that one of the incidents in the Hall had summed up his feelings. At one of the interruptions Sir Oswald said "The police will preserve the order," at this someone shouted down from the gallery "The police preserve order! They couldn't preserve jam!" Oswald Mosley said if they had been in charge the disorder would have been over with in five minutes and they could have proceeded with the meeting.

Writing to the North Mail Gateshead's critic "N.C.P." said: "For years Newcastle has heard boastful claims to possessing the most up to date police force in the country. Was it not first place with police boxes? One of the first with mobile police? One of the first to use the wireless? And so on. But what's the use of such efficiency if the whole city police force cannot deal with a handful of communist agitators who disturb the peace and wreck a meeting like that of Sir Oswald Mosley in Newcastle on Sunday night?" Henry Wilson of Lanchester wrote "Being a member of the Conservative Party I naturally love fair play and justice…regarding Sir Oswald Mosley's meeting, especially when it is pointed out that Newcastle claims to possess one of the most up-to-date police forces in the country, what is the use of such efficiency if the city's police force cannot deal with agitators who disturb the peace? The Chief Constable certainly lost a splendid opportunity on Sunday night to stand up for law and order."

Communist Party member Charlie Wood wrote that Mosley failed to get a hearing because "freedom for fascism to develop means eventually suppression of those elementary rights and liberties that have been won very dearly by the working class." Correspondent Paul Stobart replied "Now the first of these "elementary rights and liberties" is that of free speech. Is not Mr. Wood choosing a queer way of upholding his rights when he advocates the denial of them to other people? Unless, of course, he

really means that he wants the rights of free speech to be confined to his own working class. In that case I suggest that it would have been more honest of him to say so without equivocation." Another, "Tynesider" living in Stocksfield wrote "Socialists and Communists ought not to denounce freedom of speech, as they themselves have suffered in the past from the lack of it." Agnes Ferguson of Hartlepool wrote "As one who was present at the City Hall last Sunday to hear Sir Oswald Mosley...at an age when freedom is one of our proudest possessions, the obvious callousness of the police at that meeting is incomprehensible. Is it too much to ask this body of policemen to explain their conduct and also their part in politics? Sir Oswald Mosley belongs to no party. His policy is to work for the good of the whole of British mankind." From North Shields "Britain First" said "Please allow me to thank you on your fair play in reporting the not-so fair play at Sir Oswald Mosley's Newcastle meeting. Now Britain knows why the Fascists need stewards." Another wrote of Sir Oswald "He was not given fair play. And that, in my mind, not only by the communists, who themselves claim the right of free expression, but also by the police. That the Chief Constable and the Chairman of the Watch Committee were personally in attendance - the Chief Constable telling your reporter that he was on duty, and, therefore, personally in charge of his men - makes the police conduct still more inexplicable. Imagine this hooliganism being allowed at Mr. Lloyd George's meetings' or, in fact, any meeting other than at which it occurred." Tynemouth writer "Onlooker" wrote "The simple question arising from the scandal of Sir Oswald's attempt to state his views is this – is a minority of crude hooligans, with apparently police supineness, to be allowed to prevent any person from stating a political , or any other creed."

"Independent Witness" wrote "I was disgusted by the brawling and abuse hurled at Sir Oswald and his followers and I came away convinced that Communism is the greatest menace to liberty and justice." A Gateshead reader wrote "Would it not be far better for those who do not see eye to eye with Mosley's

policy to stay away from his meetings." London BUF officer Bob Plathen said "A leaflet was issued by the Communist Party prior to the meeting instructing members of the party to demonstrate against Mosley on May 26th. These were the people who were permitted to break up the meeting by refusal of the police either to permit their ejection by Blackshirt stewards or to do the job themselves. Fascist official Angus MacNab said that it was the only indoor meeting that had been stopped in the past two years.

After the exhibition of Red hooliganism at the City Hall, members were met with increased interest and some sympathy. SPO Broad held his weekly meeting in the Bigg Market without interruption and also held a good meeting in Brinkburn Street, Byker, to a larger crowd than usual. Sunderland Labour Party held a meeting in early May to interview two prospective parliamentary candidates, Mrs. Leah Manning and Mr. D.N. Pritt KC. They were known to have been "flirting" with left wing extremists and the socialist committee said this was going directly against the decision of the national party by which they must abide. The committee said "There must, therefore, be no association with communists, the left wing, or the United Front, and that this attitude of ours is very strong in Sunderland." The warning appears to have had little effect as Leah Manning, together with Labour Socialist candidate Dr. G. Catlin, addressed a meeting held on Sunderland's Town Moor organised by the local Communist Party on Nov 10th and chaired by a member of the League of Young Communists. One Catholic critic found it strange that while speaking from a Communist platform Catlin and Manning were trying to solicit the Catholic vote and professed they were willing to protect Catholic interests. He said "I fail to see how Catholic interests can safely be entrusted to representatives whose sympathy with Communism is very evident. Communism attacks the fundamental doctrines of the Catholic faith. It is actively hostile to lawful authority, to religion and to the family, and has been repeatedly condemned by the Catholic hierarchy."

The Director of Fascist Propaganda, Mr. William Joyce, addressed an audience of several hundred people for nearly two hours in the Ocean Road Congregational Church, South Shields, on May 10th. Forty Blackshirt stewards from South Shields and Newcastle branches were in attendance but were not called upon to eject any troublemakers. Mr. Joyce was subjected to a running fire of interrupters but there was no disorder and said "I have come here for the purpose of conducting an entirely peaceful meeting and if it is not as peaceful as every decent citizen would wish, it will not be my fault... and I would very much prefer to assume that the sensible citizens of South Shields have come here to listen to the case for Fascism." So irritating and obnoxious were interrupters, that even a Miss F. Robinson, a South Shields Tory worker, stood up and expressed a dislike for Fascism but appealed for free speech for the speaker she had come to hear. William Joyce went on to attack international finance and the sending of money abroad that could be better used in the development of Great Britain. Mr. Joyce said "One of the reasons we oppose Socialism in all its shapes and forms is that the Socialist doctrine lays down the theory that class war is necessary to our prosperity, progress and survival." He went on to describe briefly the Fascist plans for the Corporate State under which each major trade union would elect a representative for parliament instead of MP's elected by constituencies. He advocated the exclusion of foreign seaman employed on British ships and that all world-wide imperial trade should be carried by British ships. After answering a number of questions the meeting closed with the singing of the National Anthem while the "Red Flag" was sung by a small rival faction. The following day, Mr. Joyce spoke at the Grand Assembly Rooms in Newcastle and, although there were interruptions no incidents occurred. Mr. Joyce had said that the need to-day was for something more than loyalty which expressed itself merely in the waving of flags. "On this question of loyalty," he commented, "why should 50 per cent of the employment in the British merchant service be in the hands of foreigners?" He later declared "I need hardly say that Conservatism is infected with snobbery. If a man can become a

peer merely because he resigns his Parliamentary seat to make room for someone else we are setting up a very clear standard of aristocracy."

The British Union Director of Press Relations Angus MacNab was in the Newcastle's North Mail letters page on May 21st. He wrote "Mr. Oliver Baldwin's article, 'Our Leaders are Too Old,' is so able that it is surprising to find the writer going off at a tangent in order to have a dig at Sir Oswald Mosley. Nor are the accusations which Mr. Baldwin makes justified by an appeal to the facts. He must know perfectly well the economic base of Mosley's policy, since he himself was a signatory to the Mosley Memorandum and had the courage to follow Mosley's example in resigning when the Labour Government would not adopt that scheme of practical constructive proposals. Now that that scheme and that system have been elaborated and developed into their logical conclusion, the Corporate State, Mr. Baldwin professes to find that "Mosley's leadership cannot be effective" because "the outlook of the leader is always more against his opponent than for his objective." Mr. Baldwin resembles the 'Old Conservative men' whom he decries, unwilling to criticise the economic principles of which he himself was so enthusiastic, he is reduced to the humbug of decrying a leadership that he himself was once proud to follow." He was writing again to the Mail on June 21st regarding Italian policy in Abyssinia and said "We do not know the intentions of Mussolini, but even supposing him in fact to intend aggression, and not merely the defence of his nationals on the outposts of the Italian Empire, it would surely be in the interests of humanity if the wise and just ruler of a great civilised nation made it part of his mission to bring Western justice and freedom to the victims of so degraded a despotism. The 'No interference' cries of our democratic humanitarians sound remarkably smug, and their upholding of an absolute monarchy based on serfdom and slavery seems a strange alliance for the champions of liberty, equality and fraternity." He said again on Sept 16th that: "The public is entitled to know the rights and wrongs of the dispute - that is to say, the evidence which

the League of Nations Council has considered, but although Italy submitted her case to the League no adequate synopsis or account of that case has appeared in the British Press. In justice to those who may be called on to fight, we demand publication of the facts that have been laid before the League."

Representatives of Italian coal consumers who were visiting North East coal fields laid wreaths decorated with the Italian colours on the war memorial in Eldon Square and on the Joseph Cowan monument in Newcastle on Friday 15th June 1935. The later tribute was paid, said Signor N. Tognoli the Italian Consul in Newcastle, in memory of the great love and sympathy for Italy that Cowan always showed and which he demonstrated by his friendship and help to Garibaldi when he was in Newcastle. The members of the party who gave the fascist salute after laying the wreaths were Cavaliere N. Tognoli, Professor Dotter Commendatore Armando Leoni, Grand. Uff. Barbieri, Comm. Bolognino. Cav. De Rosa, Ing. Zucchi, Ing. Tomatis, Dotter Sales, Ing. Pesenti, Sig. Centanaro, Sig. Nicoli and Ing. Marchese Ridolfi. They had previously visited Easington Colliery that employed about 3,000 men and had an output of 4,500 tons of coal a day. A number of the visitors descended to the Hutton seam that was 1,400 feet deep and extended two miles under the sea. On the surface they saw the dry cleaning plant that was the most modern and efficient of its type before they went to Hordon Colliery, believed to be the largest in the country. The Italian visitors were greatly interested in the highly mechanical developments, the electric safety lamp and the underground stables. After the wreath laying, the visitors went on a boat trip down the Tyne and returned in time to catch the 4.45pm train for London. On July 14th, the Italian group were fortunate to meet the Prime Minister Mr. Ramsey MacDonald at Durham Railway Station and when he was about to get into his car the Italians respectfully gave him the Fascist salute.

Some Italians who had settled in the North East retained strong links with their homeland. They were proud of the improvements

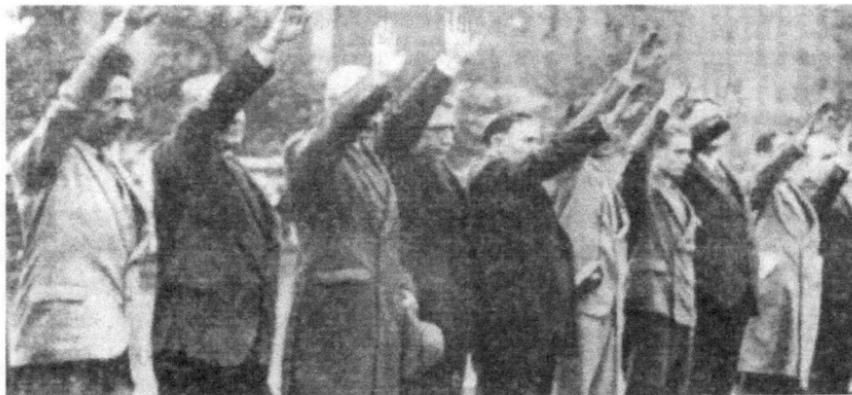

The Italian coal business delegation show their respect for British
war dead at Eldon Square war memorial, June 1935

made in Italy under Mussolini and some had formed patriotic
Fascist clubs that were not linked with British political groups.
Many of them were non-political but very patriotic. The
photograph left shows children from the Italian community at
Newcastle Central Station on their way to Italy for a holiday on
August 10th 1933.

Nearly 130 members of the Italian community in the North
were present at the County Hotel in Newcastle to celebrate the
anniversary of the Armistice and the 1923 march on Rome.
Signor C. Bava, secretary of the Fascio, gave a satisfactory
financial account and expressed that it would be possible to send
more Italian children from the North for their holidays in Italy.
Signor N. Tognoli , the Newcastle Italian Consul, thanked the
Consul-General of Liverpool, Dotter A. Rainaldi, who had
honoured the occasion with his presence, and for coming so great
a distance and mentioned that the large Italian colony in the
North was industrious, law-abiding and patriotic. In reply, the
Consul-General expressed his pleasure at the harmonious spirit
animating the assembly and drew attention to the fact that his
government had been pleased to confer on Signor Tognoli the
title of Cavaliere in recognition of his services on behalf of the
Italian colony in the North. Italians met at the office of the Italian
Consulate in Saville Row, Newcastle, in October 1935 when

Young Italians at Newcastle Central Station in 1933

there was a test mobilisation of the Italian armed forces during a time of international political tension. The Italian population of the district was about 600 and their community leaders sent a telegram of devotion and loyalty to Mussolini. The Newcastle meeting was one of many similar gatherings of the Italian community throughout the world. Speaking after the meeting, Signor Tognoli said: "We cannot imagine that anything will happen to spoil the relationship between Italy and Britain."

British Union Section Commander Crossley arrived in June to complete the branch re-organisation for the area and on the 15th they held a guest night at which Mr. S.C. Crossley outlined details of the re-structuring and also immediately announced he would also hold a meeting in the Bigg Market and in Byker. John MacNab commented on the Durham County Labour Women's' annual Gala held on June 16th 1935 when it made an attack on British Fascists. Mrs. Barbara Gould, the prospective Labour candidate for Hulme said that the idea is getting about that Labour were not patriotic and MacNab pointed out that they concluded the Gala with the singing of "The Red Flag" and wondered how anybody should get the idea that there was a lack of patriotism about the Durham Labour Party. The Saturday sales drives had good results and resulted in some members and Captain Collier went to Hexham and sold all the papers they took with them.

On the 28th he was at Lampton Street in Sunderland and spoke to about 200 people for an hour. There was some attempt at heckling but it was soon overcome and the majority of the crowd listened to the Fascist case. At West Hartlepool, in spite of two

hours of heavy rain, about 200 people stayed throughout the meeting at Stranton Green to hear Collier speak. A Blackshirt sales drive took place at Whitley Bay and the town's first British Union outdoor meeting was held on the Promenade. A local resident placed at the Organiser's disposal a plot of waste ground for the meeting. District Officer Stephenson opened the meeting and SPO Collier was listened to with interest. One of the best ever meetings was held at Darlington on June 20th when he had an audience, estimated by the police, to be about 500 with the majority of them sympathetic.

South Shields fascists held an open-meeting at Boldon Colliery on July 5th that was attended by about 1,000 people. Left wing troublemakers were out in force and police asked that the meeting be closed. The events proved so interesting that a football match that was in progress nearby was stopped and hundreds of spectators went to the meeting.

A British Union meeting was held outside the Boilermakers Institute at West Sunniside on July 12th when Sunderland man George Dewar (30) of Tatham Street was charged with the assault on British Union officer Vincent Collier, resident of 16 Lovaine Crescent in Newcastle. Dewar was fined two pounds and bound over to keep the peace. His cross summons against Captain Collier was dismissed. Accompanied by another Blackshirt, Captain Collier was addressing the crowd at 8.15pm when a gang of about 400 came over, started shouting and the box he was standing on was kicked away. When getting back on to it, Dewar rushed at him and struck him on the head, when on the ground he was kicked by a number of other people. The police stepped in and Dewar and a man named Goldberg were arrested. Asked if he had been provocative, Collier replied "Certainly not. We had been holding our regular meetings for those nights, Tuesdays and Fridays' at the corner of Lampton Street. I enquired at the police station what pitches were available and I was told West Sunniside was one. I took particular care to put my box well down the street so that I was not interfering

with the Anti-Fascist meeting which was in progress and which had started earlier, having claimed our pitch. We have the right to free speech in this country, so long as we do not deliberately cause an obstruction in the streets, to put forward our policy, just like any other people." He added: "The bullies in the street have been unchallenged for too long." The other Blackshirt, John Theodorson, a Sunderland clerk, said they were about 100 yards away and out of sight of the other meeting. According to evidence provided to the Court by Police Superintendent George Cook: "Communists went there to break up the Fascist meeting and they had to be arrested." Mr. Collier was described as a teacher of the Classics in his spare time and had done free lance journalism and had been a founding member of the British Union and has since been engaged in propaganda work for 2 to 3 years.

In July 1935, the Labour MP for Jarrow, Miss Ellen Wilkinson, said "The Communist Party are using the 'United Front' as a means of smashing the Labour Party" and resigned from the organisation. At South Shields the communists had been concerned about growing support for fascism and had been attempting to intimidate the public and prevent them from listening to Blackshirt speakers at the Market Place. On July 17th 1935 at a meeting held by Captain Collier, the Reds tried to form a barrier at some distance from the speaker but a crowd of 500 pressed forward to hear Fascist Gallagher introduce Collier who spoke on the fascist political programme.

The Economic League was speaking at the Bigg Market on July 22nd 1935 when Mr. Collier arrived and opened his meeting. Within ten minutes of addressing a crowd, the Economic League ended their meeting and Collier's audience increased to about 700 (police estimate). There were few interruptions and he was applauded at the end of his talk. There was a public meeting at Wallsend on the 24th in the Borough Fields and Collier spoke to a crowd of about 200. He talked for an hour and dealt particularly with shipping policy and industrial problems

of the North East. At Darlington, he spoke on July 25th and dealt with silly claims about fascism made by Dr. Hugh Dalton and Manny Shinwell. He had a good reception and spent fifty minutes answering questions. On Friday the 26th Crossley and Collier were at Durham and all the copies of *The Blackshirt* were sold to a sympathetic audience. A successful public meeting was again held in South Shields Market place on Wednesday July 31st. Fascist Gallagher opened the meeting and District Officer R. Stephenson spoke the case for Fascism before 500-700 people.

At West Hartlepool a good size crowd assembled when Fascist Cotter opened the meeting on the 14th to make his first public speech and then Vincent Collier dealt with local problems and fascist policy for fifty minutes. The regular meeting took place in the Bigg Market on the 12th when about 800 people heard Fascist Bell and Collier speak. On the 16th a meeting was held at Gill Bridge Avenue, Sunderland, when Theodorson made a good speech and was followed by Vincent Collier. On August 15th Mr. Collier spoke at Middlesbrough at the usual site on the corner of Davison Street and Linthorpe Road. The audience grew to about 300 people and had a successful conclusion. Other activities included a sales drive at the seaside town of Saltburn. The same day, Middlesbrough members visited the coastal town of Redcar where Collier addressed a public meeting and a sales drive also took place when all copies of *The Blackshirt* sold.

A meeting was held at Berwick, near the "Advertiser" office, on Saturday August 3rd 1935 at which S.C. Crossly gave the fascist policy assisted by District Officer Kew, W.D. Stewart and Fascist J. Ray. All copies of *The Blackshirt* were sold. Gateshead had its first Blackshirt meeting for many months on August 8th when Mr. Collier spoke to about 200 people in Warwick Street. Fascist Bell was the first speaker at a meeting held at Brinkburn Street, Byker, on August 13th and then Collier spoke to the large crowd of about 400 people. There was heckling by a number of Reds whose interruptions were resented by the crowd.

An interesting article was printed in the Newcastle Weekly Chronicle on the 10th August written by Mr. H. Phipps Hemming and entitled "Mussolini Restores Rome's Glamour." It went on to say…"Acres and acres of wretched slums have been swept away, the inhabitants of crowded tenements and squalid, unsanitary dens of stone and wood have been transferred to new suburbs and new towns on reclaimed land. Networks of mean streets have been replaced by public gardens. We are clearing away all the unwholesome hovels, purging Rome, letting in air, light and sun" proclaimed Mussolini. "There have been more changes in this 'new-old' capital in the past ten years than in any other city on earth, a truly monumental testimony of Il Duce," declared the writer.

After having settled back home in Monkseaton, another correspondent also refuted the criticism of Italy and said "Having lived there since 1920 and having in that period lived in all the important towns, I believe I may be competent to give an opinion. I have not been in Italy merely as a visitor, but have lived there among the Italians, and come to know them and value their many good characteristics. When Mussolini took the reins in Italy, his country was at least 50 years behind the times. The roads around the "Eternal City" were knee deep in the dust of centuries. Children ran about unkempt and uncared for. Trains arrived hours late if they arrived at all. All these conditions I have seen for myself. I have also seen the pulling down of slum houses which have been replaced by modern apartments for the working classes at reasonable prices, the rents being controlled by the Government. The dust covered roads have been replaced with beautiful motor roads, second to none in Europe. The train service is excellent and now arrives on time, and one has the protection of the Fascist Militia, who are always courteous and helpful. New towns have sprung up where previously malaria infested swamps existed, and surplus population have been moved in to these new areas where they have modern healthy homes and every facility for earning a decent living wage under decent conditions. True, there are things in Italy that might be

criticised but Mussolini's thoughts are for the masses and he does not hesitate to sacrifice the individual for the common good." A South Shields writer calling himself "Getting Things Done" wrote that there is no scared, sullen and dispirited race living in Italy as the press would have us believe, but "in agriculture, forestation and drainage, Mussolini has accomplished more in the last 10 years than was done in a hundred years before the war." He added: "Concessions to the working class are the order of the day - and this is the land that is supposed to be under the heel of a dictator. 'Soaking the Capitalist' in Italy has become a science," and showed the concern for the ordinary people exploited under an unjust system.

This month, Collier was again at Bewick and South Shields where several thousand attended a meeting in the Market Place. Considerable opposition was expected but it soon died down and Vincent Collier, J. Gallagher and R. Stephenson were given a fair hearing. At a later meeting, Communist trouble makers made police intervention necessary. Collier talked on the TUC campaign to implement sanctions to prevent Italian intervention in Abyssinia. He had asked the working class audience if this was the reason why they elected trade union leaders. He said they knew that sanctions could lead to war and said that's not why union officials were elected. Now, they were screaming for war! This was the start of the British Union "Mind Britain's Business" peace campaign that was popular among members of the public.

In the middle of August, the Government 'kinema van' visited Sunderland and a huge audience assembled at Sunniside for a Saturday meeting that got a sample of Red intimidation. One of the audience said "I was disgusted with the conduct of the Socialist hooligans who did their utmost to disrupt the meeting. By what right do they claim a prerogative to annoy every audience that is not of their way of thinking." Another wrote about the hooliganism shown at the meeting by Socialists and said "I spoke to one or two of the interrupters and was promptly told that something serious would happen to me if I interfered... something ought to

be done to put a stop to such conduct at public meetings and the liberty of free speech maintained. I wonder what would happen if the Socialists were interrupted? Supposing some of us formed ourselves into bands in the same manner as they do and attend their meetings with a view of busting them up, what a howl there would be that they were not getting fair play."

A Sunderland man, Thomas Alfred Richardson of D'arcy Street, was fined one pound for acting in a disorderly manner at a BUF meeting of about 800-900 people at Newcastle Town Moor addressed by William Joyce on Sunday September 1st. The speaker attacked the Communist Party and said its aims were as in the last war to start a revolution and stab the working man in the back. Legal representative Mr. Harvey Robson said that Mr. Joyce did not resent the presence of hecklers with their interruptions, but a time did invariably arise when the line was crossed between what was reasonable and unreasonable. Mr. Richardson had been warned by a Police Inspector at the request of the meeting chairman John Francis Crossley but he continued to incite parts of the crowd to be disruptive. William Joyce then spoke on the Town Moor on September 8th and spoke mainly of the Abyssinian crises and that Britain should not go to war on for that country. Italy had procured Ethiopia's admission to the League of Nations in the hope that it would develop to the level of civilisation of other people in the international community. But Ethiopia had shown she had no intention of banning the slave trade or controlling her population of armed tribes that threatened the safety of Italian East African colonies. They were continually invaded and raided with their own weapons that were supplied by the Italian Government to the Ethiopian regime to help secure domestic order. There were some interruptions and heckling but the meeting was concluded without problems. In the Shields Gazette on Sept 11th MacNab wrote of British Union policy "Our attitude has always been that foreign quarrels involving no British interests are not British business... that British blood shall not be shed except in defence of British soil."

Gateshead man George Wilson was working at Sunderland and leaving work on Wednesday September 4th when he decided to attend a large meeting in Gill Bridge Street addressed by Communists. He said: "I gathered that a demonstration in favour of peace had been organised by the Blackshirts for 8pm, but at the Communist meeting, which began at seven, I heard nothing but incitement by those present to smash the Blackshirt speaker Capt. Collier. At 8 o'clock two Blackshirts arrived with a box, one of them Captain Collier wearing a black shirt. One began to address the crowd which surged around him, speaking for about five minutes in the midst of heckling, but when Captain Collier stepped on to the box the crowd began to howl like demons in an obviously organised and concerted attempt to drown his words. Undaunted, the speaker faced the mob of hooligans until police arrived and they told him 'to clear out of it.' Captain Collier protested but closed the meeting. As a Britisher who believed in free speech for all and sundry, I am revolted at the abominable tactics of these so called lovers of freedom, and I have the greatest admiration for the courage and spirit displayed by Captain Collier and his one companion. I am not a Fascist and must say that nothing is more likely to help the cause of Fascism in this country than the tactics of our 'Red' agitators."

A British Union speaker was in Shields Market Place on Monday night Sept. 2nd and spoke about Abyssinia and how it was still a medieval regime and slave state where armed gangs roamed the country and often went on raids into Italian East African territory. On the 8th, four miner's lodges called for a mass rally against Fascism and called on trade unions and churches to support them. Mr. Will Pearson, the organiser, got about six thousand people to attend the rally in the Market Place. It had little, if any, effect on the activities of the local British Union branch who appeared, in spite of all the opposition, as determined as ever to put across the case for a better Britain with Fascism. There was some concern for the branch when local member and speaker Robert Stephenson went missing in late September from his home. He was a South Shields man who eight years

previously, after a tour of America, came back home, joined his British Union branch and regularly conducted meetings in the Market Place. Two weeks after his disappearance, his wife received a letter from him saying he had arrived at his brother's home at Northampton and would remain there until he regained his health. It was thought he had some sort of breakdown but was now improving.

Also on Monday Sept 2nd Capt. J.F. Crossley spoke at a British Union meeting at Durham Market Place, and said that the application of sanctions against Italy would mean war within 48 hours. He said that we were going to war over scraps of paper and that ten million pieces of paper are not worth the sacrifice of one drop of British blood and I urge you Britishers to cry out "We do not want war!" Capt. Crossly urged the assembly to forget all party feeling and unite as one against war.

On Friday September 27th, a Middlesbrough meeting was held in the usual place on the corner of Davison Street and Linthorpe Road and Propaganda Officer Sheville addressed an audience of nearly two thousand people. There were several attempts to incite the crowd to violence against the Blackshirts but the speaker held the platform for two and half hours and gained the praise of the audience. A number of interested people followed the Blackshirts to their office at 50 Borough Road. The Blackshirt meetings had now become regular feature in the town.

On October 8th a number of people turned out on a cold night to hear BUF speakers at Gill Bridge, Sunderland. Suddenly there appeared on the scene about 500 people who had abandoned an indoor meeting of the "Friends of the Soviet Union" and were determined to stop and smash the BUF meeting. The leaders of the Red trouble makers were cautioned by police and their noisy efforts were unsuccessful. It is unfortunate the Soviet "friends" could not experience the ideology they professed to believe in. The Russian method of dealing with hecklers was explained by Mr. R. Wale, formerly a leather worker in Petrograd. Addressing

a meeting of the Workers Liberty and Employment League, he said that it was a pleasure to him to speak at a public meeting, and even to be heckled for he had recently come from Russia where no such freedom was permitted and no criticism of Soviet methods was allowed. He had seen a meeting hall surrounded by Soviet troops, and men shot down and taken prisoner as they left. He had known men dragged off to be shot because they had heckled a Soviet speaker. On the same day, the Deputy Mayor of Gateshead, Alderman S.A.E. Ellis, attending a dinner in connection with the Borough's local government centenary, said about socialism in practice "Are ratepayers and those who pay no rates coddled by motherly municipalities? I sometimes wonder whether we don't coddle folks too much, whether there is a danger that those being looked after are losing their self-reliance and depending too much upon the state...we have to look after people from the cradle to the grave, nay, even before they get to the cradle. We have to adopt them, feed them, look after their health, teeth, their eyes........"

There was a midnight film performance at the Haymarket on Oct 9th in aid of Jewish refugees when three Blackshirts arrived to sell their newspapers and one newspaper correspondent said that it was "sheer vulgarity" for them to do so. A Newcastle writer replied "It may not have been in good taste... has your correspondent ever asked himself why there exists in the world the sentiment of anti-Semitism? Fascism claims that it will destroy racketeering and see to it that the sons of Britain get their chance of sharing in the benefits of the plenty with which we are surrounded."

An article appeared in *The Blackshirt* on October 25th that told the story of a South Shields fascist seaman who put the case of fascism forward in a debate at the Communist Club in Odessa! During his ships stay in Vladivostok he saw long queues of men, women and children herded down to the quayside. A Soviet official then called out the names of the unfortunate victims who were driven like cattle and sent off to what was called "The

Northern Isles." Russian's working on the ship worked all hours and food was scarce. When a small number of the crew were offered food by the Tyneside fascist, the Russians took it furtively and were fearful of being found out. When in Odessa he was challenged to take part in a debate at the Communist Club. The Reds were represented by a Soviet professor and an interpreter was used during the debate. When the fascist mentioned the conditions he found in Vladivostok he was howled down and later forcibly thrown out of the club.

A similar story was told when the little steamer Bausen made its way up the River Wear to the Ford Paper Mills at Hylton in March 1937 from a Russian port on the Baltic. On board she carried as second mate Alexander Boonus who had escaped from what he emphatically described as "a perfect hell." His story was that as things were slack in the Pacific Coast fishing trade, Mr. Boonus had been attracted to Russia from Western Canada in 1932 by Red propaganda. He was told that Socialist Russia was a land of milk and honey...plenty of work, money and happiness. He had caught a boat to Russia with 260 other men, women and children who had the same vision. "Now," he said "they had become wise to the fact that it was worse in Russia than in their own countries and that a great number of people had been duped." When they arrived "We had our first dinner in a railway restaurant and it was the last decent meal I had for about four years." Asked what conditions were like on the trains he replied "they were probably the filthiest in any civilised country." He was also accused of being a spy and badly treated by OGPU agents (secret police). If Mr. Boonus had not been a naturalised British subject he would have suffered worse hardships and would have been unable to leave the country.

In the middle of the month District Officer John R. Crosby of Trimdon Colliery wrote in a British Union paper of the conditions of the miner and that they worked for £1 12s 8p for a five day week with deductions for relief funds, doctor, hospital welfare, union and so on. Boys of 14-16 years of age receive 12s but if their father is out of work, they are means tested and

usually work for nothing. A meeting was also held at the Labour Exchange, Middlesbrough, on Oct 22nd when Mr. A.C. Miles addressed the unemployed. He dealt with the hydrogenation of coal that was of great interest to his audience on account of nearby Billingham's ICI factory that has just put into operation a new coal oil plant. Later in the evening, he was in Davison Street where about 1,000 people listened for an hour. Alec Miles was recruited from the ranks of disaffected Socialists and had been active in Gateshead ILP's Guild of Youth.

On the same day in Newcastle, despite the very cold weather, about 500 people listened to Vincent Collier in Byker. He spoke for an hour and was not interrupted until question time when a group of children brought in by local communists created some noise and tried to disrupt the meeting. Mr. Collier had said the next election would see the usual baby kissing by candidates but when the excitement died down people will realise they have been tricked again. Mr. Bell had opened the meeting and it was successfully concluded. At Durham, Mr. Alexander Raven Thomson addressed a well behaved meeting and said that the general election did not concern the fascists who were not contesting it. He said they would turn their attention to the real enemies of the British people - the big despots at the top and that the government was run by financiers and fascism was the only way out. Collier spoke to about 350 people on October 31st in Darlington's Market Place. He attacked the national government and exposed the so-called democratic system as a fraud.

During October, Lloyd George, who was known as the "Father" of the House of Commons, expressed his opinion at his fourteenth adoption meeting at Caernarfon that Mussolini was one of the strongest men who had appeared on the political horizon in his generation. The present British Prime Minister he described as a man possessing a variety of attractive gifts of talent and temper, but, he added, as the head of an enterprise he lacks energy and drive and the business aptitude or industry to pull through a concern in time of exceptional trouble and depression.

Speaking at Durham Town Hall on Monday evening October 28th, the Director of British Union Policy Alexander Raven Thomson addressed a large audience. He was a Scotsman who had studied philosophy and economics at Scottish, German and American universities and for a short time had been a member of the Communist Party before joining Mosley at the age of thirty-four. He said: "We are not fighting in this next General Election, we are withholding our forces for the next time. Do not come to the conclusion that we are too weak, the Blackshirt organisation has 472 constituency organisations and we are well on the way. But this election is being fought under most abnormal circumstances. You are asked to vote upon a matter of foreign affairs, and if we were in the election you would be told that a vote for Fascism would be a vote for Mussolini. Our interest is in British affairs and this election is to be fought on something that does not concern British people at all. We are in favour of re-armament in an armed world. We are disarmed enough. The Socialists do not want re-armament but they want military sanctions against Italy. But how do you apply military sanctions against a country like Italy if you deny this country the necessary forces to carry them out.

Raven Thomson continued: "It is obvious that those who support the Labour Party are going to be defeated. It will be the fault of the leaders who spent more time worrying about the slave owning Abyssinians instead of the Durham miners. The Abyssinians owned two million slaves. I understood Socialism was against all forms of slavery but they seem to think it is our duty to shed our blood in defence of slavery in Abyssinia... We are on the verge of a coal strike. What is the use of going on strike when the employers have got such huge stocks on hand that they cannot sell? Strike action will get no improvement because it will suit the employers. We would like to see the miners get 2/- extra per shift. I believe this to be economically possible but a strike would be a dangerous thing. The whole balance is on the side of the employers in such a fight. The alternative of the Socialists is political action within the democratic system... they

will be defeated because the democratic system is rotten. The rank and file have been lead astray by their leaders."

Speaking of the great financiers as being the despots of this country, he said: "They ruled and their block capital dominated the country. The small trader and the co-operative movement were being broken down by big finance. These financiers believed in competition being 'the breath of life,' but it was not breath of life for the small shopkeeper against the multiple shop; it was strangulation.. Fascism would mean the dictatorship of the will of the whole people. It was a disgrace to think there should be poverty in the midst of plenty; the class war was a grizzly relic of society in an age of plenty which ought to be an age of co-operation between classes. Industrial action and political action within the democratic system had been tried, but Fascism proposed to try power action. Power action meant selecting a leader and giving him power to carry through their will. It will mean the end of the multi-party political system. It will be smashed up, and a new system of government will be set up on an occupational franchise. Thus you will be set free from the tyranny of high finance." After the war, Raven Thomson joined Mosley's Union Movement and remained his personal secretary until his death in 1955.

It was announced in November that a new weekly publication would start in the New Year. It would be called "Action" and cost 2p and would be sold on the streets of Newcastle.

The Leader of British Union was at South Shields on Sunday November 3rd 1935 where he spoke at the Palace Theatre in, High Shields, from 8pm to 10.30pm. Members of the far left and communists came to stop the meeting and the first twenty minutes were hectic. Mosley said "This great audience has come to hear what I have to say, and it is going to hear the Fascist case, and we shall not permit a small minority of the audience to prevent you from doing so. I therefore give warning to those trying to prevent me from speaking that if they continue they will

be ejected from this meeting with the minimum force necessary and outside they will be handed over to the police. Anyone who wishes to ask questions will have an opportunity to do so. Free speech, in the old tradition of this country, has come to an end for a long time past because there are organised bands of red hooligans trying to make free speech impossible. We have never interfered with the meetings of our opponents. There is not one single case on record of a Blackshirt being charged, let alone convicted, with interfering with an opponents meeting." After Mosley had been speaking for a short while, about another thirty people left the meeting in a group. Mosley, while pausing, amusingly said: "We will just wait for one moment while the battered remnants of the Red Army leave the hall". That got much laughter and applause. Altogether, about 50 people were removed from the hall and the meeting proceeded in an orderly manner. Mosley went on to denounce the system of international trade and finance as being responsible for the impoverishment of both producers and workers in this country. He said: "All the other parties were in the grip of the international financiers of the City of London and Wall Street. Fascism alone was a national movement." He advocated a restriction on investment of British capital abroad and the development of the home market, which he claimed would be sufficient to absorb all the produce of British industry if it was adequately protected against cheap foreign competition. Later that evening, after the meeting a number of fascists were attacked and injured on their way home. One was brutally attacked by hooligans in a dimly lit part of Meldon Street and a bus taking British Union members back to their headquarters at 109 Westoe Road (corner of Spohr Street) that was held up at traffic lights was stoned by Communists in Dean Road.

Although the Fascists were subjected to violence and disruptive behaviour at their meetings, they were not the exception. In November, the Liberal MP Tom Magnay was the victim of unfair tactics by the rowdy element at Whitehall Road School that disrupted the meeting and the treatment given to the Newcastle Central candidate at a meeting in Gibson Street was

described as "disgraceful and detestable and there was not a moment given to any kind of order." A member of the audience at another meeting wrote: "I have never been present at such a disgraceful exhibition of rowdyism in my life. A large number of hooligans shrieked and howled at a man who had spent the best years of his life doing what he could for their betterment. I too came from a home where the means test had been applied but I know who was responsible for that - the Labour Party." During the November election, the Seaham Division was seething with disgust at the organised terrorism of "Reds" which had broken up three of Mr. Ramsey McDonalds meetings in two days. Mr. McDonald said it was quite plain "that Mr. Shinwell justifies it, because he says what can you expect?" He added: "It is one of the results of an alliance between Communists and Labour throughout the country. People with decent feelings, however, are disgusted with it." Another member of the public attended a meeting in Herington Street to hear a National Government speaker and had came away disgusted at the behaviour of Socialists and said "On many occasions the language of some was simply vile, the much vaunted Englishmen's love of fair play was non-existent, and any self-respecting citizen, to whatever party he belonged, must have come away wondering whether it was a meeting of English people or one of the backward races. After last night's exhibition any inclination one may have had towards voting Labour would have been definitely destroyed."

The Evening Chronicle editorial wrote: "Who is behind the organised rowdyism which is making itself manifest at political meetings between the Tyne and Tees, National Government candidates being the target? We must emphasis this because we know of no Labour meetings having been broken up by hostile National forces. In the old days, hilarity at General Election times accompanied by throwing soot and flour was fairly common... The present intimidation is a deliberate attempt to prevent one side being heard... The only good thing we can see in this sort of behaviour is that it throws a vivid light on what we might expect if ever the 'Reds' got the upper hand in

this country. All opposition would be stifled, and the House of Commons would ring to one tune 'The Red Flag.' It is the spirit that will not tolerate the opposite view. How could any intellectual life be conducted - a discourse, or even a sermon - if listeners continually jumped up and shouted 'That's a lie' on hearing something unpalatable to them? The great and lofty issues which were to hold the interest of the voters have been lost sight of, and the atmosphere has turned cold." When Mr. J.H. Thomas tried to speak at South Shields he was greeted with such a chorus of shouting that he was prevented from being heard. He offered to let anyone in the hall go on to the platform and speak for 15 minutes on condition that he was given a hearing afterwards. His proposal was received with a fresh outburst of boos. He said "This hooliganism only convinces people how hard they must work to prevent a mob like you ever governing this country." Although the popular press wasn't so sympathetic or understanding when British Union Blackshirts and members were attacked, it was something they had to suffer from their violent opponents since the start of their movement.

Physical violence against political opponents was stock in trade for communists but there were more insidious methods such as infiltration of established groups. A South Shields Socialist Councillor Albert Gompertz was annoyed and called it impertinent that a Red leaflet headed "Defend Austrian Independence" called attention to a series of meetings addressed by Socialists. He said "These meetings are held under the auspices of the South Shields Labour Party and we emphatically repudiate that it has anything to do with the Communist Party." Councillor Gompertz was Secretary of the local Labour Party and Trades Council and added: "We consider it nothing short of impertinence for the Communists to include on their hand bills meetings that are being held under our auspices." The Communist Party attempts to be affiliated to the Labour movement had been repeatedly rebuffed due to their disruptive influence and for getting their orders from Moscow and not the party membership.

Labour's Councillor Gompertz later entered into correspondence with British Union member Margaret Collins when he doubted the case for Fascism. She replied: "Fascism will abolish the system of international capitalism and replace it by a national planned system, wherein industry will produce primarily for the home market which is, in fact, the total sum of the wages of the British people. It is, therefore, in the interests of both employer and worker that wages should be as high as possible in order that the goods produced may be consumed. Our policy in regards to the mining industry is the elimination of all foreign imports of petrol and oil and the manufacture of these products from British coal, thus giving work to 94,000 miners and 50,000 oil producers. Mosley's practical policy for the mines includes the immediate imposition of a national agreement guaranteeing a real living wage to the mine-worker. The immediate re-housing of miners where necessary, immediate provision of pit head baths and the installation of adequate safety regulations and inspection and the abolition of the royalty system without compensation except in special cases where social service can be shown."

The South Shields Red comrades would have been shocked at the Russian Communist dictatorship that oppressed, starved and murdered its own people and would have promptly transferred their allegiance elsewhere if this was known. One story that came out of the Soviet Union told of a band of pilgrims, headed by an old peasant from Ryazan, who had recently visited the Lenin mausoleum in Red Square, Moscow. Above the tomb on a marble slab are inscribed the words "Lenin is Dead, but his works Live." On reading this inscription, the old peasant, in the fullness of heart, blurted out "Eh, Ilitch, Ilitch! It would have been better if thou were alive and thy works dead." The humorist was promptly arrested for this blasphemous utterance.

Newcastle's Vincent Collier was in the Bigg Market on Monday, November 4th, when police had to remove one persistent interrupter from the meeting.

Sir Oswald Mosley spoke on Wednesday 6th November 1935 at Newcastle City Hall and attracted a large crowd for the indoor meeting. At the start Mosley warned the Red element of how their communist comrades had been thrown out at South Shields and announced: "We are going to have order at this meeting tonight because we have Blackshirts in charge. We are not going to have this meeting broken up," he said calmly. "Anyone persisting in interrupting will have to get out. We don't interfere with the meetings of other parties and we are going to let the public hear our case." Three Reds were ejected for trying to stop the proceedings and there was no further trouble and he was able to proceed with his speech on British Fascist policy and the meeting ended in an orderly manner. The Blackshirts headed by Mosley then marched back to their Lovaine Crescent headquarters without further incident.

In the middle of the month, when Bill Risdon addressed a public meeting at Darlington's Temperance Hall it was packed to the doors and over 200 people had to be turned away. He explained the Corporate State and delivered a powerful criticism on the "democratic" system of today. At the end of his speech there was prolonged applause and he had to deal with many questions. The meeting finished with an enthusiastic singing of the National Anthem. Despite the cold weather, speaker Vincent Collier was again in the Bigg Market on the 25th and held a large audience for two hours without any interruptions or heckling.

The Sunderland Echo did an analysis of the November elections and described Fascism as a movement of the Right with an "extremist policy." The BUF took exception to the description and replied "The Right is the party of big capital and international vested interests, and while Fascism opposes and is pledged to exterminate the Bolshevism of the extreme Left, it is equally pledged to subordinate the Right, that is, the interests of international finance-capital, rigidly to the welfare of the nation. We are only extremist in that we demand that the criterion of every British policy and every British activity shall be the welfare of the British

people as a whole. In all things, you state, the Englishman favours compromise and safety first. This seems to conflict with our ideas of Drake, Clive, Nelson, Rhodes and all those who have made England great. We aim at security indeed for the mass of the people, since this is true economic freedom; but the leadership of the nation must be organized and composed of men prepared to dare all for England." (Dec 7th 1935)

1936: This Nation is Not Down and Out

At a badly advertised and poorly attended meeting at Morpeth Town Hall on a cold and dark night of January 11th 1936 the speaker, Vincent Collier, the Propaganda Officer for the Northern Counties, said no doubt we shall make up in quality what we lack in quantity. He said "We still have our job to do... the task to which we have set our hand. We should be doing exactly as other preceding generations have done, facing up to the situation which confronted them and by trying to find some solution." The remedy he proposed was no quack remedy. They did not in the first place imitate party politicians by playing up to the electorate for the sole purpose of obtaining their votes. The British Union tried to inculcate in people a sense of responsibility to themselves and to their fellowmen. They did not make rash promises and would have no truck with the opportunist who was prepared to make promises with his tongue in his cheek, knowing full well that there was no possibility of those promises ever being fulfilled. They believed there must be a revolutionary change, first of all in the individual outlook of the people. It was essential that the people should feel they had a sense of responsibility in the conduct of the affairs of the nation. They did not condemn individuals but they condemned the system. It was no use carrying out a system of Capitalism which was proving unworkable in the 20th century world. They would not make the mistake the Socialists made - the mistake of condemning capitalism as a whole, and that private enterprise was wrong. They believed on the contrary, that private enterprise provided the urge to do things and to achieve something. He added "This nation is not down and out. The Parliamentary machine must be adapted to the needs of the age and to build up a new and higher standard of living. Time and time again the people of Britain have voted for action to

remove unemployment and poverty from their midst but there has been no progress. We have a typical example in the state of the mining industry. The miners are a wonderful body of men which faces danger daily. They play a noble part in the life of the nation, yet they have fought consistently since the war for better conditions to which they are entitled. Well, in spite of the lockouts and strikes their earnings have been reduced by 31 per cent. We live in the shadow of another great strike. The strike weapon is not a very good one. He said that "Although the strike was a two edged sword it was all that the miner's had under the present conditions. Fascism had often been accused of being opposed to the trade unions. It should be clearly understood that this is utterly untrue. Fascism is opposed to the leadership of trade unions being used by individuals to advance their own political careers. The future of coal mining," he said "lay in the extraction of oil from coal which would be the salvation of the mining industry."

At this time, as there is no further mention of Captain Vincent Collier in the North East it is possible that he was transferred elsewhere. As he was a teacher of classical literature, he found work after the war in a private school in Kensington. After some considerable publicity in the North West for a planned BUF meeting, Carlisle magistrates decided to refuse the application to enable a Sunday meeting at Her Majesty's Theatre in Carlisle on January 28th 1936 that was to be addressed by Sir Oswald Mosley.

It was suggested by some young and energetic Newcastle branch members that a "Harrier Group" participating in a weekly road run might well provide a unique publicity opportunity and throughout most of 1936, a group of "Blackshirt Harriers" would be seen jogging around various districts and locations on Tyneside most weekends or evenings and often doing a "publicity chant." It noticeably contributed to a comradely team spirit among members from widely different backgrounds and helped to throw off the reticence and shyness of the younger members.

Sir Oswald Mosley had taken out an action of slander against John Marchbank, the General Secretary of the National Union of Railwaymen and was in court at the end of January. Marchbank had alleged at a meeting in Newcastle on July 15th, 1934, that Mosley had sent secret instructions to his supporters to infiltrate the armed forces and recommended members to arm themselves with clubs filled with shot, knives and knuckle-dusters and so on. When Mosley was asked by Sir Patrick Hastings "Have you ever issued instructions in writing in regard to carrying weapons at any time," he replied "Yes, forbidding (British Union members) the carrying of weapons at any time." The jury found in favour of Sir Oswald as the allegations were not only disproved but were admitted by his opponent in the witness box to be untrue and went as far as to say that he himself had written the alleged instructions.

There was another quiet and orderly meeting at Durham Town Hall on Tuesday, February 18th 1936 when Mosley spoke to a packed house. An article on his speech in the local *Durham County Advertiser and Durham Chronicle* is here reproduced:

"If Britain had nothing else for which to thank the Blackshirt movement they can at least thank us for restoring free speech and decency at public meetings" was the first remark of Sir Oswald Mosley, Leader of the British Union of Fascists, when addressing a large crowd on Tuesday night in the Town Hall, Durham. The whole of the seating accommodation of the hall was occupied and many were unable to gain admission. Sir Oswald had a most orderly meeting in which there was not a single interruption and at the close he answered numerous questions. A Fascist Government, said Sir Oswald, would be designed not for talk but for action, because they believed that the first necessity in Britain today was action by the government and the government could not act until it was given the power to act by the people. In three years the Fascist organisation had grown from nothing to 500 branches, that was a record not only in this country but in any other country of the world. It was alleged that the Fascists

wished to govern against the wishes of the people. Of all the absurd charges against them, he thought that the silliest. They were more dependent upon the will of the people than any other party for the simple reason that they stood for great changes and wanted to do great things. They could not bring a revolution to the life of a great country unless they had the support of the people and their passionate enthusiasm.

They would seek their powers legally and constitutionally by the vote of the people at a general election. The first act of a Fascist Government would be to pass a general powers measure. Such a government would enable the people to have the programme carried out for which they had voted. The present parliamentary machine was designed a hundred years or more ago not to get things done but to stop things being done! The only institution in the country which has never been rationalised or modernised was the parliamentary machine upon which all else depended. Today, in the name of freedom and rights of minorities, the will of the majority as expressed at elections was for ever frustrated.

Mosley proceeded to speak of what he described as "the tyranny of finance" in this country and referred to it as "the government behind the scenes while the little puppet show at Westminster went on in the front of the scenes." They would never secure a proper standard of living for the workers of Britain, for which he had fought for years, until they turned their backs upon the international system and realised that within the British Empire, thanks to modern science and the conquest of mind over the material environment, we possessed the power to produce every conceivable commodity which mankind required. Internationalism belonged to the last century, he said, and was dying before their eyes. If they clung to it much longer they would die with it as well. High finance in the City of London was the real government of Britain, the master of the nation. They must first destroy the international idea before national action could be taken.

Dealing with industrial matters, Mosley said that by excluding foreign petrol and oil from this country they would be able to put back into work 90,000 miners. Even on a small scale petrol was being produced from British coal at seven pence per gallon. The one thing preventing that development today was international finance. So strong was that interest that it could forbid any party from carrying out a national policy.

Answering questions, he said they believed in complete religious toleration. As to banking, they would establish a banking corporation to control finance as they would have a corporation in every industry. The corporation would be governed by rules laid down by the state within which the industry might operate. A question was asked as to the League of Nations and Mosley said it had been perverted to a purpose exactly opposite for which it was intended. Before they could have collective security they must have the collective spirit. France would go Fascist and Britain would also certainly go Fascist and then with Fascism in all the great countries of the world there would be established collective security. In dealing with their efforts to eliminate disorderliness from their meetings, Mosley uttered the remarks quoted above. He said he believed the best hope of world peace was the closest co-operation between Great Britain and Germany. The proceedings closed with the singing of the National Anthem.

In 2004, while having a pint at the Chesterfield Public House in Benwell, Barney Moran, a relative of Thomas Patrick (Tommy) Moran, would recollect to a local Nationalist that the family had many photos of Tommy in the BUF uniform and that, although only a small boy, he also had one. Tommy Moran was the son of a miner and born on Scotswood Road. He had been an officer in the Newcastle West Labour Party and was one of the earliest Newcastle British Union members. He was educated at a Roman Catholic school in Newcastle and served an apprenticeship with Armstrong Whitworth and Co. He served in the Royal Navy during the First World War and remained in the service as an

engine room man. During this time he won the cruiser weight boxing championship of the combined fleet. Around 1934, he was called to work for the British Union in Derby and went on to be responsible for the organisation in South Wales and had a great reputation representing fascism in industrial districts. In 1936, when the police fought to clear Communists out of Cable Street, in other areas Blackshirts were attacked by gangs of Red thugs and Tommy was one of those injured. He went down from a blow to the head from a chair leg wrapped in barbed wire. He got up, blood pouring from an open wound, and put his opponents down. Tommy wrote about his Geordie roots in 'Action' on July 23rd 1936 and spoke of the area where he grew up, his working class roots and his pride of being a Tynesider:

Tyneside: Tommy Moran Pays Tribute to its History

Few people in any part of the civilised world can have suffered more from poverty than the people of Tyneside, and yet from this centre the whole world has derived the benefits of some of the finest technical brains known to history.

In the early days of the industrial revolution we had engineering establishments being erected all along the banks of this river, from which have emerged engineers and technicians who have revolutionised the industrial world.

Lord Armstrong startled the world with the development of water pressure, and his hydraulic cranes were capable of lifting 250 tons. Bridges weighing thousands of tons were made to swing round to allow ships to pass to and fro and even British Naval artillery responded to the same delicate pressure. It was in the workshops erected by Armstrong that rifling was introduced in guns of all calibres, and so, by creating greater velocity and accuracy, the distance that projectiles could be fired was considerably increased. A humble fitter, George Buckam, was employed by this firm: not content with his daily labours, he

spent his leisure time at experimental work and at last perfected the screw breech block which is now used throughout the whole world for naval and military artillery.

Speed on Water: Charles Parsons, another perhaps still more famous engineer, experimented constructively. The people of the world were aghast at the speed he attained on the vessel which is certainly one of the most famous that ever sailed out of Tyneside. The Turbinia, a small craft, little larger than a motor boat, was fitted with the first steam turbine by him. It tore through the seas at incredible speeds, the first, which by example brought millions of pounds to Britain and revolutionised world shipping.

One could continue adding to the achievements of the sons born midst the grime and smoke of this wonderful, dirty little river, but to what end? These brains had the assistance of millions of the world's most highly trained artisans, men of unassuming character who considered the wonderful results of their labour as being all in a day's work. During the nation's hour of need, when every sacrifice was demanded of every individual and Admirals and Generals were clambering for munitions, the brains and brawn of Tyneside's womanhood and manhood were devoted night and day to unceasing effort to satisfy the demand.

Saving Britain: Guns, bombs, ships, shells, aeroplanes and coal vomited from the old Tyne in a never-ending stream. Some of the finest ships that have ever added glory to the pages of Britain's history were built on the Tyneside's slipways. Her artisans strained every nerve to turn out such superlative vessels as Agincourt, Malaya, Resolution, Furious, Courageous, Canada, Centaur and Concord, followed by many other smaller craft - quite apart from repairs to injured warriors of the deep, in a relentless endeavour to serve the nation's needs - the Lion, Tiger, Invincible, Marlborough and the Broke.

Thousands of willing hands applied themselves night and day to make these vessels seaworthy again. Millions of tons of coal

poured into the holds of ships brought from collieries for miles around the river to keep our ships in action and to guarantee food to our populace.

Epilogue: What a river, what men! The war ended and soon they came to realise that the only use the country could now find for them was to leave their skilled hands idle and to allow their bodies to waste through malnutrition. They struggled on in their efforts to survive and proved their skill by turning their endeavours to still other productions. Locomotives, paints, brushes, chemicals, every conceivable commodity was turned out in the efforts to keep alive their industrial prowess. But the odds were too heavy against them. Cheap commodities (from the Far East) ruined their markets, and as a result, derelict is now the unworthy title and reward that democracy bestows upon the district and its people.

Starving thousands, grasping the crumbs that a shameless government allows as their only means of subsistence, fight for existence. With bodies wasting and brains decaying, their shipyards overgrown with weeds, and for miles around collieries closing down, the people are waiting patiently for the turn of the tide on this famous river. Slowly, but surely, they are realising that the tide can only turn on the tide and era of Fascism.

In 1937 Tommy was posted to Northampton. He was married to Toni, the woman who was his wife for the rest of his life. She had been a regular BUF speaker in Manchester and had a daughter by a previous relationship who was Joan Rhodes, the strong woman who made a name for herself tearing telephone books in two with her bear hands. Toni looked Jewish and spoke Yiddish but was a loyal supporter of Mosley's policies. She was even a speaker for Mosley's post-War Union Movement in East London and when Jews began to shout insults she would stun them into silence by directing a barrage of obscene abuse in Yiddish at them. At a by-election held at West Ham, Silvertown, in 1940 Tommy stood as the British Union candidate on a platform of immediate

peace with Germany but it was far too late for the party to do anything and he received a poor, and expected, one per cent of the vote. When Mosley was detained on 23rd May 1940, it was Newcastle's Tommy Moran who administered British Union as Acting Leader for a few weeks until the party was banned. He was later detained under Defence Regulation 18b and interned on the Isle of Man until released in 1944. He then went on to set up in Derby "The Order of the Sons of St. George" and after the war in 1948 he took the group into Union Movement. He eventually fell out with a number of people and left the party for a while but at the end of his life, he was reconciled with Mosley and UM and Jeffrey Hamm attended his funeral on behalf of Sir Oswald.

Another Newcastle Blackshirt was George Eckert who worked as a car mechanic on Scotswood Road near the Hydraulic Crane. A Felling BUF member was Harry Miller who said that they held meetings at the Mechanics Institute just off Felling Square. Heslops Local Advertiser, published at Caxton House on Felling High Street, in November 1933 mentions Fascist speakers in Felling Square. Gateshead British Union member Walter Robinson was introduced to the movement by Yorkshireman Billy Angus who had lived in Highfield Road in Deckham. He said the organiser at the time was a Mr. Pezzone who had a physical disability and lived in or about Chester Place at Bensham. He had a hardware DIY shop near Sunderland Road end beside the Empire. He thought the branch had about 80 members and two of them travelled up from Kibblesworth. Walter had attended one of Mosley's big meetings on the Town Moor (he received a scar near his mouth when the Reds attacked) and another at the City Hall. His father did not share his politics and was a great Methodist man but would not allow him to change into his uniform at home in Cobdon Terrace. Walter said there were many times when they formed up outside the Gateshead office and marched to the High Level Bridge where they paid 1/2p at the toll booth to go across to Newcastle. He remembered one of the Blackshirt sayings was "You can't preach politics to an

empty stomach" and this developed a "real" socialist spirit in the British Union ranks. When war was declared Walter joined the army reserves but was refused permission to join up. He worked on munitions at the Gateshead Close Works and was also active in his trade union. He also remembered another local member as Bill (Willie) Thomson and Newcastle's Burt Dunn who had lived at Crowhall Towers in Felling.

In June 1936 Shields Communist Anthony Lowther continued to misrepresent British Union policy and Angus MacNab said: "The British Fascist policy is really very simple. It is a demand that the welfare of the British people shall be the first consideration of Government and that all our vast Imperial resources shall be mobilized to increase the standard of life of our own people, instead of allowing Britain to be the playground of international interests who care nothing for the welfare of the masses." Later, Mr. Lowther went on to say that "A country controlled by the working class has no intention of attacking any other country by declaring war" and was told by "Church Worker" that the working man who represents the majority has no control over armaments, not even in Russia. The Russian worker's ignorance of state affairs excludes him from pulling the strings of Soviet intrigue, and this was the obvious privilege of the nation's minority. Moreover, he added, all communist nations must be loyal to one another and in the event of a communist nation launching an attack on Britain or her colonies the communists would refuse to fight and simultaneously issue pacifist propaganda. "Church Worker" had attended Mosley's South Shields meeting at the Palace Theatre and became a British Union supporter. He added: "In accordance with what I understand to be the true British spirit of self-defence, a Fascist government would encourage the Cadet Corps and the Boy Scout Movement would be stimulated. I am not unmindful of the fact that the man who is prepared to fight is often a man of peace. In my opinion Fascism will banish class war and would eliminate all wage cuts, strikes and lock outs by making trade unionists and employers the joint directors of national enterprise."

Mr. Lloyd George had visited Germany in September 1936 and afterwards said: "I talked to many of these young workmen, both middle aged and young, and they admitted frankly that their Workers Councils with the right of appeal to the district arbiter or judge were a great advantage and produced quicker and more definite results than the old method of strikes. More than one of them said to me that it was a good thing to have got rid of what they described as the 'political trade unions.' They preferred to keep questions affecting the conditions of their working life out of politics. John Burns, Henry Broadhurst, Thomas Burt, and most of the old trade union leaders were strongly of that opinion when it was decided to incorporate the unions in a political party." G.D.H. Cole in his essay "The Socialist Control of Industry" stated: "Among the regulations which it will certainly be necessary to issue at an early stage will be…regulations giving the trade unions the statutory right of negotiation such as Mussolini has done to the Fascist unions in Italy." Such comments from eminent people did not appear as though "trade unions had been smashed" in those countries or the workers repressed.

MacNab was again at loggerheads with Lowther when he said that the Communist Party was financed from Russia and Lowther said he wanted proof of it. MacNab said "The evidence I gave him was that of the extreme left wing Member of Parliament Mr. McGovern… the fact is that the Communists hate the blunt statements of people like McGovern because these men, while advocating extreme Socialism, refuse to have anything to do with the Communist International. They think in terms of the welfare of the British workers they represent and their policy is a great deal nearer to National Socialism than is either the finance-controlled Labour Party or the Moscow-controlled Communist Party. We disagree with the policies of the ILP Socialists, but we do recognise that they speak for themselves and are not the mouthpiece of any international organisation, whether financial or Bolshevistic, and when McGovern plainly states that the Communist Party gets its funds from Russia and the statement is allowed to pass unchallenged at a Socialist congress, we as anti-Socialists are entitled to accept it."

There was some unpleasant correspondence in the North Mail when "Ex Front-Liner" taunted Fascists as being unwilling armed forces conscripts and he repeated the gibe of Lady Oxford and Asquith, suggesting that if Fascists wished to wear uniforms they should join the army. Fascist J.A. MacNab replied "All these sneers we are all very familiar with; they always come from those who are unable through ignorance or lack of political sense to criticise our actual policy. Ex Front-Liner does not refer to this policy, so we may assume that he neither knows nor cares what it is, but is only interested in trying to heap ridicule upon us. Ridicule never killed any great idea. The Germans had to put up with scorn and contempt, but in face of the iron necessity of facts, the people recognised their policy and leadership were the only one's to save Germany. We claim a similar right to lay our policy before the British people and are perfectly content to abide by their judgement. If the British people do not want Fascism after they have heard its policy, all they need to do is to withhold their vote." Soon afterwards, on June 13th 1936 "Another Front Liner" correspondent wrote alleging that the British Union was built up by Left-Wing revolutionaries, but as soon as it was established the movement had got rid of them. MacNab pointed out that the organisation was built up by adherents that came from both Right and Left and that far from being "got rid of" John Beckett, former ILP Member of Gateshead, was editor of party newspapers; that Bill Risdon, former ILP agent, was now in charge of election plans; and Mr. Raven Thomson, an ex-communist, was Director of Policy.

Blackhall Colliery Band refused their services to a communist controlled Means Test demonstration in September. Mr. T.W. Orr, a subscriber to the band, requested the president of the band, Councillor E. Chicken, to meet a deputation but he replied "I beg to inform you that the band is an entirely independent institution who will accept or reject engagements as they think fit. If any contributors are dissatisfied they can cease their contributions by giving notice at this office. I am meeting no deputations to discuss the management of the band." Mr. Orr

later received a postcard from West Hartlepool that said "The day will come when all you Reds will be cleaned out of Durham and every corner of the country."

On September 25th British Union Press Secretary Margaret Collins, the Assistant to Angus MacNab and whose sister he later married, wrote in the North Mail that "At the Trade Union Congress, Mr. A. Finley referred to Fascism and the attacks on the democratic institutions." She went on to point out: "With regard to Fascism, in Britain, under a Fascist Government the trade unions would be maintained and strengthened. At present they represent about 33 per cent of the workers. Under Fascism they would progress 200 per cent. Moreover they would form one of the two pillars of the Corporate State to govern industry side by side with the employers' institutions. It is interesting to note that the Italian trade unions secured a 40 hour week for their members at the end of 1934." She wrote again in October explaining that one of the economic problems of the day was one of under-consumption and that science had solved the problem of production, but that we still have the spectacle of starvation in the midst of plenty. She said: "Fascism will solve this problem by the following means: Britain will withdraw from the struggle of world markets, which drags down the standards of British workers to a low level in order to compete with sweated coolie labour at one fifth the wages. That a self-contained Empire should be built, in which the wages of the British people could be raised to a level in accordance with the vast potential wealth of the Empire. Through the corporate system, wages and salaries to be raised over the whole field of industry in order that the people may have the purchasing power to buy the goods they need. As to the idea of 'work for works sake,' we do not advocate this policy. It is possible in this mechanical age that, at a not too distant future date, man will only need to work for one hour a day. But it is necessary for the good of the individual that he should render service in some way to his country before he is entitled to receive his share of the wealth. Otherwise, the system breeds nothing but a new class of social parasite."

Pointing out the split personality of the Labour movement, Edwin W. Spain wrote to the Echo on Sept 9th 1935: "I observe from proceedings of the TUC that Mussolini was referred to as a blood thirsty bully, and force was the only remedy that would bring him to reason. If necessary, sanctions should be applied. Mussolini states this would mean war. I also remember that quite recently these same Labourites were shouting out against and trying to abolish the Scouts, Boys Brigade and military tattoos, yet they now advocate the use of the military machine. Not very logical, how do they reconcile one statement with the other?

A Labour candidate took exception to another member of the Spain family during the local elections. "It is up to the electors to show my Fascist opponent that he can't wash his black shirt white just for this election," said Councillor Miss E. E. Blacklock, Socialist candidate for Sunderland Colliery Ward when speaking at Southwick Green on Oct. 29th 1936. She was referring to the Independent candidate Thomas H. Spain who over three years previously had been persuaded by his friends to attend two or three BUF meetings but it was a very brief association as their principles did not agree with his own. It did not stop Miss Blacklock from attempting to use it against him and insult his character. Mr. Spain said the difference between Miss Blacklock and himself was that she had to obey the dictatorship of the Socialist Party, whereas if he represented Colliery Ward he did not have to represent any political doctrine whatever. He still managed to receive more than half the votes cast in spite of the opposition giving a roasting to independents and moderates. One writer said she was present at a Pallion Ward meeting at Havelock School in support of the Moderate candidate and that no speaker, including the candidate, was "allowed a hearing by the disgusting exhibition of organised hooliganism. The language of both men and women was terrible. If these are Labour supporters I say it is imperative that all responsible voters in Pallion to vote on Monday for Mr. Jeffery."

Unity Mitford

Sir Oswald Mosley married Diana Mitford in October 1936. She was born in 1910 in London and was one of seven children of David Bartram Ogilvy Freeman Mitford, the 2nd Baron of Redesdale in Northumberland. Her sister Unity Mitford (1914-1948) was also a BUF member and they both visited Germany in 1933 to learn the language. Unity loved the changes taking place in that country. She met Hitler in 1935 and they became friends. When war broke out on September 3rd 1939, and was caught between the two countries she loved, Unity tried to kill herself with a small calibre pistol while in the English Garden in Munich. Hitler provided his best specialists to save her life and sent her home, but she was never the same again. She died on May 28th 1948 and is buried in the graveyard of St. Mary's Church in the village of Swinbrook, Oxfordshire, where Lady Diana Mosley was also interred in August 2003, following her death in Paris.

Dr. Nicholas Zernov, Lecturer at the School of Slavonic Studies that was affiliated to London University and Secretary-organiser of the Russian Church Aid Fund, gave a talk at St. Nicholas' Cathedral in Newcastle on February 2nd 1937. He said that Soviet rulers must change their anti-religious policy because Russian Christians were willing to sacrifice their lives for their faith. He added that English people thought Russian Christians were persecuted because of the failure and mistakes of the Church but, in fact, the Communists were building a nation without Christian belief which they thought prevented social progress. Press censorship in Russia was responsible for the fact that persecution was proceeding silently, and that there was no doubt that several million people had been

killed for Christianity's sake and that children were reared in anti-religious schools. Appealing for support for the Russian Church, Dr. Zernov said "They are not defending their own faith and religion alone. If they are defeated, it is not only a defeat of the Christian Church in Russia but the whole of the body of the Christian Church." On March 25th he gave a talk at St. George's Church Hall in Gateshead to the Ruri-Deconal Conference and said that the Russian Communists would never bring about the extermination of Christianity. He said that due to Soviet persecution the training of priests and the publication of literature was only possible among the colonies of exiled Russians and asked for assistance for the work from the Churches in this country.

It was at this time that the rulers of Russia were finding that some Socialist policies did not work. School reform started to take place in September 1935 and a return to regular reports, lessons and exams got under way at a rapid pace. After the 1917 revolution school children were given a free hand in school. They decided what lessons would be given - if any - and did practically as they pleased. The experiment was a dismal failure and it was found that children required discipline if they were going to do any work at all. The social problems and cost of abandoning traditional marriage, previously considered a "bourgeois taint," was also re-assessed and it was declared that "cupid and love" were to be the bases of proletarian marriage and that official scorn on easy divorce and extra marital relations was in the pipeline.

William Joyce spoke again at South Shields Congregational Church on March 20th 1936 to a sympathetic hearing and the meeting was conducted without the slightest interruption. Condemning Britain's interference in foreign quarrels, Mr. Joyce said: "If there are any enemies of peace in England today they are to be found in the established political parties. They are encouraging us to believe another war is imminent when the necessity for the war does not exist. The remilitarisation of the Rhine by Germany was pointed out as an act that was

threatening the peace of Europe but Hitler had simply moved troops from one part of Germany to another, an operation which in this country would be claimed as the legitimate right of the nation. England feels she has the right to transfer its garrisons from Aldershot to Catterick, Mr. Joyce declared, and if any foreign power denied us that right we would say that power has no authority to be dictating to us. When our troops were on German soil during the occupation of the Rhine they behaved as Englishmen always behave. But the same cannot be claimed for the French whose African troops frightened and intimidated the German people. It was said that Hitler had broken the Lucarno Pact but he had observed it until it was broken by the victorious powers. France's alliance with Soviet Russia was a direct violation of the Lucarno pact. It was ridiculous to tell Germany she was entitled to equality with other nations yet at the same time propose to march foreign troops onto her soil. At the end of the meeting, some Communists walked out during the singing of the National Anthem.

Writing in April to the North Mail, Mr. W. Watson attacked British Fascism and claimed that Blackshirts had mistreated a woman at Olympia when they were defending the rally against a massed attack from organised communists. British Union officer Mr. J.A. MacNab, replied that the claim was without foundation and wrote: "On the contrary, at least two of our women at that meeting suffered injury in the face from the razors and broken glass employed by those who had come to the meeting for the express purpose of wrecking it."

On May 2nd Middlesbrough reported that there had been progress and newspaper sales had doubled and that outdoor meetings held by Mr. Whittam were doing well. On the 9th Collier wrote that the Trimdon Unit was walking and cycling for miles visiting village after village, making personal visits door to door and distributing hand bills. These members were miners leaving their shift at 2am and then advertising meetings by day and stewarding meetings at night as well as preparing for a visit by Mosley on May 18th. At

one meeting 500 miners heard District Officer Crosby explain how fascism would help the workers. Some opposition leaders attempted a rival meeting but it failed and the miners stayed listening to Crosby. Meetings were held at Sedgefield, Trimdon, Wheatley Hill and Wingate by Captain Collier on May 4, 5, 6 and 8th. At Wingate, many interested miners who stayed to hear the talk missed the last bus and had to walk miles home. A special campaign was progressing at Trimdon and a report by Collier said the local socialists were quite concerned. It revealed that the Blackshirt popularity was increasing and that they were sowing distrust of the Labour Party in the minds of the miners. It said miners in the district were losing faith in their leaders and cases of victimisation, corruption and nepotism were brought to Collier's attention nearly every day by the miners. The local cinema had showed slides announcing Oswald Mosley's intended meeting in the area and they were received with applause!

On May 18th, 1936, in the Miner's Welfare Hall, Deaf Hill, Co. Durham, Mosley received a good hearing in a crowded hall. The audience resented the activities of some Reds that were imported for the occasion from Stockton and Teesside and who were told to "shut up" every time they tried to interrupt. The anti-fascists had arrived the previous day but were unable to stop the meeting going ahead. On some ground opposite the entrance to the hall, several Communists, using a mineral water box for a platform, addressed a "United Front" meeting in which they denounced fascism to only a handful of listeners. On the platform Mosley was received with applause, mingled with a few boos, but order prevailed. One or two members of the audience persistently heckled but Mosley in a friendly way requested them to reserve their questions to the end, when he would answer them all together and this had the desired effect. When the time came he answered many written and verbal questions and there was no organised rowdyism. At the close when he called for the National Anthem, part of the audience struck up the Red Flag, but these were drowned by the rest of those present who sang the first verse of the National Anthem.

During his speech Mosley said: "The Fascist creed, like any other new creed, was subject to misunderstanding and misrepresentation. We believe it is impossible to get anything done in England today until you have changed the system of government. It is absolutely impossible to get business done in a hurry through the present parliamentary machine for the simple reason that the system was invented 100 years ago by comfortable people not to get things done, but to prevent them being done!" In reply to an interrupter who asked about Italy and Germany, Mosley said he was not looking for any model in Germany, Italy, or anywhere else. He said he was proud enough of his own country…it is not a case of us to imitate them…our constructive policy goes far beyond anything they have ever conceived and that is why I am not looking for any foreign model. A voice from the audience asked 'why do you go to Italy.' He said that he went to Italy and Germany whenever he had the chance but that unfortunately he had few chances because of his work. He said he considered it a duty of any public man who was trying to govern a country to study other countries and establish friendships with them and that, if he had the chance of going to see Italy and Germany and establishing friendly relations with them, that he would be a fool if he did not take the chance.

He went on to say that "Because we study other countries and want peace with them it does not mean that we are seeking to model ourselves upon them, because we are quite certain that we can do better than they can." To another interrupter who declared that we would get bloodshed and murder under Fascism, Sir Oswald answered "If you think I want to introduce bloodshed and murder into Britain you must hold to that opinion, but I think I shall persuade most of this audience to the contrary. But I want to clear away every misapprehension. Why we have avoided bloodshed in Great Britain in the past is because we have had the sense to act before the collapse. That is the genius and wisdom of the British people and I ask them to be true to themselves, and to avoid continental excess by adopting the creed of their age, not through collapse but because they want to have it as a means of salvation.

In conclusion, Mosley asked his audience whether they would any longer submit to be tricked, betrayed and sold, or whether the "British people would form a movement of their own, carrying with it the fire and flame of a revival which would light the path of the nations of the world to higher and nobler things." That day fascism was established in the area and many miners were friendly towards the Blackshirts.

During late May and June there was a rush of correspondence to the North Mail's "Letters Page" asking if the British Union was associated with the "No More War Movement," another inferred the party should be trampled into the gutter and one disparaged Fascist ex-servicemen, and Director of Press Relation's Angus MacNab (Scottish surname) was told he should not be dabbling in the affairs of England. In reply he said the correspondent had unfortunately missed the opportunity of addressing his remarks to James VI of Scotland who went on to became James 1st of England uniting the two countries and that the British Union was not in any way connected to the No More War Movement, who thought that in some magical way they could outlaw war, but the British Union believed in a strongly armed Britain that minded its own business and avoided interfering in foreign quarrels. As for the disparaging remarks about ex-servicemen in the movement he said they were entitled to wear medals on their chest as "evidence that they had defended their country in its hour of need and that Fascism in this country was not being built by those who remained behind during the war but by ex-servicemen who fought for their country. To these can be added the younger generations, many whose fathers gave their lives in defence of Britain, as mine did." He wrote again on Oct 10th and said: "According to your report on the Socialist Conference at Edinburgh, Sir Charles Trevelyan stated "When Germany and Japan try to destroy Soviet Russia I hope the Labour Party will have some other policy to offer than their sympathy accompanied by bandages and cigarettes." MacNab replied: "This is the same party that only a few years ago resolved to call a General Strike against war, even a war in defence of British soil. "Yet, those

who would not defend Britain openly advocate war in defence of Soviet Russia, just as they advocate it in defence of a slave owning and turbulent Abyssinia. The Fascist policy is that British people should only fight in defence of their native soil."

Sir Walter Citrine, Secretary of the Trade Union Congress gave his report in early June that included some comments on his visit to the Soviet Union. Talking on housing conditions, he said: "In Baku the overcrowding seemed to me to be the worst of all. The amount of space per person is only six square meters. In the country districts the congestion is terrible. I saw married couples living in the same room where 15-20 single men were accommodated. More often than not no water supply is laid on in these 'barracks.' Nor was there any provision for cooking beyond oil stoves. The Russian best in housing is far below the British best. The Russian worst has to be seen to be believed."

Robert Dalgliesh published a letter he received advertising employment opportunities in South Africa. He said that no help was likely from the government "but all that arrive will find plenty of work awaiting them in all the towns. Immigrants are pouring in from Holland but one hears of very few Englishmen grasping this wonderful opportunity. Within the last couple of months there has been a very great shortage of civil engineers, hospital nurses, teachers and tradesmen of all kinds... There is no doubt that every man and women who arrived in the Union will find work within a few days." He told readers that further information was available from the 1820 Settlers Association, Piccadilly, London.

A letter appeared in the Durham County Advertiser on the 19th June from BUF member Michael J. McCartan regarding the Labour Party. He wrote "It is interesting to note the lack of similarity between two views expressed by Labour leaders. One example of this was found recently when Mr. Emmanuel Shinwell, member for Seaham Harbour, declared at Newcastle Regional Conference on May 23rd that 'The Labour Party

propaganda must be enormously strengthened if it is to secure power.' On the same day, at the Sheffield Regional Conference, his colleague Mr. W.W. Henderson, was declaring that the Labour Party 'Never had better prospects than now of getting a government with an effective majority.' It looks as if a further conference is needed among labour leaders themselves for the purpose of finding out exactly what the party does or does not require in order to have a chance at the polls. Whether the party gets power or not, something needs to be done and done at once for Gateshead, for the alleged decrease in unemployment in the press is lamentably counter-balanced by the appalling increase in P.A.C. relief for 9,016 people."

Also in July, Raven Thomson, Director of Policy, spoke at Darlington Market Place to a crowd who had gathered for the meeting and the talk left a good impression on the audience. He then spoke at Middlesbrough to about 1,000 people. Another meeting in the town held in Davison Street was addressed by Mr. E. Clark and several people came back to the branch Headquarters. There were three good meetings in the middle of the month in Trimdon, Spennymoor and Cornforth and the miner's were showing a keen interest. At a later Spennymoor meeting in early August, Mr. Clark spoke to 500 people and, when he was interrupted by the Reds, challenged them to come up and let the people decide who they wanted to support. The local Reds then went quiet and the meeting closed with a round of applause for the Blackshirts. The following week a fund was set up by the Northern Command of the British Union on behalf of the wife and three children of member Henry Lee of Barnsley who was tragically killed in a disaster at Wharncliffe Woodmoor Colliery when 57 men were killed. On Aug 10th, Mr. E. Clark met with organised and violent opposition when he spoke at Shotton. A small group of Reds tried to terrorise the audience and stop the meeting. As the speaker left stones were thrown but, nevertheless, a number of people were still sympathetic and it was intended to visit again in the near future. In the middle of the month Mr. Collier and Mr. Bell spoke outside Vickers

Armstrong's works on Scotswood Road. It was considered a Red district but the workers were interested and there was no trouble. Also in August Mr. Clark spoke to 250 miners outside Trimdon Unemployment Exchange. He blasted the hypocrisy of the Labour Party stand against the Means Test when it had introduced it itself! They then went to West Cornforth where there was some support and they enrolled a few members. At the end of the month in Newcastle, Mr. Clark had a good reception in the Bigg Market when the meeting was opened by Fascist Bell to a crowd of 1,000 people.

The Newcastle Weekly Chronicle printed an article on August 15th 1936 by reporter Rene Lignac on the Spanish Civil War. He interviewed General Mola who he described as a tall man with a pleasant face and piercing eyes behind steel spectacles. Around his waist he wore a red belt with golden tassels. "Sir," replied the General, "there are two men leading this movement, General Franco and myself. I will tell you of this movement, and you can count it an official declaration, it is a Nationalist rising. It is directed and has been prepared by the Generals of the Spanish Army with the wholehearted support of the Spanish people. Our ambition is to wipe out once and for all the organised principles of Marxism with its Internationalism. We want to establish in this country order and peace based on purely Spanish ideas and Spanish ideals." After the civil war, on June 11th 1939, the Pope was in Spain and addressed the soldiers of Franco's army and referred to them as "The defenders of the faith and the civilisation of your fatherland." He also imparted his Apostolic Benediction to General Franco and all those present.

Miss Winifred Clark experienced life in Spain. She was a Dipton girl who went to Spain in 1936 to work after she left school. During her stay she became engaged to be married to a young doctor. She went to England to make the final arrangements for the wedding but when she returned civil war was raging and her fiancé was reported killed after being taken away by the police. His brother Fernando was afraid of the same fate and she set

about helping him leave the country through one of the foreign embassies that was crowded with people seeking sanctuary from the Communists.

Many of the young men who had in the past taken some part in politics were living in daily fear of arrest. Having a photo of the King in the house was enough to be taken away or your house ransacked and looted. Miss Clark wrote "I heard of one young girl who lived at one of the convents in Madrid where some of the wonderful embroidered clothes used to be made (the Spanish women are particularly clever with their hands). Her home was at the convent and she used to go out daily from house to house taking in orders. As she was out in the streets one day she was arrested and taken away. The officials said she had information about members of the aristocratic class. Later she was found shot, with two nuns, in the head. I heard of one youth of only 17 who, because he had a friend who was a fascist, was taken away to be shot. He broke down and begged them not to shot him as he was his mother's only means of support. The sight was too much for one soldier who refused to do it, another with less heart pushed him out of the way and shouted: 'Your mother will be the next one,' and shot the boy down. The soldier boasted to me that they had shot 15 people that night. The Communist soldiers who generally carried out these shootings were of a very bad type. They were cruel and callous without any sympathy for their victims. They preferred to shoot their prisoners in one of the cruellest ways possible - through the eyes. Sometimes the militia had to take out parties of nuns and shoot them. Lorries full of armed men were rushing through the streets...some even children as young as 15. Many of them were simple people from the country. They had little idea of the issues involved and they had little training. It was the coming of the International Brigade, including the Russian and English communists, that really stemmed the tide of a quick defeat." Miss Clark left the country by way of Valencia on the British destroyer Grenville and made her way back to her home in Gosforth.

One Jesmond correspondent told the Evening Chronicle "The truth, of course, is that the Spanish Government, although constitutionally elected, has never been allowed to function. Ever since the brutal revolt of the 'Reds' in Asturia in 1934, the Government have been puppets in the hands of the anti-God minority and have failed lamentably to restrain, if they have not actually condoned the excesses of these terrorists who for the past two years have waged an unceasing campaign of bloody persecution against all that the Spaniards hold sacred - particularly their religion. I appeal to the misguided people in this country who are inclined to sympathise with the Spanish Government to ask themselves this simple question: Can any government which has permitted the burning of churches, the murder of priests, the violating of nuns, the confiscation of property and the teaching of blasphemy in the schools, be regarded as a 'popular' government in a country where the vast majority are staunch Catholics? It is good to read of the recent successes of General Franco and his liberators, and I hope we may soon hear of his triumphant entry into Madrid."

Will Lowther, Secretary of the Durham Miners Association was hot under the collar when Fascist speakers and leaflet teams visited Shotton Colliery during August and distributed a leaflet on how Fascism would save the mining industry. Mr. Lowther said that however plausible the Fascist story might be once they got to power "democracy would be ended." Angus MacNab responded that "they had no complaint against the statement and could see no reason why democratic life should have endeared itself to the 2,000,000 unemployed, to the inhabitants of the distressed areas, to the millions who dwell in slums and to the 13,500,000 people who had incomes bordering on the starvation line. The right to bleat like sheep once in five years when expressing a choice between discredited politicians seems a high price to pay for 'democratic' liberty. We maintain that the present system under capitalism is a sham and that under communism there is no freedom at all. Fascists, on the other hand, offer the first requisite of true freedom which is economic

security and the guarantee of work or full maintenance, together with a standard of life at a level justified by the great potential wealth of the nation." Commenting on a recent Derby bye-election when Conservatives were asked to vote for a League of Nations candidate who happened to be the Labour man he said: "This seems to indicate what is becoming clearer day by day, that the old party labels are ceasing to mean anything at all, and that all the parties from Tory to Communist are lining up for their last fight against the Fascist creed which proposes to abolish them all, together with the poverty and corruption which they exist to perpetuate."

The Secretary of Follonsby (Wardley) Miners Lodge and DMA Executive Committee member George Harvey also wrote in August on social issues and described the Means Test as "Fascist" in character. As it was an inappropriate term to describe it, MacNab replied "Since the Means Test was originally drafted by the Labour Government and its twin brother, the Anomalies Act, was introduced by them at a time when Mosley vigorously opposed both, this argument would seem to be particularly stupid and ill founded. Mosley's attitude, both then and now, is that the only means test that is justifiable is the offer of a job at full trade union wages and the right of an insured person to draw the full benefit of his insurance."

At this time a number of *Sunderland Echo* critics said that British Union had become anti-Catholic because it had drifted away from an alleged policy of 100 per cent Mussolini and Italy to 100% Hitler and Germany. It was neither, but they did pursue a British interests first policy and British Union's Margaret Collins said that it was a pity that religion was being dragged into the debate and "I would merely state that I also am a Roman Catholic. There is nothing in the British Union policy incompatible with the teachings of religion. The British Union stands for the complete religious toleration for all, and the right of a man or woman to worship his Maker in whatever manner his religious beliefs may dictate. There will be no interference

by a fascist Government in Britain in the affairs of religion. The British Union, however, does not ally itself with any particular church or sect."

Early September meetings were held in Trimson where the unemployed listened to the Blackshirt speaker and also at Red Lion Square in Spennymoor where literature sold well. There was some argument at the close of a meeting on Newcastle's Scotswood Road by the Reds, and also at Durham Market Place a few days later but there was no real problem. On September 21st Mr. Clark was again at the Bigg Market and, over the next few days, also spoke at the Clock Tower in Morpeth, Hexham, West Cornforth and Coxhoe.

When Tyneside Marxists celebrated the 1936 "Battle of Cable Street" where it was claimed that Oswald Mosley's group was smashed, ex-Blackshirt John Christian wrote on 23rd Sept 1986 to the Evening Chronicle that they were "Trying to portray a communist myth into historical truth, a manoeuvre in which they are traditionally prone." He said the 'victory' was a non-event and two weeks after Cable Street thousands of East Londoners rallied to enthusiastic mass street meetings that were called at a few hours notice without a sign of protesters. It was never the intention of any of the four British Union marching columns to go up Cable Street where violent communist protesters fought with police. The British Union had continued to remain popular in the district and six months later Blackshirt candidates polled nearly 25% of the votes in the LCC elections.

Replying to a debate in the Shields Gazette on September 30th about the origins of the Fascist movement, Angus MacNab said: "The Italian movement emerged from post-war chaos as the revolt of mainly ex-servicemen against internationalism and red anarchy. Its primary object was to restore order after the failure of liberal-democratic Government, and only after attaining power were its embryonic ideas of syndicalism developed into the corporate system of state organisation. In Germany the

Nazi movement expressed the revolt of the people against the humiliating 'dictated' peace of Versailles which sought to maintain Germany in permanent economic and political slavery. The origin of the British Fascist movement was rather economic than political, and was founded upon the famous Mosley Memorandum at the time when Mosley delivered the greatest challenge ever known to the official Labour Party machine in his scheme for national reconstruction. Ramsey MacDonald made it an issue of confidence and many of Mosley's supporters, such as George Lansbury, toed the Labour Party line and turned against the Memorandum at the last minute."

MacNab was also accused of fostering the "Superman" image and replied "The Fascist movement in the first instance represented the revolt of Mosley and his followers of the war generation against the betrayal of ex-Servicemen and the unemployed which had been carried out by every Government since the war. From that it has developed into a revolt against the whole internationalist idea in which Capitalism and Socialism are both partners. There is admittedly a Nietzschean element in the Fascist doctrine; the idea of the Superman who refuses to be conquered by his environment but carves out a passage for himself and, by a curious paradox, from the complementary Christian doctrine of self sacrifice in the cause of others."

Councillor Ernie Gompertz and George Reay tried to take British Union to task on trade unions and unemployment but on October 3rd Margaret Collins replied they "were unable to meet the Fascist economic case and have now descended to the tactics of refusing to accept official Geneva figures concerning Fascist countries. They further produce a large number of entirely inaccurate statements, e.g. that trade unions do not exist in Fascist countries and that one-third of Berlin's enormous population is starving. These statements are simply untrue, Mosley's policy was fully developed before Hitler even came to power and even if there were some atom of truth in these statements, their relevance to a discussion of Mosley policy would be exactly nil.

What is much more important is what the British miner is going to do and whether he is prepared to sit down for ever on 17s 3p a week while foreign oil floods into the country, knowing perfectly well that the only political movement with a policy to produce oil from British coal on a national scale and give work to hundreds of thousands of miners is a British Union policy. The Socialist policy is international, which means that the British miner has to compete with the sweated labour of Poland and Hungary at wages of approximately 30s a month. The Fascist policy is national and means that the wage level can rise to the point justified by our immense national resources instead of being kept depressed to meet the demands of International finance."

The "Jarrow Hunger March" got under way to London in October from what Ellen Wilkinson called "a town that was murdered." Out of every ten workers, seven were out of work and unemployment still growing. On the journey they were assisted by all shades of political opinion but it did not help when they arrived in London as Stanley Baldwin refused to see them and remarked: "This is the way civil strife begins." It was a terrible reflection of the inability of the old parties to change the awful economic conditions that created such a response from the poor and unemployed.

Blackshirt meetings in the first few days of October saw miners present at Atkinson Road, Newcastle, and at Spennymoor they bought all the available literature and asked for more. The miners and their wives showed interest at another Coxhoe meeting and at Sedgefield, Clark spoke about BUF agricultural policy. Around the 13th Clark was at Ferryhill and also outlined BUF mining policy to a crowd at Low Spennymoor that resulted in good literature sales. In Middlesbrough the crowd were reluctant to leave the meeting in Bedford Street despite the rain. A meeting was attempted in North Ormesby Market Square on October 12th but a crowd of several thousand, many of them Communists, waited for the 13 uniformed Blackshirts as they

arrived in the High Street and marched to the open Market Square. The meeting had to be cancelled but Peter Whittam of Leeds, who was to have been the chief speaker, said afterwards that he was disappointed by the reception but that "We shall come again very soon."

British Union Press Secretary Margaret Collins replied on the 10th to Shields left-winger George Reay who was claiming that: "The employer under fascism becomes the leader and his word is law." She said: "He is incorrect in saying that in the Fascist corporations the employer's word is law. These corporations consist of representatives of workers, employers and consumers equally. It is interesting to note that the Fascist trade unions are the only ones in the world to have secured a 40 hour week for their members - which they did in 1934... Fascism believes in the policy of controlled private enterprise and ownership, giving a man the freedom to own property or to run a business but abolishing the freedom to work against the interests of the community or to exploit the nation for his own selfish gain."

The Woman's Administration Officer for the region, Miss Olga Shore, a former active suffragette, wrote in November that Middlesbrough had a very active women's section that was doing excellent work and that progress was being made in Northumberland and Durham.

With the impending uniform ban on political parties MacNab said on Nov 25th 1936 that people were mistaken in imagining that the primary objection of the British Union to the so called Public Order Bill simply depended on the uniform question. He said: "The uniform was a novel and effective means of propaganda; also, it ironed out class distinctions which we wish to break down. But no one pretends, surely, that taking away a piece of cotton from a man can destroy a great new faith which is held with the fervour of a religion. The reason why we think the Bill destroys the principles upon which British law is built is that at least one clause throws the onus of proof on the accused

man, for Mosley can be sent to prison for two years under this Bill, not on account of anything he had said or done but on the evidence of words used by a self-professed 'adherent' whom he had never seen or heard of and who need not even be produced in court. The opportunities granted by this clause for the insertion of agents provocateurs into any organisation - not necessarily ours - are almost limitless and the clause challenges the very principles of British law." He had already pointed out that those who denounced Fascist uniforms as "provocative" were obliged to eat their words in July when in Manchester the Red element that had consistently attacked Fascists in uniform attacked them with the same ferocity, and lack of sense, when they were in plain clothes. He added: "The fact is that there exists in our country a deluded body of people who have been so reduced to neurosis by Soviet propaganda that they regard as provocative the very sight of the Union Jack."

The death of Lord Joicey was announced on November 28th. He was once a clerk in a Newcastle Quayside office and went on to be chairman and managing director of James Joicey and Co. Ltd and the Lambton Colleries Ltd. He was born in Tanfield on April 4th 1846 and his father, Mr. George Joicey, was a Northumbrian and a colliery engineer. International politics had always been his close study and in an interview at the age of 84 he said "I believe things are so serious in this country that the only remedy is for someone to arise and insist upon a changed point of view. A dictator could do this by compelling all of us to face the facts. Italy has won through because there was a strong man at the helm."

One critical Wearsider had wrote that the "cannon fodder fascists" would welcome a uniform ban as they wouldn't have to salute or say "Yes, Sir." MacNab said in response that the attitude of the critic "Is so class conscious that he even speaks of Fascist 'officers' and 'cannon fodder Fascists' - the latter being apparently those who do not hold any office. He fails to realise that a Fascist 'officer' is not a person of a different class but from

the rank and file. I know labourers who are 'officers' and ex-Army officers who are rank and file members. I know a farm labourer who is an 'officer' and a big landlord who is a ranker. 'Office' in our movement is simply earned by service and there is no class distinction at all. Is it seriously supposed that if our rank and file membership could be justly described as 'cannon fodder' they would stay inside such a movement for one minute? The only reason we are able, with slender resources and with no millionaire press, to organise a parliamentary fight against the immense vested interests of the old parties is because we possess a devoted mass membership who voluntarily perform the services, for which the old parties have to pay, and without this mass membership the efforts of a handful of 'officers' would be totally useless. The background of the movement is not a handful of directors at headquarters but the local branch membership and the local leader, who is a voluntary worker, in the towns and villages of England, Scotland and Wales."

In the first few days of December, Mr. Ernest Clark was invited to talk to Durham City's Rover Scouts and they listened with interest to what he had to say. A week later, two good meetings were held in Middlesbrough's Bedford Street on Thursday and Friday. On Sunday, activity was centred in a working class quarter of the town which resulted in many copies of "Crisis" being sold. In the evening a private meeting and cinema show was held. Clark addressed 500 people in the Bigg Market on the Monday with no trouble. That December, Newcastle Central branch was top of the Action and Blackshirt sales league in the Northern Command. To see out the old year, Clark was again at Bedford Street in Middlesbrough and his arguments against wage cuts held the interest of trade unionists and a Newcastle cinema queue listened to the party programme at Atkinson Road.

On December 10th 1936 King Edward VIII abdicated. He was a popular young King who wanted a modern and streamlined monarchy in touch with his people's needs. He visited the

poor areas of Wales and the North East and spoke about the poor conditions in which they lived and the unemployment they suffered. Speaking to the Association of Municipal Corporations on May 1933 he said: "I appeal to our generation to tackle the slum problem so that it will be remembered as the one which swept away this blot and disgrace to our age. I have been appalled that such conditions can exist in a civilised country such as ours. The great mass of slum dwellings in our country are more than a century old. They have grown up around manufacturing plants during the industrial revolution of the last century and are relics of a bygone idea of what was tolerable for the working man. This type of home must be demolished. Children are growing up under conditions in which they are expected to contract disease from an early age. It is for their sake that we must rid ourselves of this social evil and we must do it quickly or we shall be too late in providing homes worthy of habitation by the children of the new Britain we desire to build. What is the sense of treating the slum dweller, and especially the slum children, for disease and when they are recovered sending them back to the very centres where the disease is rife! To me this is an appalling process of waste, inefficiency and expense. Nor can the nation afford the moral and mental degradation which slum conditions create in those who inhabit them. The psychological harm also is at least compatible with the physical evil. Let public opinion awaken. Great risks require great energy, vision and determination. Let us put forward a great national effort, irrespective of party or of politics. This is an age of planning and building. Let us build a new Britain and provide houses worthy of the dignity and greatness of our race."

Early in 1935, the then Prince of Wales met Sir Oswald Mosley where he questioned him about the strength and policies of the fascist movement and encouraged the signing of an Anglo-German alliance. The old established politicians and vested interests intrigued to remove the King and used his love for divorcee Mrs. Simpson, who he wished to marry, to do so.

The Prince of Wales visits Durham 1934

During a visit to Durham in December 1934, the then Prince of Wales was welcomed as a friend of the miners. Six years previously he spent three days among the miners and working class people of the North East. They remembered how he turned up his trousers to wade through the inches deep pit mud of Brandon; how he bought Woodbine cigarettes at a little village shop and had a word of sympathy for the shopkeeper; how tears came to his eyes when a canny pitman's wife of Seaton Burn asked "after his father"; how he was guided round Winlaton by Taffy Lewis and, when the official party was just leaving the village, he refused to go until Lewis was found to be thanked personally for his help. There were "human stories" that surrounded the Prince of Wales. At Hebburn, when he was in the midst of a close thronged crowd he heard a woman crying "Oh, just let me touch him." The Prince turned, and seeing that the woman was blind, he quietened the crowd and made a passage through for the poor woman, that she might come up to him. He shook her warmly by the hand and had a word of friendship for her. Then, nearby, he walked into a little settlement of old, obsolete,

well-nigh derelict colliery houses, set around what was that dreary winter's day a lake of horrible black pit mud. The Prince said one word: "Ghastly!" and he said it out aloud. Not long afterwards the houses were pulled down. At one house he called at, the daughter told him with sobs catching her throat, that her Mother lay dead upstairs and, as much as the family wanted him to enter the house, they were afraid...but the Prince intervened. He asked that he may be taken to see the mother, and with his arm around the miner's daughter to comfort her in her sorrow, he went into the room of the dead mother to pay his last respects too. The Prince called on everybody with the utmost informality. Just a knock on the door and an enquiry if he could enter. He went to the house of the pitman and colliery manager alike. He was a friend of all men. The BUF promoted a "Stand by the King" campaign and in Newcastle the streets resounded with the chants of the young Blackshirts who regularly jogged around the city distributing leaflets chanting "Two-Four-Six-Eight-The King-Must Not-Abdicate."

After his forced abdication speech, King Edward left Windsor Castle and arrived at Portsmouth dockyard at 12.30am in the morning, boarded HMS Fury and at ten past one slipped out of the Solent and into the English Channel. There was no one there to say farewell as he quietly and secretly had to leave his native land. The exiled former King died on May 28th 1972 at his home in Paris. His funeral took place at St. George's Chapel, Windsor, attended by the Queen and the Royal family and he was buried in the Royal burial ground behind the Queen Victoria and Albert mausoleum at Frogmore.

In December 1936 a new book "Portrait of a Leader" was published which was written by A.K. Chesterton. It had an excellent review in the Shields Gazette and it said of Sir Oswald Mosley: "He was a Lloyd George Coalitionist in 1918, and afterwards being elected twice as an Independent in the teeth of the most determined Conservative opposition. That was a noteworthy achievement for a young man of 22 years of age...

Sir Oswald made his mark in Parliament. He was an exceptional debater, clever, witty and courageous. Almost without exception the leading political writers predicated that he would be Prime Minister in due course, being the stuff of which Prime Ministers are made." The review went on to say that "Mosley found himself in a Parliament mostly of profiteers and opportunists assembled not to further the cause of the new world but to patch up and conserve the ugly old world which had brought them great wealth...He went over to the Labour Party thinking it nearer to his own aims but found it just as much a racket as the other parties and gradually developed the ideals of Fascism which he has been preaching ever since."

1937: British Union Wants Stronger Armed Forces

Although the Public Order Act became law on January 1st and the Blackshirt uniform was banned, an added incentive was given to Newcastle members that month when it was announced that at the next General Election the branch would contest a local seat. The candidate for Newcastle West was to be Robert Sheville who was born at Newcastle where his family had long associations. After leaving Rutherford College, he took a course on Low Temperature Research at Cambridge and later assisted in his father's business as public works contractor. He joined British Union in July 1933 and soon became a prominent speaker and writer becoming first rate in both. Mr. Sheville was one of the best boxers in the British Union, having been amateur welterweight champion of North East England at seventeen and went on to do valuable propaganda work in Scotland.

Mrs. C. Wilson wrote in *The Sunderland Echo* on Jan 2nd that Sir Oswald Mosley was a "very wealthy man" but was told that "He was wealthy once, but emerged from the Labour Party far poorer than he entered it, and sustained further losses in the New Party. He differs in this respect from the Socialist leaders, many whom entered politics poor and have become wealthy. Mrs. Wilson further refers to members of our organisation as 'uniformed hirelings.' She is evidently unaware that every Fascist buys his own uniform and that no Fascist, with the exception of a small headquarters staff, receives any pay whatever for the work he or she performs on behalf of the movement."

British Union member John Sefton wrote in the local press on September 22nd 1933 about the Vicar of Eppleton, the Rev. Gibson Salisbury, who had written some very understanding

and sympathetic comments about Germany and its situation since the end of The Great War, but had recently joined the Hetton Labour Party. Sefton suggested the Vicar should read Sir Oswald Mosley's book "The Greater Britain" which would be more in line with his thinking. He went on to tell him that "Neither is Fascism a creed of government tyranny. But it is definitely a creed of effective government. Parliament is, or should be, the mouth piece of the will of the people, but as things are at present, its time is mainly taken up with matters of which the nation neither knows or cares. Most Bills before Parliament demand technical knowledge, but they are discussed, voted on and their fate decided by men and women chosen for their devotion in opening local charity bazaars or for their lung power on street corners."

Apparently, the Rev. Salisbury, did not change his views as he wrote in his parish magazine in Feb 1937 about his concern for the "Germanophobes" in the House of Commons. He said: "In thinking of the possibility of war our thoughts turn naturally to Germany. The peace of Europe depends upon the attitude of Germany to the other nations of Europe, just as it depends on the attitude of those of other nations to Germany. Now there are few people who do not believe in their hearts that a friendship between us and Germany would make for the peace of Europe. We know that Hitler and his people have desired a close friendship with this country and that our statesmen are pursuing a policy which is driving Germany further and further away from us.

"Why? That is a question we may well ask. The fact is we are still suffering from the effects of our own lying and poisonous war propaganda. We find it hard to harbour a decent thought of a nation which, we were told, cut off the hands of Belgian babies, ran corpse factories and the like. Three other lies of that propaganda are still rife. First, that because Germany struck first, she alone caused the war. The truth is that if Germany had to stay in her own country she risked being cracked like a nut

between Russia and France or she had to make attack the better part of defence. When a man is coming for you with a poker you don't wait for him to hit you on the head before trying to knock him out. The second lie is that Germany invaded Belgium to put her people to the sword. The truth is that Germany wanted a passage through a narrow strip of South Belgium to get to Paris as quick as possible. Germany only defended herself against the Belgians when they attacked her in the back. The third lie is that Germany had designs to attack England and that our safety lay in protecting the ports across the channel. The truth is that Germany had at no time sought to quarrel with England. The story was pure bunk."

He went on to say: "In the interests of the peace of Europe we must make up our minds about Communism, Fascism, the Jewish question and the Treaty of Versailles. Communism is working for a classless society and a society in which a nation's wealth shall be shared equally. Communism can only exist at the price of wholesale murder to crush the instinct to acquire, and when she has done the killing the instinct will still be there. In facing the Jewish problem we must be hindered by no squeamish sentiment. The Jewish problem is not a new one. As far back as the third generation the race was enslaved in Egypt. At its deliverance it made for itself an image of gold and it has never turned its back on the image. Old Testament history is a long record of its apostasies. It was the despair of its own prophets and the prey of its own priests. Today its own policy is its undoing."

In an open letter to Anthony Eden he said: "We are writing to say how profoundly disappointed I am with your work at the Foreign Office... in the few short months you have been in office we have seen England on the verge of war with Italy, the continuation of the terrible conflict in Spain, the nations of Europe aligning themselves bloc against bloc and we have seen ourselves once again, ourselves and our sons, committed as cannon fodder for France and Flanders. That is a terrible indictment after only a few months work. We 'cannon fodder'

want to tell you that we don't believe all this blarney about Germany wanting to attack England, and that our only safety lies in fighting on the continent. That is a war lie to lure us into the trenches.... Some of us have fought against the Germans, some of us have fraternised with them, some of us have been prisoners of war in Germany and some of us have been billeted in the Rhineland. We never had any difficulty in making the closest of friends with the Germans. We cannot understand why our rulers can't do the same. Of course, we allowed nobody to come between ourselves and our German friends and if you are to ask us whether we would rather be friends with Germany than cannon fodder for France we have only one answer. The fatalism of incompetence hangs over our parliament. We are drifting nearer conscription, nearer our gas masks, nearer to war and nobody seems to care."

The Rev Gibson Salisbury wrote again in his parish magazine in May 1938 that a hate campaign "has gone on incessantly for five years" and that "It has made the name of Germany reek in the nostrils of thousands upon thousands of English people. We find it difficult to understand why the leaders of the English working classes should so malign a neighbouring country." He said: "A terrible responsibility rests upon the Labour Party in this country. The great campaign of hatred and untruths emanates largely, if not entirely, from that party." The Rev. Salisbury was educated at Durham University and ordained deacon in 1911 and priest in 1913 by Bishop Moule.

Writing from St. Peter's Church vicarage in Bishopwearmouth, Sunderland, Clare Silva-White, the wife of Canon Algernone Silva-White, said that the Rev. Salisbury deserved congratulation for his article and that the National Government should follow up the recently signed Anglo-Italian Pact with talks in Berlin that could provide the surest guarantee for peace. She said: "That there is a desire for friendly relations on the part of Germany that can only be doubted by those misguided people who allow themselves to be deliberately hoodwinked by others

215

who, for their own reasons, misrepresent the true facts. How many people understand the true nature of Germany's problem in Czechoslovakia? There are three and a half million Sudeten Deutsch and the conditions under which many of them live are bitter to the extreme. One who travelled among them a few weeks ago declared 'Such evidence of hunger and stark misery as I saw here I did not encounter in South Wales during the worst of the depression. Factory after factory stands deserted, with broken windows like the eye sockets of a skull, and indeed they are the corpses of industry that have been murdered by racial hate. Women look starved, their children are blue with cold, unemployment relief, when given, amounts to 1s 6p a week. Is it to be wondered at that the German Government, knowing of these things, should seek to redress the grievances of its own people?"

Another minister of the Church, the Rev. James Duncan, Vicar of Dawdon, had described his visits during the summer months of the years 1932 to 1935 to Germany and his time as chaplain at the English Church in Bad Nauheim in a series of articles published in *The Sunderland Echo*. Staying at Berlin's Hotel Kaiserhof he said: "I sat down to dinner hungry. I rose satisfied and refreshed. The waiter had been attentive. I asked him 'Were you at the Somme 19 years ago?" He grinned, 'I do not want to shoot anyone except...' He paused, 'Except?' I prompted, 'except the fanatics who try to engineer war, and the fiends who make poisonous gas."

Rev. Duncan quoted Balder von Schirach, the leader of the Hitler Youth who ridiculed the idea that the Nazi uniform and training are for war purposes. "Why do we wear these clothes? Why do we all enrol in this one organisation. We do this, my Comrades, because we look upon this uniform as the garb of comradeship. We do not want to conquer the world, but rather our own Fatherland. We don't want to be masters of other nations. We want to master ourselves. We say peace and we mean peace. But real peace can only exist under equal rights and security. Adolf Hitler has announced that Germany is willing

to disarm down to the last machine gun if others do the same."
The article continued: "As far as the youth are concerned we are
willing to co-operate. Can we do more? What of the Arbeitienst
- the Labour Corps, which has nearly 250,000 people in its
1,200 camps. Is their attitude war-like. There is regular physical
culture followed by classes in various subjects of intellectual and
social value. There are cinema, entertainments and concerts.
The boys make roads, cut down timber, drain marshes, build
open air theatres and cultivate allotments. The nobility of
work is preached. 'It is not what you do but how you do it that
matters' they are told 'It is the spirit of service that counts. A
man who sweeps a crossing from devotion to his country is as
worthy of honour as a professor who informs the mind of youth.'
University graduates are not allowed to take their degrees until
they have had six months at the Labour Front. Class barriers are
broken down, all members are regarded as equal and strength of
personality ranks higher than birth or riches."

In April Rev. Duncan had brought to the attention of the Echo's
readership the formation of an Anglo-German Society based
in Stuttgart and that visitors would be helped and welcomed
by the society in the hope that the contacts would lead to a
more cordial relationship and pave the way to peace. In another
article on March 27th 1936 he said that during long holidays in
Germany during recent years he had talked to all sorts of men,
rich and poor, influential and obscure, wise and foolish and had
read many important publications written by authoritative and
official writers and had studied the statements of the leaders of
the Nazi movement. He went on to say "Frankly, the progress
made by Germany since Hitler gained power has amazed me.
In three years a stricken and dejected country has given rise to
a new power and hopefulness... The young despair no longer.
The future is bright with promise. Unemployment is decreasing,
industry is developing, unity of purpose has been achieved,
and all classes have been welded in service and sacrifice for the
Fatherland. I believe that Hitler is sincere in his offer to make the
peace and keep the peace. He knows the tragedy of war and the

ruin it brings to victor and vanquished alike. He was wounded in the Great European conflict and was blind for weeks. And none understands more clearly that a mad gambler's throw of the dice might bring defeat and with it the collapse of Nazism and the total eclipse of himself... Frequently, I have been told by Germans 'Herr Hitler is honest, he means what he says. He wants peace not war. His chief mistake is in thinking that others are as honest as himself.'

On March 15th Tommy Ackroyd addressed a well attended public meeting in Durham and explained party policy and was at Trimdon the next day and had excellent results.

Speaker Ernest Clark was in Middlesbrough's Carlton Hall in April and new members were enrolled. Communists were present but were manageable. Raven Thomson also spoke in the same place to a packed house on the 24th when the Reds were put in their place by the speakers ready wit and quick replies. He also spoke in the Town Hall on May 1st and was given a good hearing. During May there was a good attendance of members at the Coronation dinner arranged by the Newcastle district and Newcastle West election candidate, Mr. Sheville, was the guest of honour and delivered a short speech. Due to the posting of administration staff to different areas and a number of other issues it was later decided to withdraw Mr. Sheville from the election. At Shildon, a meeting was addressed by Dick Plathan in the Market Place and at Trimdon Grange he spoke at the Labour Exchange.

Alexander Raven Thomson, the Director of British Union Policy, was again speaking at Durham Town Hall on Monday evening April 19th. He said that Fascists were organising all over the country and that they had some success at the London County Council elections and they were still building up the movement. "Communists had now become merely the foreign agents of Moscow" and "We are not in favour of the present party system because it is not a true form of democracy. We must

find another means of carrying out the will of the people," he added. He went on to say that in the Spanish troubles, Germany and Italy intervened only when it was discovered that "Red" France and Russia were rushing troops in aid of the Spanish Republicans.

Dealing with high finance in this country, Mr. Raven Thomson said that enormous concerns had set up branches in almost every town and had driven the small trader off the main streets. Many of them thought that was all very well as they could get things cheaper and a quicker service, but was it a good thing that private enterprise in this country should be extinguished? The farmer was ruined by the importation of foreign goods. Small men have been driven out of business everywhere by great trusts. He said "I can see no reason why we should be ruled by money. We want to be ruled by authority and not by money power."

He remarked "that Fascism would only come into power by the vote of the people and not by any violent methods but there would be a complete and final destruction of the money power that rules to-day. They would abandon the present party methods because of their hopeless and complete failure and their one object would be to carry out the will of the people. Voting would be done on an occupational basis so that everyone knew what they were voting about. Democracy today, he said, worked on the principle that everybody knew everything and that was absurd. People in the mines would vote for their own particular nominee, shopkeepers for theirs and so on, and thus they would have self-government within their own industry or occupation."

Mr. Raven Thomson went on to say: "Fascists were in agreement with the miners in their desire to secure one trade union for the mining industry and they would insist upon a national agreement for all the miners in the country. They would abolish the great multiple stores and make greater use of the co-operative movement. Central government would be in the hands of the people and a referendum would be taken periodically."

Early in June, Mr. Clement Bruning arrived on an intensive British Union speaking campaign in the area. It was said: "He was a pleasing man on the platform, which often has the effect of gaining support of a previous hostile audience." He opened his campaign with a quote from Karl Marx who said that "The English people cannot make the (communist) revolution, foreigners must make it for them." In the middle of the month, Tommy Moran spoke at Cowen's Monument when the Red Front were well and loudly represented but the speakers humour prevented any trouble from the "comrades" who were clearly looking for it. The Reds were amazed that many of the public were in agreement with the BUF "Mind Britain's Business" policy. The noise from the Young Communist League tried to drown Tommy out but he was too much for them. It was a good meeting that helped supporters in the local area.

At the start of the summer, Newcastle branch received complaints from the local Billboard Advertising Agency about the unauthorised appearance of Action placards on a number of rented sites. This complaint coincided with the visit of a plain clothes police officer enquiring about the appearance of graphic slogans with a BUF connotation painted alongside busy suburban traffic routes. Assurances had to be given, with tongue in cheek, that any illegal "Fly by Night" squads would be told that they risked being taken before a Court if caught.

While British Union campaigned for a strengthening of the armed forces to deter any aggressor, it was reported in the summer that dangerous Communist Party propaganda that included attempts to foster unofficial strikes was used to hold up rearmament work. The Chairman of the annual meeting in Newcastle of the North-East Coast Area of the Economic League, Mr. Clive Cookson, also said that they faced a growth of propaganda among what might be called intellectuals and referred to the foundation of the Left Book Club which concentrated its activities on the higher middle class. The political Left, and the Communist Party in particular, continued to campaign against strong and

well equipped armed forces until the Soviet Union was attacked in June 1941 by a German pre-emptive strike. The Reds then did an about turn and formed "Friends of the Soviet Union" and similar groups and called for the opening of a second front in Western Europe by our troops to rescue their financial and political foreign master in Moscow.

In 1937, William Joyce, and the former Gateshead Labour MP John Beckett, left the BUF and formed a radical racial nationalist organisation called the National Socialist League. Joyce argued that Hitler was a great German patriot and that England needed National Socialism. Before the outbreak of the war, he went to Germany in July 1939 and wrote that England was now morally decaying and in terminal political decline and that only Hitler's Germany could provide the leadership and drive for the reconstruction of Europe. Although born in New York and raised in Southern Ireland, he took out German citizenship and began radio broadcasting his infamous Lord Haw Haw speeches to Britain. It was not all bad as the Evening Chronicle on May 20th 1940 told the story of Mrs. T. Kelly of Hadrian Road, Primrose, Jarrow, who had been in ill health for some weeks and had received a set back when the war office notified her that her son, serving with the Green Howards, was missing in Norway. Joyce had announced in one of his broadcasts that her 21 year old son, Private Thomas Kelly, was alive and a prisoner-of-war. Mrs. Kelly said "I am 100% better now and whatever people say about Lord Haw Haw, he did a good deed last night."

A Shields Gazette correspondent received a reply from British Union Staff Officer Henry Gibbs on June 18th when he wrote "I note with great interest the letter from your reader, Mr. J. Coxon, who states his grievance 'that when a person becomes dictator and has no official opposition and rules without mandate - what security have the people?' Surely Mr. Coxon does not imagine that the present plight of our official unemployed, the unacknowledged unemployed agricultural workers and the black coated men and women out of work represents security for

the people. If he studies the election figures for the 1923 and 1929 General Elections he will receive a shock; at both these elections a party got into power only because it won a majority of seats in Westminster but actually a majority of the electorate voted against the party which formed the Government. British Fascism is using constitutional methods to place its proposals before the people; in the same way that Herr Hitler formed the Third Reich through obtaining a majority support from the German voter. In a Fascist State criticism is always encouraged when it is voiced with the desire to help the interests of the nation. In England today the admitted enemies of the Throne, and therefore of the people, are permitted to voice their hatred of everything that is so dear to the English heart and to work openly for a revolution similar to that which accompanied the rise of Bolshevism in Russia. Is it wise to permit free speech to be carried to such lengths? Finally, none whose interests are allied to the well-being of the nation ever have any cause to fear any punishment attendant upon the intrigues of traitors. Fascism puts Britain first, and the only people who need fear the termination of their schemes are those who put Britain last."

At the end of the month, and making available her views in *The Sunderland Echo* to its readers, Margaret Collins wrote: "Commenting on the proposed increase of £200 per annum in the salaries of MP's you have levelled 'glib misrepresentation of the pocket-lining type' in parliament over this question. In April this year Mr. William Gallacher, the Communist MP, stated in the press 'I am living in London on slightly under £20 per week and living very well.' Yet, Mr. Gallacher voted for the raise of £12 per week! The Socialist Party were also heartily in favour of this increase. Yet, the whole House of Commons, with the exception of a handful of MP's, was equally agreed on the decision to allot 2s per week as the allowance adequate enough for keeping the child of an unemployed British worker. One must conclude, therefore, that our democratic politicians, who have shown no ability to cope with the problem of unemployment, assess their own value in comparison with that of children of

Mosley represents Britain at World Fencing Championship in 1936

unemployed workers as over one hundred times greater than these victims of their ineptitude and inefficiency. Nor on the basis of payment of services rendered, does there exist any justification for this increase. In 1930 the Socialists initiated a means test which was made law when the Tories came to power. Yet, there is no suggestion of a means test to be applied to these MP's who clamour that they are 'starving' on £400 a year."

When presenting Trade Union Congress awards for meritorious service to seven of his members in the Newcastle area on June 3rd, John Yarwood of the National Union of General and Municipal Workers said: "We have evidence that certain well known trouble makers in our ranks have entered the Labour movement by back door methods, and we suspect that many of them have done so on the direct instructions of the Communists...I appeal to all trade union delegates to attend every possible meeting for their apathy and neglect to do so leaves the floor clear for the trouble-makers who take advantage of every opportunity they get...Loud mouthed agitators have been sent to breed discontent with trade union policy and in their sly way they do their best to decry all efforts towards reasonable settlement. What reasonable negotiation cannot accomplish anarchy can never do and the majority of the members of our union at least recognise this, and pay no heed to the glib-tongued tools of Moscow."

Part of the developing Anglo-Fascist culture was the BUF annual summer camp. The largest of these was held on the coast at Selsey, West Sussex during July and August 1937. An appeal to the public and BUF members was launched to send young

Cadets on a free two week holiday from Saturday July 17th to July 31st. Women Blackshirts took over the camp between August 29th and Sept 5th. Sir Oswald Mosley attended but at a date later than arranged due to his representing Britain as a team member at the World Fencing Championships in Paris. A number of Geordie's attended the Selsey Camp and former Newcastle District Leader Ken Dick wrote "The British Union Summer Rally and Camp held at Selsey, West Sussex, was being discussed by most of the members of Newcastle Branch. Many wanted to attend but the distance of 350 miles was almost comparable nowadays to an overland journey to Bulgaria. Nevertheless, starting at dawn, a party of six Geordie Blackshirts made the journey. Three motorcycles and one motorcycle and side car were the transport. The chief navigator was familiar with 50% of the route and was aided by a road map borrowed from the local library. This long range group finally drove into the camp site to find out they were but 15 minutes late for OM's presentation ceremony. The disappointment was quickly forgotten as we were rapidly absorbed into the infectious enthusiasm and spirit of comradeship which pervaded the camp. The weariness of the journey soon evaporated. We met many Blackshirt comrades from different parts of Britain and exchanged experiences: not least of all about the great London BU marches! At the Selsey camp we felt strongly that Britain was at long last awakening.

"We felt privileged to be part of the tremendous crusade in the company of such a great Leader." Ken remained a Mosley supporter until the end and, in his latter days, wrote the history of "How the BUF came to Geordieland." He passed away at St. Peters Residential Care Home in Wallsend on March 2008 aged 95 years old and still faithful to his life long beliefs.

During July 1937, Mr. Richard A. Plathen, the National Inspector for Scotland, visited Berwick, Durham and Darlington and Newcastle's Atkinson Road where the ten points pamphlet and *The Blackshirt* were distributed to many people. At the end of

the month, Mr. Johnson and Mr. Gordon spoke at Darlington's Market Place on a Thursday, the audience was small but the people listened and a sales drive was held in Middlesbrough with good results. Miss Bell addressed an audience of several hundred at Davison Street while, two streets away, the Labour Party meeting hardly attracted anyone. Middlesbrough members also visited Redcar and 6,000 leaflets were distributed in one night.

Winston Churchill wrote an article for the *Sunday Sun* called the "Ebbing Tide of Socialism" in which he said that with the extension of the vote to all it would spell the dominance of Socialism or more extreme left-wing ideas. But this did not happen in Britain and its appeal to any large portion of the British nation proved to be untrue. This he said also reduced to impotence the conceptions of Sir Oswald Mosley as he had built his hopes upon a Socialist or Communist menace to materialise to gain popular appeal. Speaking for British Union, Margaret Collins said: "This statement proves that Mr. Churchill has omitted to acquaint himself with our policy and aims before proceeding to rush into print against us. The British Union seeks a dictatorship of the will of the people; not a Right-Wing dictatorship nor a Left-Wing dictatorship. We are a mass movement embracing all sections and classes of the community, and stand for a National Socialist society in which the barriers of class are destroyed and all sections of the community unite for the common good. I would point out that if there never had existed either a Socialist or Communist Party there would still have existed a need for a change in the system of Government. The record of the Tory Party, whose 'Conservatism' consists in preserving the anomaly of poverty in the midst of plenty, is sufficient to warrant such a change."

Miss Ellen Wilkinson MP for Jarrow was taken to task by British Union's Olive Hawks in September. 'Red Ellen' had said that we are not going to have "police Fascism in England." The Blackshirt spokeswoman replied: "We do not understand why disputes as to the justice and legality of police methods should

involve the use of a word which has come to be accepted as implying economic nationalism and corporate representation. It is a tactic of the opposition to prejudice the mind of the people against us by applying the word 'Fascist' indiscriminately to action of every kind which may be unpopular with a section of the population. This is a tendency which must be exposed. Let opposing movements fight us with clean weapons and use against us only such faults as they may be able to find in our stated policy."

British Union staff member Margaret Collins then went on to reply to "Fellowship" in the Shields Gazette on Sept 7th. "It is hardly fair to attempt to criticise Sir Oswald Mosley's policy without, as he admits, not having read Mosley's book "The Greater Britain" on which that policy is based. With regard to our newspapers we do not preach a 'gospel of hatred' against the Jews, Socialists, Liberals, and professing Christians. Most of our membership falls into the last category. With regard to the rest, we criticise the policy of the Socialists, Liberals, and other political parties. That is not a 'gospel of hatred'; it is justifiable criticism. With regard to the Jews, we do not preach hatred against them, we merely state that Jews living in Britain must put the interests of Britain first. In reply to the rest of the letter, a British Union Government would not be able to enforce 'any policy that suited them' against the will of the people... The life of Government would be dependent on a direct vote of the people taken at regular intervals and, in addition, a direct vote of the people will be taken on all important issues that arise during the lifetime of a Government and had not arisen when the Government was elected. With regard to his other query, the franchise under our policy would be an occupational, not a geographical, one. The people would vote through their own industries for practical men to represent them."

Both Olive Hawks and Margaret Collins continued to reply to accusations of a "gospel of hatred" and "protecting women and children from thugs and blackguards." Olive said: "The object

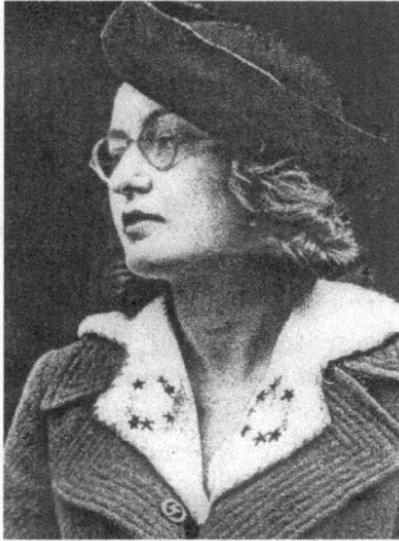

of this movement is to obtain power through constitutional means and it is therefore very unlikely we should attempt a 'reign of terror' which could only alienate all decent people from us. The truth is that support for our movement in East London, as proved by results at local elections in March that were much better than any such first results of any other party, has grown to a volume which has frightened the opposition into a campaign of lies. We are quite prepared for anyone who doubts these statements to investigate for themselves, to listen to Blackshirt meetings, and to examine our publications for alleged vulgar abuse."

Olive Hawks

On September 24th 1937 Mr. Plathen had a great meeting in Durham City and the people showed a lot of interest in the fascist cause. In October, Middlesbrough reports showed the branch to be divided into East and West districts. The East area was progressing with literature sales taking place every night and new members enrolled. In the West leaflet distribution was taking place nearly every evening and policy and speaker schools were being held every Tuesday and Thursday throughout the winter. Redcar members were circulating in all the outlying areas and farmers were taking a keen interest in agricultural policies. Old copies of Action and Blackshirt were finding their way into many country farms. In Darlington, Mr. Desmond and Mr. Johnson spoke in the Market Square and some of the audience stayed back for a discussion with members. Many papers were sold and literature distributed. It was announced at the end of October that, after a short illness, the County Propaganda Officer for Co. Durham, Mr. Ernest Clark, had passed away. It was said

"He rendered invaluable services to the movement as a speaker of great force and ability and made a real and personal sacrifice for the movement." Middlesbrough also held its General Meeting at the district Headquarters and National Inspector Sant outlined the party programme for the next few months.

In mid-Autumn The District Leader Jack Lynn moved from "Geordieland" and Ken Dick was appointed to the post who described his predecessor as "innovative and imaginative" whose successes included many branch activities during the 1935 General Election and intensive street sales techniques. With Jack Lynn's departure came also a move of branch Headquarters from its City Centre premises in Clayton Street to more compact accommodation in Lovaine Crescent.

On October 26th, Russian exiles performed a recital at Durham Cathedral. The Bishop of Durham, Dr. Henson, commented "Your wonderful singing has in it the pathos of the sadness of the exiles whom you represent" when he addressed the seven members of the Russian Orthodox Academy of Paris. The Bishop put into words the thoughts of the congregation who had gathered there within the great church to hear the voices of the men who are the victims of the turmoil that has been going on within European nations in the last twenty years. The choir was lead by Professor M. Ivan Denissov, late of the Imperial Opera House in St. Petersburg. They formed an impressive group as they sang, unaccompanied, vespers and chants. The singing was incomparably beautiful and cast a spell over the whole congregation. During the interval the Rev. P.E.T. Widderington made an eloquent appeal on behalf of the Russian Church Aid Fund. He said: "It is almost impossible by the imagination to picture the suffering, privation and frustration of these people, defenceless, with no citizenship, no flag to cover them." He added that there were 180,000 Russian exiles in France and many of them were people of education and culture and that they suffered heavily from unemployment. They had established 19 new parishes in and around Paris and wanted to create more. All

that Russian priests could be granted was 300 francs a month, about £2-£3 and that there were parishes where the priests, married men, received no money but only food and shelter. The parishes are not only places of worship but also community centres equipped with clinics. They were touring England to raise money in order to help them get through the next winter and the Rev. Widderington begged the congregation to help.

In November, a Blackshirt speaker addressed the Workers Education Debating Society at Wingate. There were many questions from local socialists and councillors and the speaker was thanked by members of the audience at the end of his speech. On the 22nd of the month Sir Oswald Mosley arrived in Newcastle on a short visit to meet officials of the branch and hear reports and to give encouragement to the local organisers. The conference took place at a 300 year old mansion called "White Knights" in Spital Tongues. Ironically, many years later, this is where Marxist Labour Councillor Nigel Todd, one of Tyneside's leading "anti-fascists," lived.

The early days of December saw a sales drive and literature distributed in Middlesbrough. Later, outdoor meetings were cancelled due to the bad weather, but Mr. Budge held a policy class and interesting discussions took place. When the weather improved he spoke at Darlington Market Place and the members had a sales drive after the meeting.

1938: Tagging Fascist to
Anything Unpopular

As Germany pursued the re-unification of its land and people, the British Government announced in January that all children were to be issued with gas masks and a mock "black-out" exercise took place in Leicester. War was a possibility and severe weather restricted the North East "Action" sales teams with its peace in Europe policy. When street sales became fully operational concerned members of the public asked "Will there be war?" or "What can Mosley do now?" Local Red opposition would shout: "On whose side are you now... Nazi!" which was met with an equally loud reply: "I'm ready to fight for Britain! - are you?"

Nevertheless, street activities continued and in April 1938, member John Stoves addressed a good meeting in Davison Street, Middlesbrough (East) and there were many questions from the crowd. Another meeting was held by Mr. Budge at the Temperance Hall in Trimdon and also on The Green at Billingham. Parts of Trimdon were also covered with leaflets.

London BUF staff member Olive Hawks wrote to the North Mail on April 14th concerned about the misuse of the term "Fascist." She wrote "Councillor Charles Wilson, when he mentions the "Fascist" methods adopted by the Labour members of the Crook and Willington Urban Council, is being misled by the new tactic of the Left, which is to apply the word "Fascist" to anything which may be disagreeable, in order to build up unpopular associations about the word. What their actions have to do with the policy of British Union is not clear. The principle on which this movement is founded is that of Christian service - the whole of the nation working together for the good of the whole. From this foundation we come logically to a system of

100 per cent trade unionism, given real power in Government and enabled to have a direct voice in the conditions of the people. If Councillor Wilson would give careful and impartial study to the policy of British Union, he would not then misuse words which have a very real and definite meaning." With the advocates of war leading Europe into another great tragedy, Olive was to be interned in June 1940. After the war she was employed by the Imperial War Graves Commission and sent to Greece to assist in organising War Cemeteries for the British casualties of WW2. While there she met and married a Greek soldier who had fought both against the Germans, and then later the Communists in the Greek Civil War. They had three sons and in the early 1960's emigrated to Perth in Western Australia where she passed away in 1992.

Communist thuggery reared its ugly head again in Red Spain when local man Edgar Stutchbury, a refrigerator greaser of the steamer Celtic Star who lived at Quarry Road, Hebburn, was arrested in Valencia on his way back to his ship. He said that in early May a car pulled up beside him and two men jumped out and searched him and then ordered him into the car. He was then asked to join the International Brigade and when he refused he was taken to a military prison. He was held for a day without food or bedding and not allowed to see anyone. He made an effort to escape but was forced back by soldiers using revolvers. While in the prison square he talked to a German sailor and afterwards was moved into a sort of dungeon. He said he resisted all the way but they used bayonets on him. He denied any knowledge of spying and had been a sailor all his life. In the 24 days as a prisoner he had not had a wash, shave or change of clothing and for the last three days had been ill with dysentery. His treatment by Communist authorities was a disgrace but not uncommon.

That July, Marxists tried to pass a resolution at the National Union of Railwaymen's conference pledging support for the Popular Front but it was defeated by a majority of more than three to one.

Knowing the devious methods employed by the far left, Labour member Mr. H. Hailes, the Gateshead delegate, had opposed the resolution as another method of getting Communists into the Socialist Party and remarked: "If you allow the cuckoo to hatch its egg in the sparrows nest the young bird will spread its wings and the Socialist Party will be no more."

Due to severe weather conditions throughout the winter for outdoor sales teams, hundreds of unsold newspapers had accumulated and it was decided that on May Day fit volunteers would assemble in Lovain Crescent outside Newcastle British Union District Headquarters for a distribution campaign. On the day, they exceeded the six teams (each of four personnel) that had previously been briefed. Two of the teams included female volunteers plus a further dozen members had turned out to help. Two members in each team had knapsacks containing a supply of "Action" and the members formed into a column and set off jogging to the target area. As war clouds were gathering the branch was making every opportunity to break the press silence on the BUF!

During the early days of June, Darlington crowds were very interested at the meetings held on the steps of the covered in market. In Middlesbrough, a meeting was arranged for June 12th when a debate with Mr. Watson of the Labour Party was to take place but he failed to put in an appearance much to the disgust of the audience. As part of his annual speaking tour, Sir Oswald Mosley spoke at Newcastle on Tuesday June 14th, and again in Edinburgh the next day.

The Communist Party's Annual District Congress was held at Gateshead on August 27th and 28th 1938. A "Geordie" correspondent wrote in the weekly Action newspaper that at the meeting "Reference was made to the Communist Party's association with the Tyneside Peace Week, Stockton Peace Assembly, Labour Unity gatherings, United Peace Alliance and other pacifist organisations. It was also stated that a "very friendly relationship"

now exists between the Communist and Labour Party, not only in Newcastle but in Blyth, Stockton and other towns and that efforts were being made to gain more influence in the co-operative movement locally." The report also stated that "Campaigns among women folk in the district and among Durham University students are now being urged." Commenting on this, the BUF said that "While Oxford and Cambridge are completely out of touch with the lives of people and have dabbled in abnormality and effete 'isms', provincial universities have still remained a bulwark of the level-headed Britain against academic perversions. What this communist move reveals is that even now down to earth centres of learning like Kings College, Newcastle, are going to find themselves turning out the sort of rich Marxist with whom we are all so familiar." The Gateshead Lord Mayor Timothy Armstrong had given the congress a civic welcome and the "Geordie" writer of the article wondered how long it would be before the left-wing "pinks" would be digested by the Marxist reds.

Towards the end of September, Sir Philip Dawson, Member of Parliament for West Lewisham and first chairman of the Anglo-Italian Parliamentary Committee, died while returning from Warsaw in a Berlin nursing home aged 71 years. He had an intimate knowledge of Italy, having lived there for a long periods, and was an admirer of Signor Mussolini. Earlier in the year he said "Only those who have known Italy intimately, both before and after the war, can realise the marvellous achievements of Signor Mussolini and the gratitude of the mass of his Italian people for what he has done for them."

Newcastle District Leader Ken Dick had to reply in October to a South Shields Communist Anthony Lowther who thought there was a Fascist under every bed and alleged a pro-Fascist group was in the Cabinet whose policy was "to rescue Fascism abroad and help to establish it at home." Ken Dick said "that it cannot be too strongly emphasised that if there were any pro-Fascists they would long ago have resigned their posts in disgust and left the farce of Democratic politics behind them

and would now be working in the ranks of the British Union. The Government has shown by its repeated attempts to suppress our movement that it is no more their wish than it is that of the Labour Party to see the triumph of Fascism in Britain. It is indeed strange and somewhat flattering to note that when any member of the Government makes a sensible remark or action he is immediately dubbed a Fascist."

He again defended the movement on November 22nd against misrepresentation when he pointed out that the British Union never boasted "that it intends to suppress and annihilate the Jews." He wrote: "It is not in accord with the British character to keep Jews in order to bully them - this we will never do. On the contrary, the statesmanship of the future must find a solution of this question on the line of the Jews again becoming an integral nation. The collective wisdom of Europe should be capable of finding a territory where the Jews may escape the curse of no nationality and again acquire the status and opportunity of nationhood."

He went on to say "If the Jewish declarations are sincere, the efforts of European statesmanship to find a solution to this problem by the creation of a Jewish national state should not be resisted by Jewry. In summary of British Union policy on this question, we affirm the right of every nation to deport any foreigner who has abused its hospitality and we hold the aim of finding, together with other European nations, a final solution of this vexed question by the creation of a Jewish national state, in full accord with the age-long prayers of the prophets and leaders of the Jewish race. Is this persecution or is this justice?"

One correspondent called "Love One Another" continued to doubt British Union policy and Ken Dick replied again: "May I further enlighten you upon the British Union's attitude toward the Jews. It is not the intention of a British Union Government to expel from Britain all Jews. Those who are willing to conform to the laws of the country and put Britain first will be able to

remain. Throughout the ages the Jews have maintained a narrow tribal religion, under which they regard themselves as the 'chosen people' of God, discouraging their people from intermarriage with the Gentiles and otherwise supporting the very racial policy to which they object when applied to themselves in Germany. Indeed, the Jews have been racialists throughout history, as is amply confirmed by Disraeli in his novels.

The correspondence went on: "The Jews themselves complain that in every country in the world they have been persecuted at some time or another. If they remain in other countries what guarantee have they that this persecution will not break out at some later date." His critic was concerned that the Jews were to be segregated and he responded "Is 'Love One Another' of the opinion that Denmark, Sweden and every other nation is segregated from the rest of the world? A British Union Government is offering Jews something for which they have asked for generations. Is it really suppression and persecution of the Jews to suggest that they again become a nation? Is it suppression and persecution to be given that which has been acclaimed by the prophets and seers of Jewry as the final objective of their race for the last 2,000 years.

"Finally, may I say that we of the British Union hold no brief for suppression and persecution in any form, whether it be of the Jews in Germany or Catholic bishops and nuns in Spain. We believe that here in Britain we can find a solution for the Jewish people in a manner fully in accord with the British character."

1939: Britain Declares War

With the ending of the Spanish Civil War members of the communist International Brigade returned home. One was Mr. W. Norris of South Shields who was intent on blackening the name of fascism. The Peckham British Union District Leader Frederick Burdett said: "I would like to remind Mr. Norris that the Foreign Enlistments Act of 1870 definitely prohibits Britons from serving in the armed forces of a foreign country. In spite of this Act these people left their own country and served when they might have stayed and have done something for their own people. If a Blackshirt, whose whole life is devoted to the service of Britain, were to appear on the street in uniform and break the Public Order Act he would soon see the inside of a police court and yet these individuals were allowed to go to Spain and were accorded a civic reception on their return. Now they are attempting to divert food and money from the starving people of this country to Spain...we are interested in Britain and it should be a punishable offence for any person or society to attempt to send money abroad while there is want in Britain."

On a tour of the North of England, Sir Oswald was invited to speak to a meeting of Rotarians at Hexham on April 26th 1939. Addressing the meeting organised by the Hexham Rotary Club in the Royal Hotel, Hexham, he stressed "Why have we to be allied to every little country in the East of Europe" and he maintained that we had nothing to fear from Germany if we had the will to hold and develop the resources which our grandfathers had the courage to win for us. Rotarian Mr. F. Chaffey, President of the Hexham club, presided, and Rotarians were present from North Shields, Chester-le-Street, Gateshead, Ashington, Morpeth, Newcastle, Whitley Bay and Carlisle Clubs. Mosley said "I have had the pleasure if talking to Rotary Clubs before

and I hope that it is well known that on these occasions I do not talk Party politics. When I arrived here I asked what I should talk about and the answer, as one usually gets at this time, was the international situation and foreign affairs. I hope that before long we shall be able to talk about different matters, for I would rather talk about our own country."

"Whatever view we have for the betterment of our country and our people, we know that at any moment it may be shattered as the fear of war hangs over us. And we British people, whatever our opinion, will fight for our country if she is attacked, as we did before for her safety. I do not think that anyone will dispute that. I am probably getting on to more controversial ground if I say that if we are not attacked, we have to look into what we are going to fight for when we are asked to intervene in some European quarrel on behalf of any state."

This statement led Mosley to ask how we could preserve British interests and maintain world peace at the same time. He said: "Our duty is to serve Britain and world peace. Let us come to the crux of the matter. Surely the present relationship of Great Britain and Germany constitutes the greatest threat to the peace of the world, primarily because we are the two strongest powers in Europe. We have therefore, to ask ourselves in seeking peace whether war between Britain and Germany is inevitable or not." Sir Oswald thought it was not and proceeded to name the constructive proposals he considered would achieve this.

"In power and faced with this situation I would advance a policy of four simple points. First of all we do not have the slightest interest in the East of Europe and whatever happens Britain should not intervene there by force. Two, in return for this we ask for a great disarmament pact in the West of Europe in which Germany would be willing to join on account of our non-intervention assurances. Third, return of its Mandated Colonies on certain assurances from Germany. Four was concentration on our Empire policy. The British people have to realize that

we must look after and build up the greatest heritage known to man: the Empire of Great Britain.

"In regard to the first point," he continued, "Why have we to be allied to every little country in the East of Europe? Is it because that in Germany we are confronted with a great and growing power. But this policy is a corollary of the doctrine of cowardice, fear and defeatism which has been pumped into the British people. It is my painful duty at times to arouse the British people to some sense of their own greatness. Who are we to cower in fear before any foreign power, and to believe that we cannot face Germany...Why should we run around seeking alliances with every little country in Europe and telling them that we should come to their aid when attacked if they would send their army to help us.

"In the British Empire there is a white population of 70 million and 500 million in all. Covering one quarter of the Earth's surface, it contains every raw material and natural resource that Germany does not possess. Why are the Germans stronger than us? One year ago they had 70 million people in the German Empire. Since then they have got 10 million more from Czecho-Slovakia. If our 70 million white population in the Empire can account for the 70 million Germans, surely the other 430 million can manage the few extra million they have obtained. If it is a question of resources, well, it is simply foolish to talk about German resources. We have nothing to fear from Germany if we have the wit to hold and develop the resources which our grandfathers had the courage to win for us" he declared.

"I am the last man in England," he said, "to ask the British people to imitate the Germans. My doctrine is a national one. But if we are to live in a modern world beside nations that have modernised their systems, we cannot afford to continue with the methods of the 19th century when other nations have adopted those of the 20th. Once this country is awake, it will not be for us to look for models abroad, every other country will look to us.

It will not be a question of can we live beside other countries but what countries can live beside us.

"What then, is the good of running about Europe making these alliances? Why are we guaranteeing the independence of Poland and Rumania? Is it to protect British interests in these countries and ensure the maintenance of supplies from them? What I ask you does Poland export? You in the North-East should know that. It is coal, coal which is under-cutting the British coal industry and obtained by sweated labour from mines which have been developed by British finance from the City of London. What does Rumania export to this country? Wheat and every bit of wheat brought into this country means less money for the British or Canadian farmer. The whole of our wheat requirements can be produced in East Anglia and with the help of Canada. Can you suggest there is anything we want from these Eastern countries which makes it necessary to have an international war to save the resources of these countries? Let us enquire carefully into what 'interests' urge us to go to fight for Rumania and Poland."

On the subject of disarmament, Mosley said: "We could tell a power like Germany that she would never again be in a position of having to fight England, France and Russia at once, and in return for that we could obtain from them a pact of peace and disarmament. I am told, however, that under no circumstances would Germany disarm.

"If you believe that, let me ask you to cast your mind back to November 1933, when Germany made three offers in the interests of world peace. One of these was the Naval Agreements with Great Britain, which limited German naval power to 33 per cent of Britain's. This was an exceptional agreement and both sides kept to it. As a matter of fact, I do not think that Germany has actually built up to the point allowed by the Treaty. The second point was to limit the German Air Force to half that of France, and the third was to cut their army down to 350,000 men if France would do the same. And what happened? In place of the

second and third points there came the Franco-Soviet alliance to which our Government was a party. Germany then began her huge rearmament programme, the result of which we know only too well, and she began looking for other partners where she could find them. Let us reflect that Germany did propose a disarmament pact, but instead it was met by an alliance of the Western Powers."

Going on to discuss the return of German colonies, Sir Oswald asserted that he would not give away one inch of British territory in the world. "But," he said, "these Mandated Colonies are not British and never have been, and I would give these colonies back if I were satisfied that they would not be used to threaten other British territory in Africa. The one factor that would prevent this," he thought, "was the British Navy, for as long as the British could maintain command of the sea no country could supply war materials to colonies in Africa. They would be starved out in a military sense in an unbelievably short time, for after the war broke out all the sea routes from Europe through the Mediterranean and round the coast of Africa would be cut off, and Africa would simply fall into British hands.

"With the policy of strength, of vigour and determination," the speaker said, "I believe that the peace of the world can be saved. The opposite policy is to run around to any country in Europe and offer them mutual assistance alliances. We thus buy allies who in a military sense are valueless. Any soldier can tell you that there is no means of saving Rumania in the event of an attack by Germany." The policy of encirclement he condemned as certain to force a European war. "We are trying to build a wall around Germany and Italy so what do you expect them to do. Before long the Central Powers are going to burst out of that wall if they can. This strangulation policy will throw Europe into a war if anything will and it is the result of the fear and defeatism which has been pumped into the British people by the press. The way out of this is to give the British people a sense of their greatness again."

Mosley was warmly applauded at the close of his address, and he afterwards answered a number of questions put to him from the meeting. Charged in one instance of having made no reference to the moral responsibility of going to the aid of small European states, he replied that "To me the greatest moral question is whether a million British youths have to die through intervening in an unjust quarrel on the Continent. I can conceive of no greater moral question than whether we who fought in the last war are going to sentence the Youth of Britain to die in another. And before we run to help a smaller nation against a bully we have to make sure there is a bully.

It is alleged that the German bully jumped on to Czecho-Slovakia, and when, after Germany had marched in, Lord Halifax was asked in the Commons whether Britain had not committed herself to defend her against external aggression. He agreed this was true, but that the pact did not cover the present situation due to internal disruption and not external aggression. The country was told this through the Press, and took it surprisingly calmly, yet a few days afterwards, the Premier, speaking in Birmingham, accused Germany of an act of brutal aggression. The Press also made a volte-face and condemned Germany.

"We have, therefore, to make up our own minds which of the two are correct. If what Chamberlain and the Press said was true, then I regret to say, Englishman as I am, that we were guilty of a very dishonourable act of betrayal." The talk was the last of a series on international affairs arranged by the Rotary Club, and a vote of thanks to the speaker was proposed by President B.A. Iveson. Mosley then went on to Edinburgh for another speaking engagement.

British Union supporter Mr. G. Miller showed the inconsistencies of left-wing propaganda when he said in June: "For years Labour and the Trade Union leaders have been entertaining credulous minds with hair-raising accounts of Nazi atrocities and about the complete restriction of Labour rights in Germany. A few days

ago Will Lawther, Acting President of the Miners Federation of Great Britain, published a pamphlet in which it was stated that German miners were resisting speed-up and longer hours "in some cases with the open strike," but everywhere with a "go-slow" movement. Mr. Miller then asked when did the Labour leaders lie? (a) When they told us that the German workers had no liberty to oppose measures imposed by the Nazi Government, and further, that strikers were shot or (b) when they tell us that the German miners are on strike. For if they are opposing Nazi measures it stands to reason that they still had the liberty to do so." Many of Will Lawther's family were decidedly on the far left and his younger brother Clifford Lawther had died fighting for the church burning Spanish Republican forces in the battle of Jarama in 1937.

With political tension increasing, the last German and Italian vessels left the Tyne at the end of July 1939 and the Duke and Duchess of Windsor were brought back to England by a Royal Navy destroyer. In August British nationals were heading home from the continent and Germans were speeding up preparations to leave Britain following advice from the German Embassy.

The Blackshirt campaign for 'Peace with Honour, British People Safe and Empire intact' was unsuccessful and on September 3rd Britain declared war on Germany. Mosley immediately began a tour of British Union districts and during November was on Tyneside where he addressed members and had private talks with local leaders. Although the Blackshirts and other patriots found themselves in a difficult situation, they adhered to the motto "My Country, Right or Wrong" and many joined the armed forces ready to defend Britain. At the outbreak of war, it was decided by British Union that public activity was to continue and a "peace with honour" campaign was launched as an alternative choice for the British people.

In August 1939, Newcastle District Leader Ken Dick left to join the army and his place was taken by Colin Ferry, a cashier

Ken Dick 1913-2008 Former Newcastle BUF organiser. Served in Territorial Army, joined the Paras for six years, wounded in Normandy. Awarded Queens Coronation medal in 1953 for voluntary services.

in a local haulage firm. Colin's father, John Robert Ferry, had been an Independent Labour Party member before joining British Union and they lived at Holystone Crescent in Heaton. On March 2nd 1940, three months before the mass BU arrests, Colin married Joan Davison, the daughter of a chemist and a member of the Monkseaton British Union Branch, at St. John's Methodist Church. On the 3rd June he was detained as a Regulation 18b political prisoner and sent to Liverpool Prison. None of the British Union members were found to have anything incriminating in their homes and had given the police the fullest assistance and had willingly handed over all documents and papers. Colin Ferry was released from 0/3 Internment Camp, that was built on the Race Course at York, on January 3rd 1941 and returned to his home at 41 Holystone Crescent in Heaton. He later joined the Durham Light Infantry, was commissioned and awarded the Military Cross for action during the D-Day battles.

Margaret Ellen Camfield, together with her sister Dorothy and mother, were members of the Newcastle branch. They had moved from Crowborough in Sussex and had belonged to the Tunbridge Wells branch. As they ran a small shop in the Jesmond area, Margaret, who worked as a hairdresser at J.T. Parrish was not an active member but Dorothy was. She had her bag packed expecting to be arrested but it was Margaret they took on July 3rd! Margaret was a single woman and was sent to Holloway Prison. After been imprisoned without any

reason for five months, she was released on December 2nd 1940 and returned to her home at 39 Red Hall Drive in Heaton with the condition that she report each month to the nearest police station.

The known members of Newcastle British Union that were interned in 1940 under 18B were: Miss Margaret Ellen Camfield; Colin Ferry, District Leader; Les Hooper, a former Canadian farmer; Alan James; Frederick H. Jebb of Whitley Bay; Mrs Freda 'Rose' Jolly (she went on hunger strike in Durham jail); 'Tubby' Lovegreen, District Treasurer; Wilfred John 'Nick' Nicholson, District Leader Newcastle North and later Newcastle District Inspector, released November 7th 1940 from the internment camp at York Race Course; Anthony le Suer; J.A.(Bill) Williams, District Leader who joined the Royal Engineers on release and was seriously wounded in North Africa; Leonard Williams (father of Bill); Arthur Canning; and Lt. Col. James Cherry. In Sedgefield, John Stoves, the Durham District Leader, was arrested as was Robert Anthony Sedgewick of Middlesbrough and Harry Simpson, a Washington member who on release became a Private in the 6th Battalion Northumberland Fusiliers. Patrick McMullen, District Leader of Ryhope and later Sunderland, was also arrested as were Mr. L.S. Merchant of 50 Double Row, Eldon, Co. Durham and Mr. J.G. Regan of 11 Coronation Terrace, Trimdon Village. Other interned local members included Alan James and Mr. J. V. Shields. Internment Orders were also issued for member Leslie Guy who had worked at the British Oxygen Company but it was found that he was already serving in the British Army and no action was taken against him.

Some other Newcastle British Union members were Gordon Thomas, Robert James Sandy and Thomas Sancaster but it is not known what happened to them when the draconian 18B law was enforced. None of the members of Mosley's party had committed any crime and were not given the right of trial during their imprisonment.

Several Blackshirt amateur yachtsmen were arrested immediately after returning from Dunkirk where they had helped evacuate British troops. Many Blackshirts fought in the armed services and over 1,000 died serving their country. One Tyneside Blackshirt was Thomas E. Hastings, Royal Air Force, who belonged to VR 7 Squadron and who was killed in action aged 31 on March 31st 1943. This was in marked contrast to Arthur Henderson MP who wrote in "Labour's Way to Peace" that the trade union movement should call a General Strike to stop war.

The man who founded Newcastle branch, Bill Risdon, who had gone on to work in the London National Headquarters and became the Chief Election Agent for British Union, was also interned under Regulation 18b. After the war he became the Director of the National Union Against Vivisection.

After the outbreak of war, the far left and the Communist Party continued their industrial subversion and the BUF continued to advocate, as it always had, the build up of a stronger British Army, Navy and Air Force and called on its members to join the armed forces and defend Britain from invasion. On January 13th at a North-East Federation of Trades Councils held in Newcastle, Communist Will Lawther was howled down by hecklers that included his two brothers. He had asked why the TUC had not done something to stop the war and that French trade union officials had told him that Communists had been expelled in France "because they deserved it." This was greeted with loud cheers from most of the 160 delegates that drowned out the Red element in the audience.

Many people were concerned about the activity of the far left and Sir Walter Citrine, General Secretary of the Trades Union Congress, warned on April 8th 1940 that "it is the duty of trade unionists who value their freedom to be alert and not play the communist game." The Communists, he said, were running a campaign to make trade unionists believe that the trade union movement had been handed over to the Government hand and

BUF members interned on Isle of Man

foot. He added that after clamouring for war against Hitler, when Germany and Russia signed a pact they had suddenly discovered that the war was a Capitalist conspiracy against the workers. "They are now doing their utmost to divide and weaken the national will and to exploit every grievance of trade unionists to influence them against the war." The Red's subservient following of Moscow's orders was not welcomed and locally several hundred members of the public broke up a Communist meeting in Beamish Street, Stanley, in June when the speaker was pulled from his stand and the threat of violence to the Communists was only ended when four women and two men were arrested.

During April 1940, Germans, Austrians, Italians and other "enemy aliens" were interviewed in Newcastle. Mr. William Jardine, K.C., presided over the No.1 Regional Committee (Northern Civil Defence Region) at Moot Hall where the aliens were examined "in camera" to implement the policy of "combing out" any suspected subversives. If there was any reason to doubt the bona-fides of any of them they were sent to an internment camp. This was somewhat ironic as on May 24th, at the quarterly meeting of the Newcastle Co-operative Movement held at the City Hall, Communist delegate Mr. W. Donaldson caused a

general uproar and loud booing when he put forward a "Stop the War" resolution which was unanimously rejected. People had risen to their feet and repeatedly interrupted him with cries of "shame" and "sit down." A few days later, Stanley Urban District Council wanted to ban Communists from chalking notices of "peace meetings" on pavements and accused Reds of sneaking out in the middle of the night to do it. Councillor G. Graham said "We in the Socialist Party are supporting the prosecution of this war and we don't want any foreign power coming here trying to disrupt this work."

When Mosley and senior British Union members were arrested on May 22nd, the party newspaper *Action* printed a "Message from Moran." Newcastle born Tommy wrote: "The shocking news of the incarceration of the Leader and senior members of the Movement left other members in a mood of intense determination...Mosley has never depended on the brains of democratic professional politicians and he based his firm faith, spirit and intelligence on the man in the street. Leaders, he has said, will arise from the masses and given a job to do they will carry out that task. Now is the time, the real testing time of that principle, when every Blackshirt, men and women alike, can take upon themselves the responsibility of leadership and prove by individual initiative that the spirit of Mosley shall live forever. So go to it, suffering as you must suffer, sacrificing everything if need be, so that you also will emerge from the struggle strengthened in will and determined to carry out the greater tasks of reconstruction."

Locally, in June 1940, Bill Williams was a 20 year old member of the Newcastle Branch and a pupil Civil Engineer with the local authority, when he was given 10 minutes to leave the Borough Engineer's office in the Town Hall. This notice was given by a leftist councillor who had been a conscientious objector in World War I. The Borough Engineer expressed to William his regret it had happened, as did all his colleagues who were aware of his BU views. Later that day he was detained under

the notorious Regulation 18B by the police. William's father, Leonard Williams, was an early active BU member in the North East who had served right through the first war ending it as a Tank Officer. He also was detained. They were not kept long; about a month in the local police station and everyone was quite friendly to them. On his release William registered for military service. Eventually he was called up for the Royal Engineers, was commissioned and later came to grief in a minefield in North Africa. He spent a year in military hospitals and when he came out in uniform, his old chief, the Borough Engineer, invited him back to the office from which he had been banned in 1940. His father died in 1947.

The last issue of *Action* No. 222 was published on 6th June 1940 when, due to men joining the armed forces or being detained under Regulation 18b, it was written that "We regret to announce that further detentions during the past week have deprived us of the services of more valued assistance in the production of *Action*" and that it would be the last issue of the paper. There were over 1,000 British Union members interned during the war for their political beliefs and because they had campaigned for an honourable peace. Many of them were decorated patriots who had served in WWI.

The first two official casualties of WW2 were both members of the British Union of Fascists. They were RAF gunners Aircraftsmen Kenneth Day, 20, and George Brocking, 22, who were killed in a raid on the German fleet over the Kiel Canal on the second day of the war, September 4th 1939. Both need not have gone on the raid because they were RAF ground crew, but they had volunteered to be air-gunners for the mission. Kenneth Day was buried with full military honours by the German Luftwaffe, but sadly, Brocking has no known grave. Although not a Blackshirt, South Shields man 19 year old Aircraftsman Flying Observer John Oscar Smith was one of the leading aircraft crew members and credited with dropping the first bomb during the famous Kiel Canal Raid and one of the lucky RAF men to come back home.

About 1,000 Blackshirts died in the armed forces serving their country while many of their Communist opponents were still involved in causing industrial disputes or were in jail for incitement or acts of sedition. After the war, Sir Oswald Mosley wrote *"The Alternative"* in which he set out his post war ideas for Britain and Europe and founded Union Movement in 1948.

Oswald Mosley passed away at his home outside Paris on December 3rd 1980 aged 84 and his ashes were scattered at the Pere Lachaise Cemetery. The "Friends of Mosley" continue to publish a journal 'Comrade' and maintain a website at www. oswaldmosley.com that continues today to provide the public with a more accurate account of British Union history and its members who wanted a better Britain for all.

While many of their establishment tormentors were "pacifists or conscientious objectors" during WWI, many members of the British Union of Fascists, like Mosley, were patriots who had served in the armed forces with distinction - and many of them did so again during the Second World War. On closer examination the Blackshirts were the victims of violence rather than its perpetrators and have become one of the undeserved victims of history.

True Geordie, Born and Breed

"What is a Geordie?" I've heard many people ask
To give a definition is not an easy task
Some say he is a heathen, grows leeks and lives on beer
But if you listen for a while I'll give you my idea.
When God first made the universe His handiwork was grand
He made a man of every creed to cultivate each land
He made Eskimos for Iceland, Africans to stand the heat, but
When it came to Geordieland He said I doubt I'm beat.
So he made a man of iron, with muscles of forged steel,
For building ships and hewing coal - a job he's done right weel
And just to finish off his job, so I have been told,
He completed his first Geordie by giving him a heart of gold.

Now when you ask "What is a Geordie?" Just stop and think again,
If it wasn't for Geordie Stephenson we'd hev nee railway train
And a'ad Joe Swan from Sunderland first made electric light
And St. George slew the dragon I'm very sure that's right.
So do ye wonder that I'm proud to be a Geordie lad,
A forst class team, the world's best beer. Surely that can't be bad.
And when my early days are done and I leave the world of Sin
I'd like to hear St Peter say 'Haway Geordie, it's your turn to get
them in.'

Unknown author

About the Author

Gordon Stridiron was born in 1946 in the back room of his Grandmother's house at 22 Corrofell Gardens, Heworth Shore, Felling, in Gateshead. His parents had a flat at the back of South Street, off Wellington Street in Felling but back in those days the daughter would normally go to her Mother's to have the baby and be cared for during such events. A few weeks later, the family moved to Waggonway Street, Wardley Colliery, where, after serving six years in the RAF, his Dad had found work at the pit. In 1950 they moved to the new Ellen Wilkinson Estate and tasted the luxury of electricity, an indoor toilet and a bath with running hot water.

He attended Wardley Colliery School, Bill Quay Secondary Modern and Hebburn Technical College. His Dad's friend, Ray Bradley, arranged an interview to serve a five year engineering apprenticeship at the Marconi Company. Although it was excellent training, it was something that he did not enjoy and when it was completed he quickly moved on to working as a labourer at a Felling pop factory, assistant gardener at Felling Parks and as a postman for the Royal Mail for nearly twenty years. He then took a course on youth training work, with one placement working with multi-handicapped deaf children at Northern Counties School for the Deaf and the other based at St. Chads Community Project at Bensham. For the last ten years of his working life he worked part time as care assistant to a number of disabled people or as a carer for friends or family members.

The family name Stridiron was brought to this country by his Great Grandfather James Henry Stridiron, a seaman who was born on the island of St. Croix in the Caribbean in 1865,

who later married and settled in Sunderland and found work at Wearmouth Colliery. It is known that Stridirons were on Antigua in 1702. There is only one family in Europe with this unusual surname.

He has taken an interest in local history and in 1998 compiled *"A History of Wardley, It's Colliery and People."* Since then he has published *"The People of Wardley"* Vol. 1, 2 and 3 together with a publication on the records of St. Mary's Church at Heworth.

References

Evening Chronicle

Oct. 20th 1923. April 2nd, 3rd, 23rd, 24th 1925. Aug 27th 1932, Sept 11th 1932, March 17th 1933, April 7th, 12th, 25th 1933, May 1st, 16th, 17th, 18th, 19th 1933, June 27th 1933, Aug 7th, 11th, 30th 1933, Sept 9th, 11th, 12th, 13th, 19th, 21st, 23rd, 26th, 27th, 28th 30th 1933, October 2nd, 6th, 13th 1933, Nov 22nd 1933, Dec 1st, 13th, 14th 1933. Jan 2nd, 22nd 1934, March 5th, 23rd 1934, April 21st 1934, May 7th, 11th, 4th, 16th, 17th, 26th 1934, June 2nd, 5th, 6th, 9th, 10th, 11th, 13th 15th, 16th 19th, 21st, 22nd, 23rd 1934, July 11th, 16th, 25th, 28th, 30th 1934, Aug 1st, 2nd, 7th 1934, Sept 7th, 21st, 25th 1934, Dec 6th 1934. Feb 4th 1935, May 28th, 30th 1935, June 1st, 3rd, 5th 1935, July 13th, 15th 1935, August 21st 1935, Sept 6th, 16th, 17th, 23rd 1935, Oct 1st, 3rd 1935, Nov 8th 1935. Jan 8th, 30th 1936, Feb 4th, 5th, 6th, 7th, 17th 1936, March 14th, 24th 1936, April 15th 1936, May 1st, 22nd, 25th 1936, June 1st 1936, Sept 22nd 1936. Jan 6th 1937. Sept 20th 1939. April 22nd, 25th 1940. May 20th 1940. Sept 23rd 1986.

The Journal

May 2nd, 10th, 17th 1933, June 3rd 1933, 10th July 1st 1933, Aug 8th, 30th, 31st 1933. Jan 10th, 16th, 17th, 23rd, 24th, 25th 1934, Feb 7th, 21st 1934, March 5th, 8th, 19th 1934, May 9th 21st, 25th 1934, April 16th, 23rd 1934, June 1st, 4th, 12th , 20th, 21st, 25th 1934, July 5th, 16th 1934, Dec 13th 1983.

Sunderland Echo

Sept 2nd, 6th 1932, Oct 1st, 9th 1932, Nov 1st, 11th, 16th 1932, Dec 12th, 22nd 1932, Dec 22nd 1932. Jan 6th, 9th, 10th, 19th, 23rd, 26th 1933, March 17th, 22nd 1933, May 6th, 11th 1933, June 9th, 23rd, 30th 1933, July 14th 1933, Aug 8th 1933, Sept 8th, 9th, 13th, 16th, 18th 1933, Oct 13th, 17th, 18th 1933, Nov 4th, 9th, 16th, 17th, 20th, 25th, 29th 1933, Dec 2nd 1933. Jan 10th, 30th 1934, Feb 2nd, 6th, 8th, 9th, 13th, 16th, 23rd 1934,

March 5th, 7th, 19th, 27th, 28th 1934, April 13th, 30th 1934, May 15th, 16th, 17th, 23rd, 25th 1934, June 12th, 13th, 14th, 16th, 19th, 23rd 1934, July 2nd 1934, Aug 24th 1934, Sept 12th, 13th, 14th, 22nd, 26th 1934, Oct 11th, 19th. 30th 1934, Nov 5th, 6th, 7th 13th 1934, Dec 18th 1934. Jan 9th 1935, March 9th, 13th, 26th 1935. April 9th, 18th, 26th 1935, May 1st, 6th, 10th, 13th, 17th, 20th, 25th 1935, July 13th, 26th 1935, Aug 20th, 23rd 1935, Sept 3rd, 7th, 9th 1935, Oct 1st, 4th 1935, Nov 8th, 12th 1935, Dec 7th, 10th 1935. Jan 17th, 30th 1936, Feb 10th, 14th, 17th, 19th, 24th 1936, March 11th, 27th 1936, April 3rd 1936, June 24th 1936, July 10th, 24th, 27th 1936, Aug 12th, 27th 1936, Sept 1st, 19th 14th, 29th 1936, Oct 2nd, 14th, 24th, 30th, 31st 1936, Nov 5th, 7th, 25th 1936, Dec 10th, 11th, 22nd 31st 1936. Jan 2nd, 21st, 22nd 29th 1937. Feb 17th 1937, March 29th 1937, June 2nd, 9th, 18th, 28th 1937, July 4th, 10th, 18th 1937, Aug 19th 1937, Oct 5th, 13th, 23rd, 29th 1937. May 2nd 1938. June 4th 1940.

Sunday Sun
March 12th 1933, Sept 10th, 24th 1933, Dec 10th 1933. June 3rd, 10th 1934, July 8th 1934. April 14th 1935, June 16th 1935. Nov 22nd, 25th 1936, Dec 2nd, 10th 1936. July 18th 1937, Aug 8th, 18th 1937, Oct 17th 1937, Nov 21st 1937. June 30th 1040.

Shields Gazette
May 10th 1933, Sept 27th 1933, Oct 5th, 9th 1933. Jan 22nd, 27th 1934, Feb 1st. 2nd, 7th, 10th, 12th, 19th, 22nd, 23rd, 24th 1934, March 5th, 10th, 14th 1934, June 4th, 11th 1934, July 4th, 5th, 12th 1934, Sept 8th 1934. Feb 23rd 1935, March 1st, 7th, 20th 1935, April 3rd, 9th, 11th, 13th 1935, July 27th 1935, Sept 11th, 13th 1935, Oct 5th, 31st 1935, Nov 4th 1935. Jan 30th 1936, Feb 3rd, 4th, 5th, 8th, 11th, 14th 1936, March 21st 1936, May 2nd, 11th, 20th, 25th 1936, June 2nd, 5th, 6th, 9th, 16th, 25th, 26th, 30th 1936, July 13th 1936, Aug 2nd, 24th 1936' Sept 2nd, 10th, 12th, 17th, 22nd, 23rd, 28th, 30th 1936, Oct 2nd, 3rd, 6th, 10th, 13th, 15th, 19th, 27th, 28th, 1936, Nov 21st 1936, Dec 12th, 21st 1936. Jan 26th 1937, April 23rd 1937, June 10th, 15th, 22nd, 25th, 30th 1937, July 23rd 1937, Aug 25th, 30th 1937, Sept 7th, 22nd, 23rd 1937. Sept 26th 1938, Oct 25th 1938, Nov 22nd, Dec 3rd 1938. Jan 4th 1939, June 10th 1939, July 26th 1939, Aug 26th 1939, Sept 14th 1939, Oct 29th 1939.

References

Chester-le-Street Chronicle
August 18th 1933.

North-Eastern Daily Gazette
Feb 11th 1933, May 15th, 16th, 22nd 1933, June 23rd 1933, Sept 1933. Feb 5th, 21st 1934, April 30th 1934, May 17th, 19th, 26th 1934.

The Shields News
Oct 9th, Nov 1st 1933. Jan 31st, Feb 21st, March 10th, April 30th, May 17th, June 13th, July 4th, 7th, 11th, 12th, 14th, Sept 20th, Oct 26th, Dec 9th 1934.

North Mail
March 10th 1925, April 9th, 15th 1925, May 18th, 19th 1925, Aug 8th, 12th, 14th 1925. Jan 3rd, 16th 1933, March 2nd, 17th, 27th, 31st 1933, April 3rd, 4th 1933, May 2nd, 10th, 13th, 15th, 16th, 17th, 18th 1933, June 16th, 19th, 26th, 30th 1933, Aug 11th, 14th, 15th, 24th, 30th, 31st 1933, Sept 11th, 16th, 18th, 20th, 21st, 23rd, 25th, 26th 1933, Oct 16th, 20th 1933, Nov 1st, 3rd, 9th, 22nd, 23rd, 25th, 28th, 30th 1933, Dec 8th, 11th, 14th,, 16th, 30th 1933. May 12th, 14th, 15th, 16th, 25th, 29th 1934. June 2nd, 4th, 11th 13th, 15th, 22nd 1934. July 18th, 25th, 26th, 30th 193. Aug 1st 1934. Sept 6th, 10th, 15th 1934. Nov 8th 15th. 26th 1934. Dec 6th 1934. March 13th, 16th 1935, May 7th, 10th, 11th, 21st,, 27th, 29th, 30th 1935, June 1st, 3rd, 6th, 7th, 14th 1935, June 14th, 21st 1935, July 6th, 25th 1935, Sept 2nd, 16th, 17th 1935, Oct 3rd, 4th, 7th 12th, 16th 26th, 29th 1935, Nov 2nd, 4th, 8th, 9th 1935, Dec 9th, 28th 1935. Jan 13th 1936, Feb 4th, 5th, 7th, 8th, 19th 1936, March 21st, 23rd 1936, April 7th 1936, May 11th, 19th, 23rd, 26th, 29th 1936, June 4th, 6th, 8th, 12th, 13th, 16th 1936, Aug 28th, 29th 1936, Sept 1st, 15th, 23rd, 28th 1936, Oct 10th, 13th, 19th, 27th 1936, Nov 6th 1936. Jan 2nd 1937, Feb 7th, 12th 1937, March 10th 1937, May 26th 1937, June 11th 1937, July 22nd 1937, Oct 13th, 14th, 15th 1937. March 8th, 29th 1938, April 14th, 26th 1938, May 26th 1938, Sept 21st, 23rd 1938. March 6th 1939.

Newcastle Weekly Chronicle
March 29th 1924, April 19th, 26th 1924, July 26th 1924, Aug 9th 1924, Sept 20th, Oct 11th 1924. Jan 10th 1925, Feb 7th, 28th 1925, April 4th

1925, May 16th, 23rd 1925, Sept 26th 1925, Oct 17th, 24th, 31st 1925. July 10th 1926, Nov 6th, 13th, 20th 1926. Feb 12th 1927, March 5th 1927 April 9th, 29th, 30th 1927, May 7th, 14th, 28th 1927, Aug 13th 1927, Sept 24th 1927, Oct 15th 1927. Aug 19th 1933, Sept 23rd 1933, Dec 9th, 16th, 30th 1933. Feb 3rd 1934, March 24th 1934, June 16th, 23rd 1934, July 14th, 28th 1934. April 20th 1935, May 11th 1935, July 27th 1935, Aug 10th 1935, Oct 12th 1935, Nov 9th 1935. Aug 15th 1936

Morpeth Herald
Jan 10th, 13th 1936.

Heslops Local Advertiser
Nov 10th 1933.

Durham County Advertiser
July 1929, June 30th 1933, Sept 22nd, 29th 1933, Nov 10th 1933. Dec 15th 1933. Jan 12th, 26th 1934, Feb 16th 1934, Dec 14th 1934. Sept 6th 1935, Oct 4th 1935, Nov 1st, 8th 1935. Feb 21st, May 22nd 1936, June 19th 1936, July 10th 1936, Sept 4th, 25th 1936, Oct 30th 1936, Nov 13th 1936, April 23rd 1937, Sept 24th 1937.

Hexham Courant
April 28th 1934, May 5th 1934, Sept 29th 1934. Sept 21st 1935. Oct 12th 1935, April 29th 1939.

'My D-Day Recollections'
(Parachute Battalion)' by Ken Dick, former Newcastle BUF District Leader.

Fascist Weekly
Dec 15th, 22nd, 29th 1933. Jan 4th 1934.

The Blackshirt
Jan 5th, 19th, 26th 1934, Feb 2nd, 9th, 16th, 23rd 1934, March 2nd, 9th, 16th, 30th 1934, April 29th 1934, July 20th 1934, Aug 3rd, 10th, 17th 31st 1934, Sept 7th 1934, Nov 23rd 1934, March 1st 1935, June 28th 1935, March 28th 1936, Jan 30th 1937, Feb 6th, 27th 1937, March 6th, 20th 1937, April 8th, 17th, 24th 1937, May 1st, 22nd, 29th 1937, June 5th 1937,

References

July 3rd, 10th, 31st 1937, Oct 9th, 16th 1937, Nov 30th 1937, Dec 18th 1937, April 1938. Information on branch activities available in "On the March" columns in most issues.

Action
April 29th 1939.

Other Sources :

British Fascism (Linton Orman Fascisti) June 1930.

Gateshead District and Municipal News June 1934.

A Pilgrimage of Grace: The Diaries of Ruth Dodds.

My Life by Sir Oswald Mosley p215 and p306.

Mosley by Nigel Jones (2004) p 45.

Hurrah for the Blackshirts by Martin Pugh (2006) p170.

Rules of the Game by Nicholas Mosley (1982) p90. 123, 129.

Fascism in Britain by Richard Thurlow (1998) p64 and 65.

In Excited Times by Nigel Todd (1995) p11, 14. 55.

How the BUF came to Geordieland by Robert Richards (Ken Dick).

Jeff Wallder Correspondence 20th October 2011 and April 15th 2012.

Interview with daughter of Arthur Henry Baggs, Gateshead BUF member on July 11th 1994.

18b files held at Tyne and Wear Archives.

Comrade, publication of the Friends of Sir Oswald Mosley.

Newcastle upon Tyne: A Modern History by Robert Colls and Bill Lancaster p184.

www.ingramcontent.com/pod-product-compliance
Lightning Source LLC
Chambersburg PA
CBHW050213270326
41914CB00003BA/397